Today I shall judge nothing that occurs

For Tommy Gear

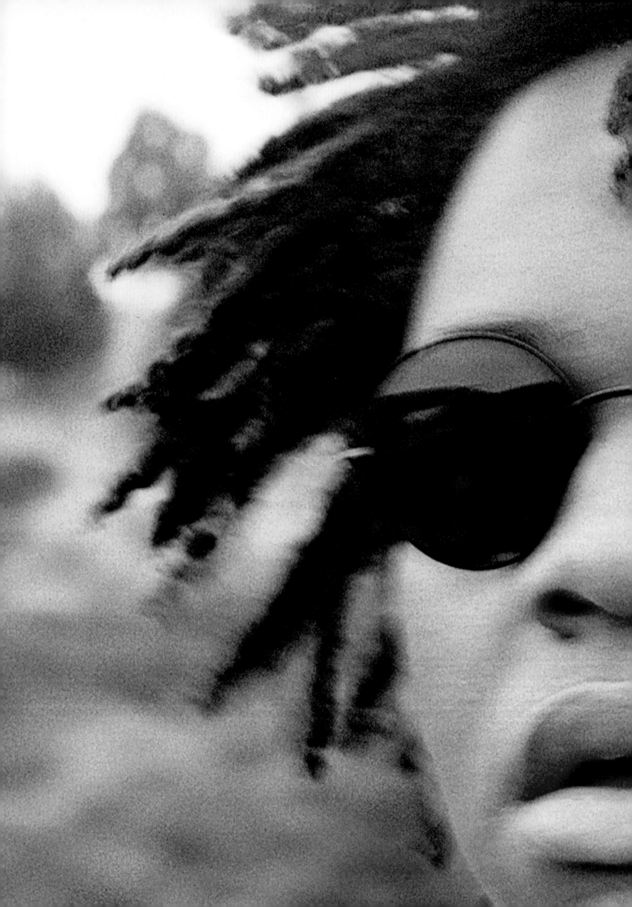

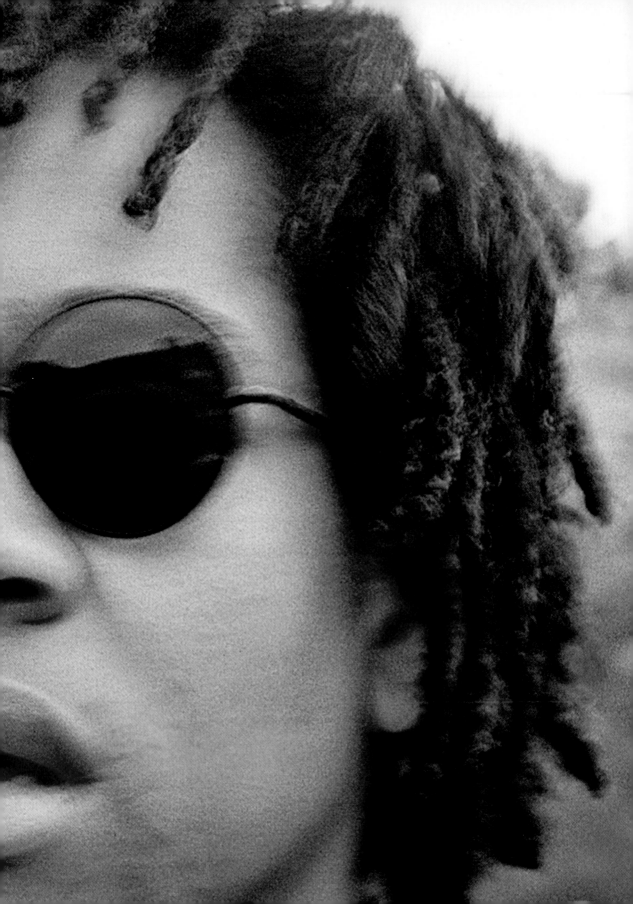

Lyle Ashton Harris, upper Baja, Mexico, mid-1990s

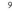

INTRODUCTION BY Johanna Burton
CONTRIBUTIONS BY Vince Aletti,
Martina Attille, Gregg Bordowitz,
Adrienne Edwards, Malik Gaines,
Lucy Gallun, Rashid Johnson,
Thomas J. Lax, Sarah Elizabeth Lewis,
Catherine Lord, Roxana Marcoci,
Pamela Newkirk, Clarence Otis Jr.,
Robert Storr, Mickalene Thomas,
and Iké Udé
ADDITIONAL ESSAYS BY Ulrich Baer and
Robert Reid-Pharr
CONVERSATION WITH Thomas Allen Harris
BIBLIOGRAPHY BY Parissah Rhayee Lin

Today I shall judge nothing that occurs

Selections from the *Ektachrome Archive*

Lyle Ashton Harris

aperture

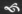

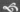
*The journals included in this book have been selected and
scanned from the artist's original notebooks. Selections
include entries from 1997, 1998, 1999, and 2000.*

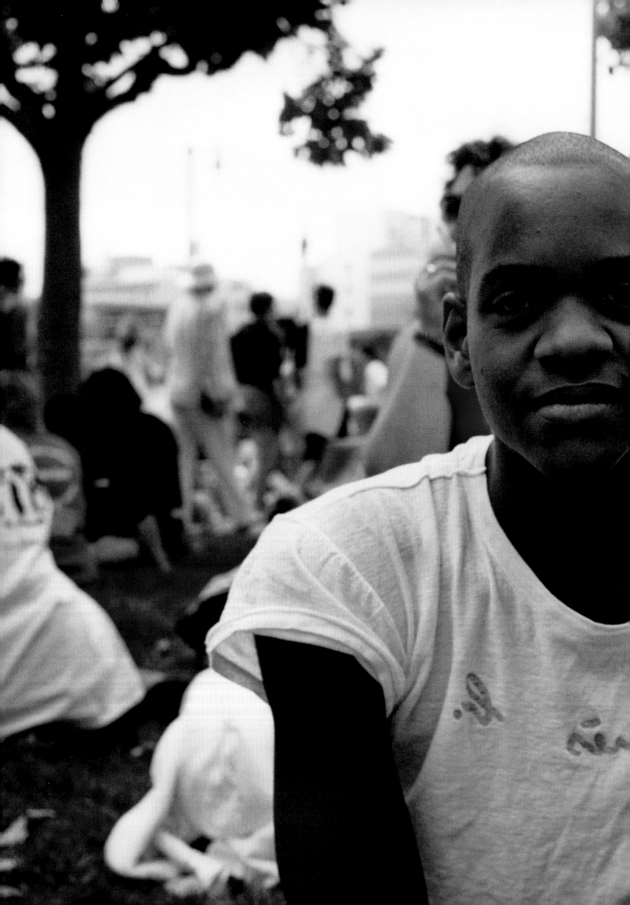

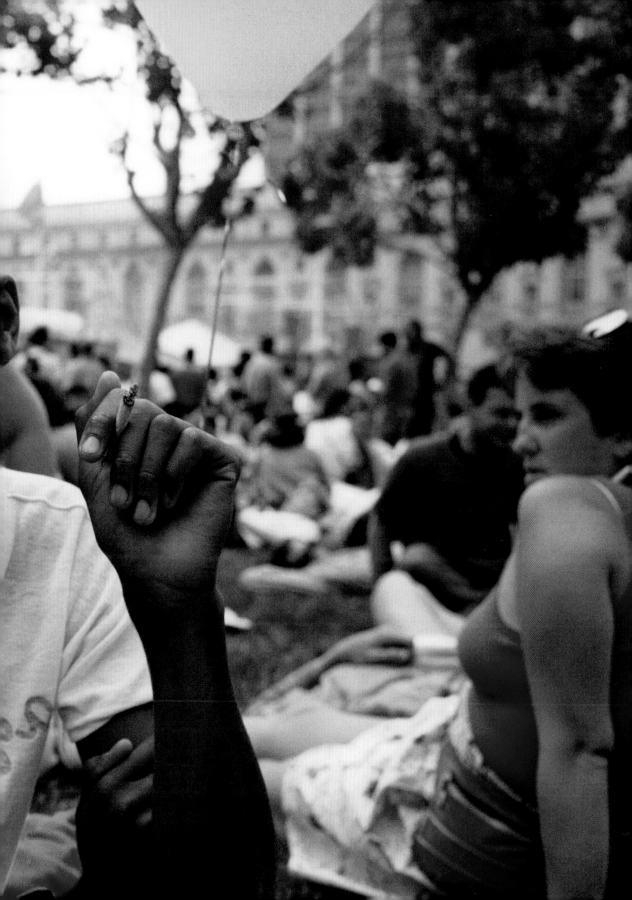

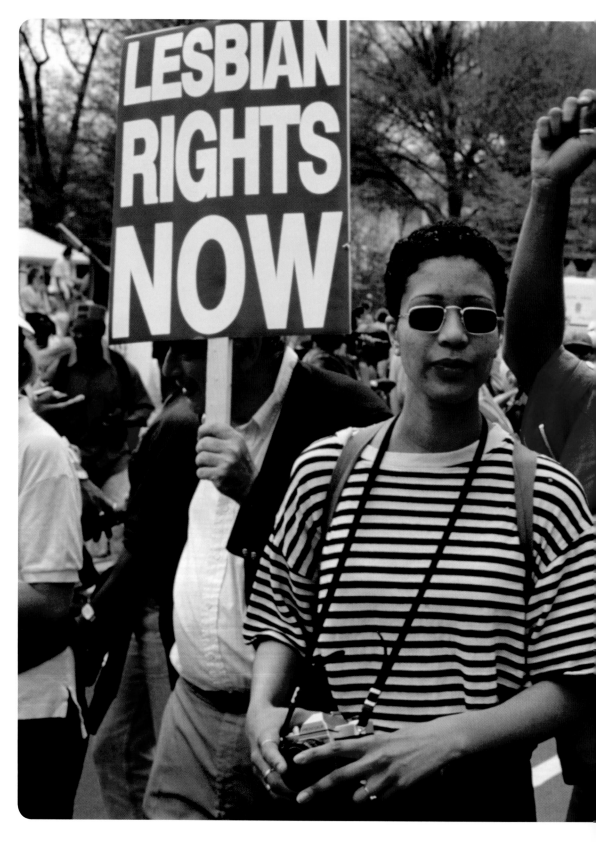

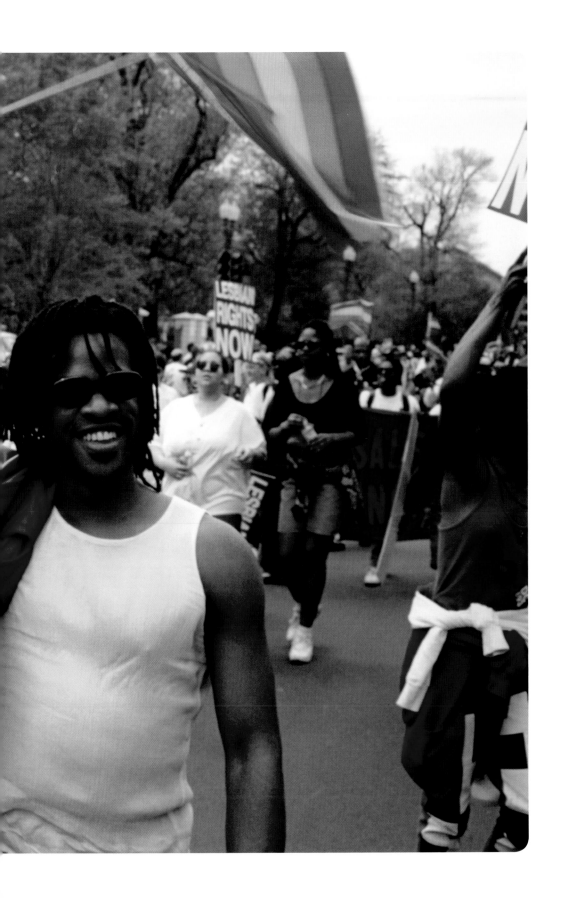

Alex Epps and Thomas Allen Harris, March on Washington for Lesbian, Gay, and Bi Equal Rights and Liberation, Washington, D.C., April 25, 1993

Nancy Barton, Los Angeles, early 1990s

Unknown person, Sunset Junction Street Fair, Los Angeles, early 1990s

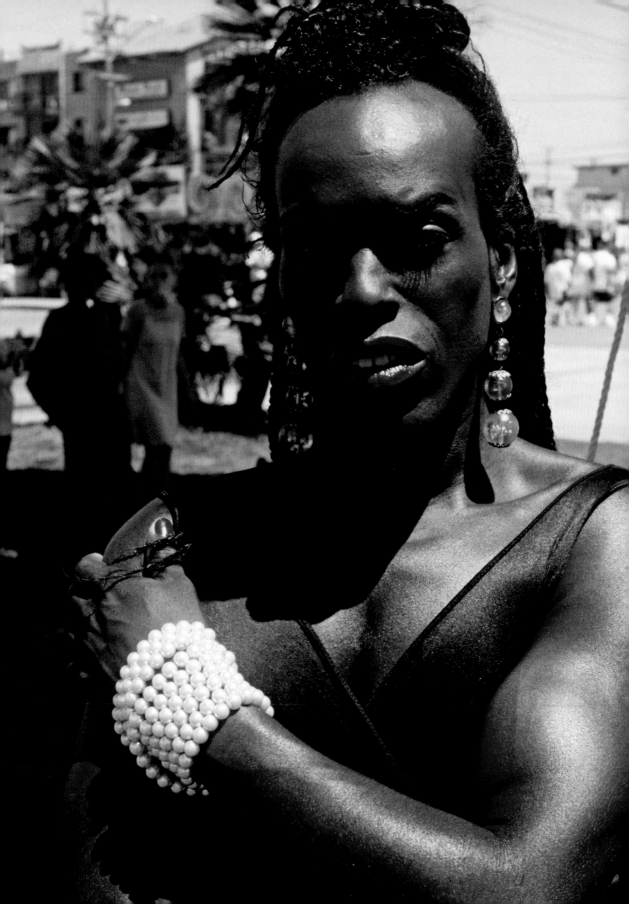

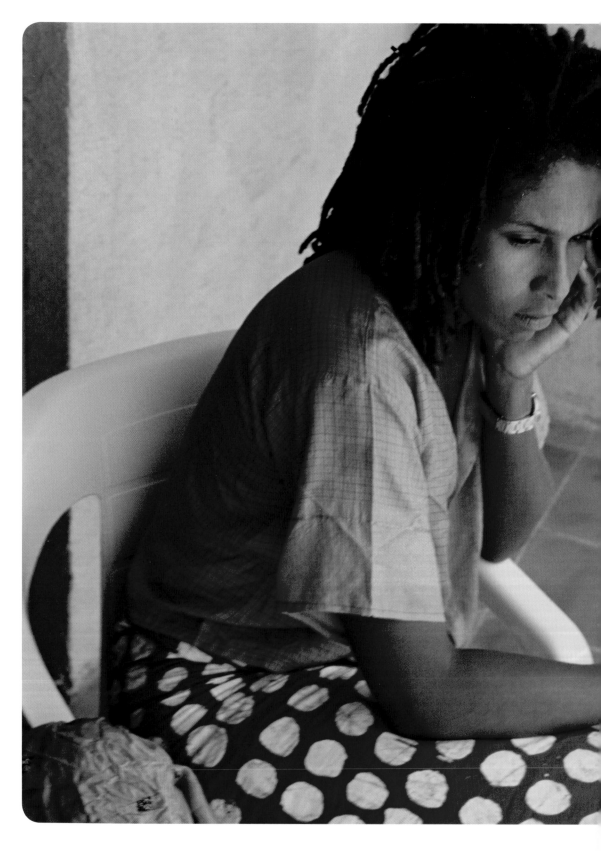

LEFT: Renée Cox, upper Baja, Mexico, mid-1990s FOLLOWING SPREAD: Renée, Lyle, and Thomas, upper Baja, Mexico, mid-1990s

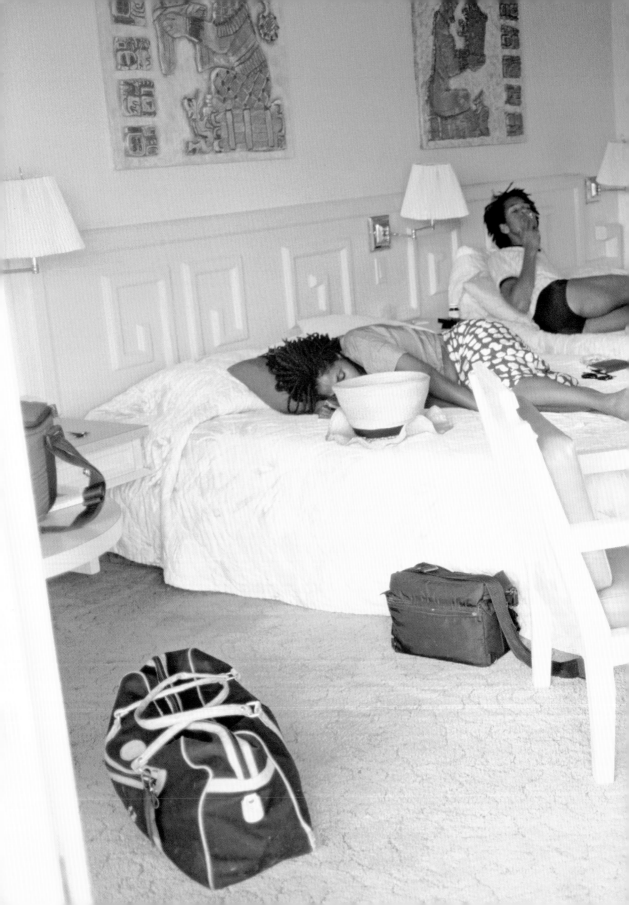

#1, Europe 1997

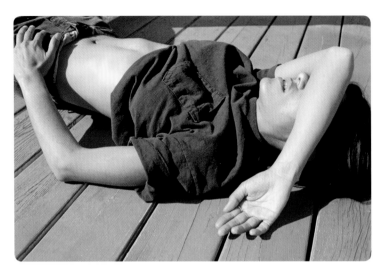

Meena Nanji, Los Angeles, mid-1990s

30

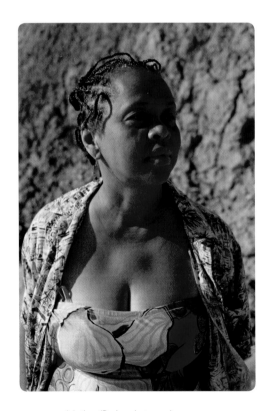

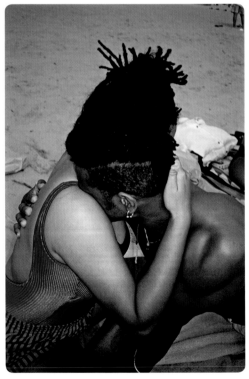

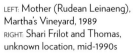

LEFT: Mother (Rudean Leinaeng),
Martha's Vineyard, 1989
RIGHT: Shari Frilot and Thomas,
unknown location, mid-1990s

Self-portrait, Black's Beach, La Jolla,
San Diego, mid-1990s

ABOVE (TOP): Jenny Shimizu and
Catherine Opie, Sunset Junction
Street Fair, Los Angeles, early 1990s
ABOVE (BOTTOM): C. C. H. Pounder
and Lyle by Terry Mathis, Mandela
Freedom Tour, Los Angeles, 1990

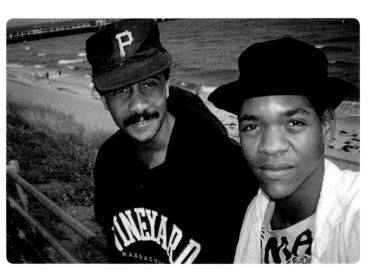

David Mills and Lyle, Inkwell, Martha's Vineyard, late 1980s

Use Me / Aloe (Journal #1), 1997

USE
ME

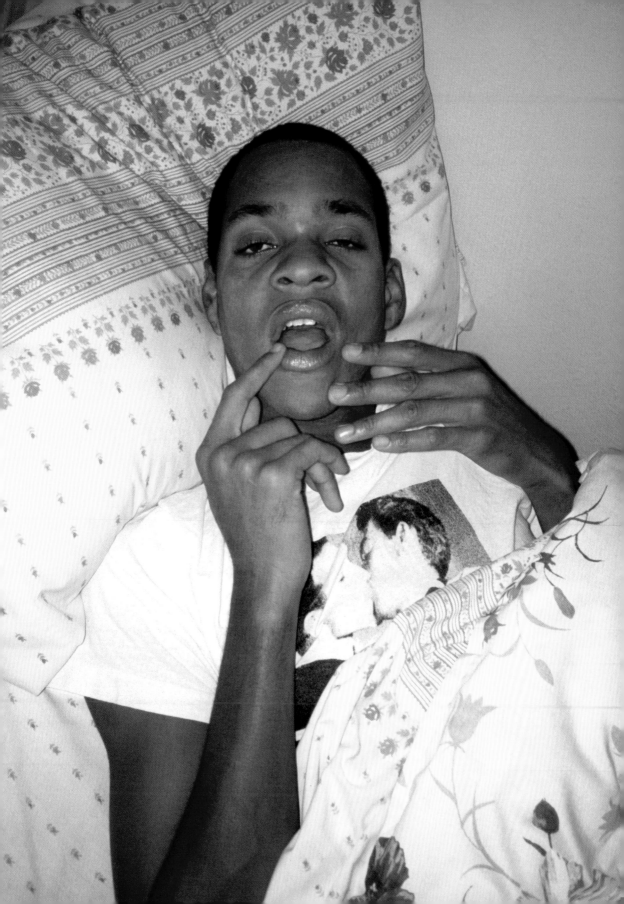

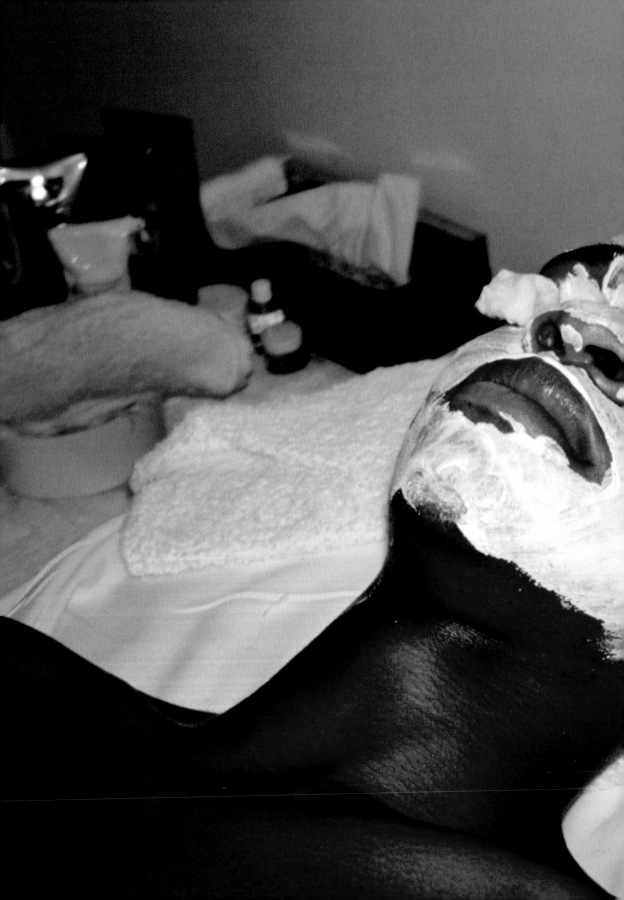

38

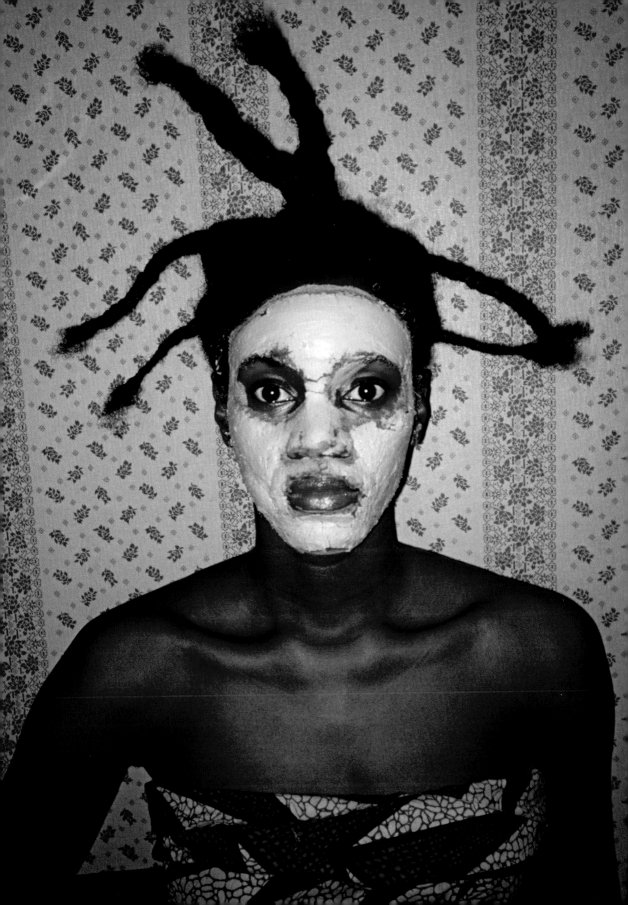

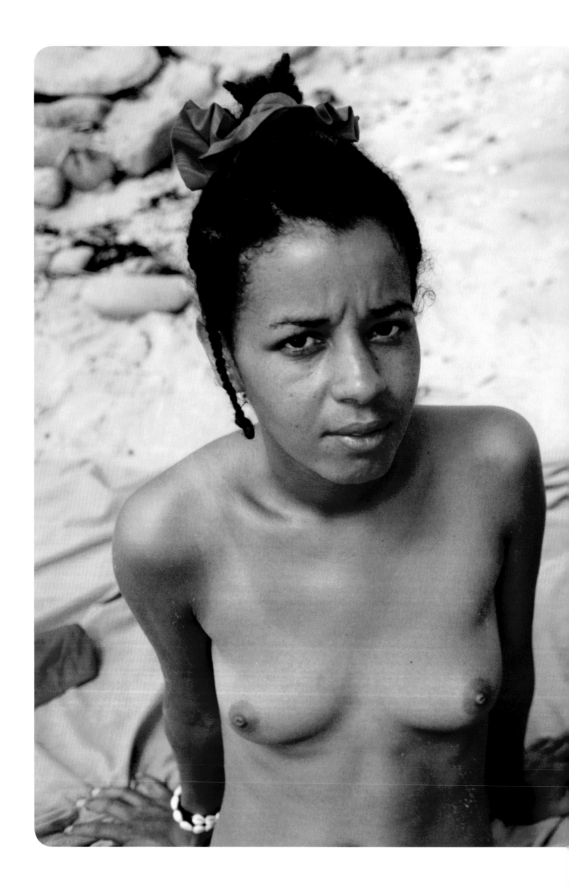

Lynne Mendes and Christina Sharpe, Gay Head, Martha's Vineyard, late 1980s

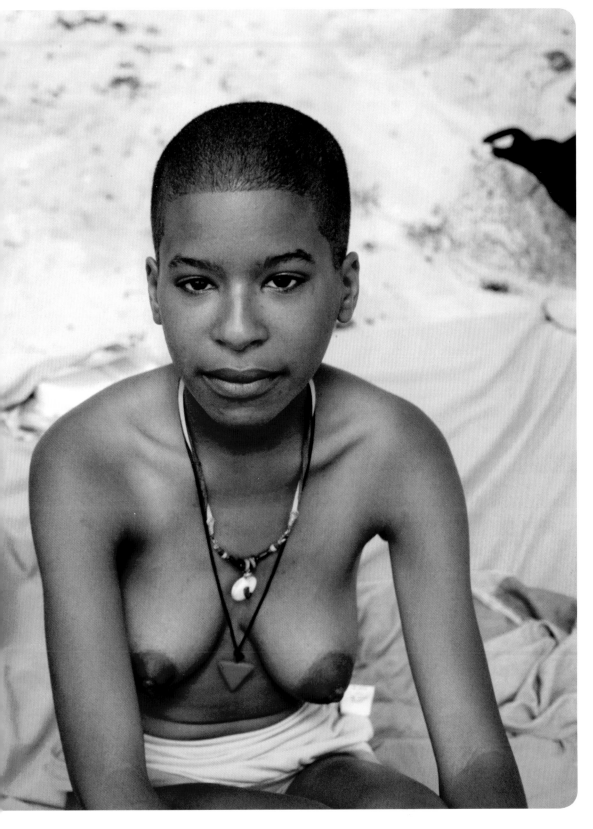

41

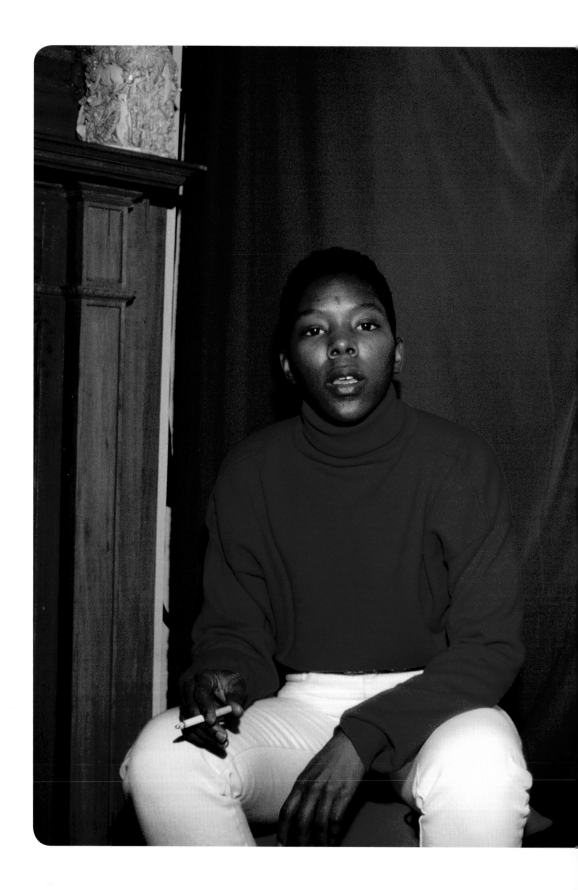

Gail Burton and Peggy Nelson, Fort Greene, Brooklyn, late 1980s

Gail Burton and Alex Epps, March on Washington for Lesbian, Gay, and Bi Equal Rights and Liberation, Washington, DC, April 25, 1993

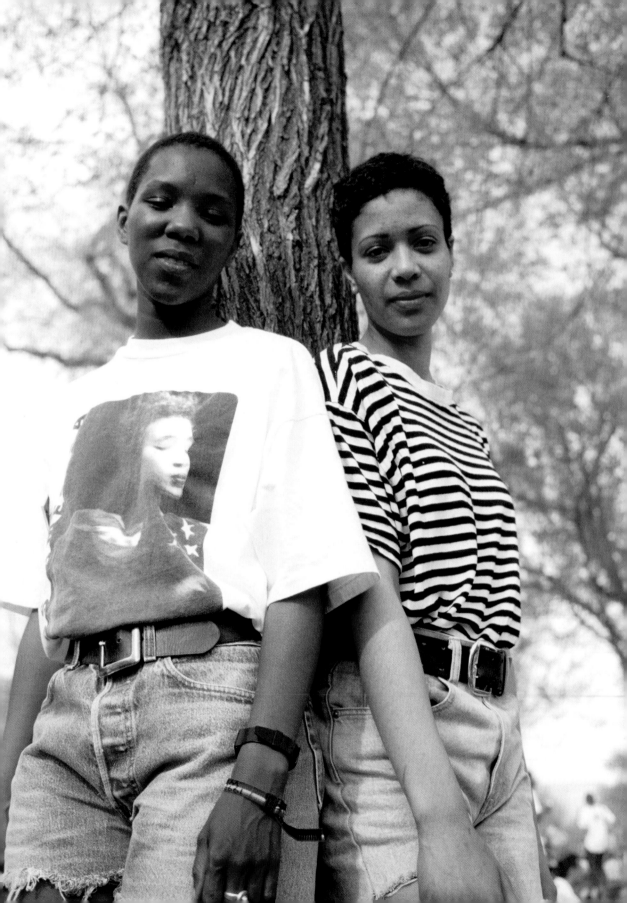

Today
I
Shall
Judge
nothing
that
occurs

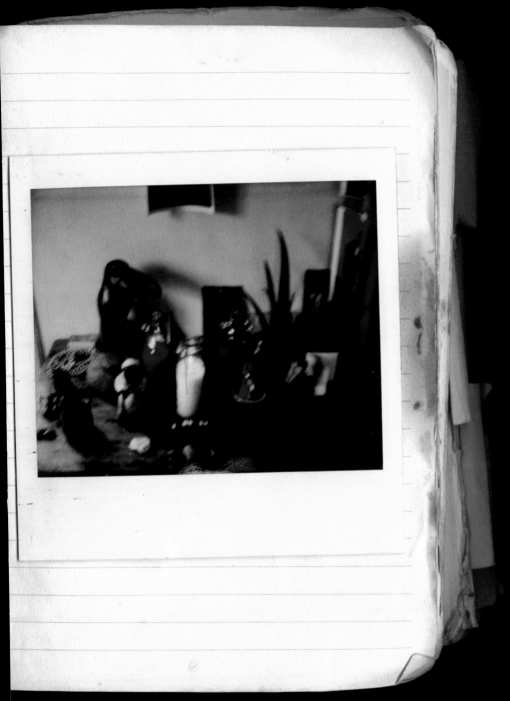

Feverish: An Introduction to a "Chorus" of Reflections and Speculations on Lyle Ashton Harris's Ektachrome Archive
Johanna Burton

In a conversation with his brother Thomas, conducted on the occasion of and published in this volume, Lyle Ashton Harris notes that the thousands of pictures he shot on slide film between 1998 and 2001—now drawn together and retroactively titled the *Ektachrome Archive*—amount to a lush, messy collection of interwoven stories. Such messiness, such interwovenness, he suggests, resists the longstanding, still-prevalent idea that there are public events in the world that should be recognized as primary, and that our own personal (emotional, intimate, internal) daily lives and actions exist on a secondary plane. The latter, of course, deeply inform how we experience prevailing "master" narratives, yet are rarely visible, or considered relevant, within them. "In actuality," Harris says, "personal subjectivity is central, and it's informed by, and in turn informs, intellectual discourse in the public sphere—each represents interdependent tracks that sometimes collide, sometimes coincide."[1]

It is compelling to consider the ways in which individual subjectivities inherently challenge the impulses and priorities of cultures at large, particularly those that are presented as neutral or universal. Every negotiation of "self" also denotes a public stance, subtly but indelibly, and the accumulations of such negotiations might even be said to produce multiple publics (or "counterpublics," as described by Michael Warner when accounting for race, sexuality, and class, among other things).[2] Indeed, the true porosity between terms like "public" and "private" is highlighted in a project such as Harris's *Ektachrome Archive*; the stark contrast between scenes and contexts for modes of being is only made more evident. Here are people presenting themselves in situations ranging from professional (conferences, lectures, exhibition openings) to private (sex, substances, sleep). So many of these figures are now iconic to us, heroes pictured by Harris ahead of their time but now properly historic, if not in all cases fully recognized for their importance. To look at these pictures now is to understand the tender ruthlessness of time. In fact, they inevitably prompt reflections on the poignancy of earlier cultural and political moments, and of the too-often overlooked ties between, and unlocked potential of, such intimate settings and the shape taken by broader discourses. Harris's images thus may kick up the desire to hold on to—to grasp—those instants in time he captured. But just as palpable is the obvious truth that they were gone as quickly as they happened, even if evidence of them is right here, in the images reproduced in this book.

Theories of the archive, of course, have long pointed to the contradictions at the heart of any "public record." Jacques Derrida's 1995 *Archive Fever* did away with the notion that the archive truly retains the past, arguing instead that its function has been to exteriorize *signs* of the past, but always at the expense of "the place of originary and structural breakdown of the said memory."[3] That is, memories are necessarily singular. When they become shared—when they become "history"—they become something else.[4] Yet, for Derrida, any stark opposition between internal experiences and their external-ization in the name of conservation or history also misses the point. It is in the translation—or perhaps better, approximation—between the former and the latter that the archive's potential is truly found. Indeed, the very instability of the archive marks something of its ontology. The encounter is marked by desire, not just for an earlier time but also for an altered present. And this is why for Harris, as for a number of other contemporary artists, the archive must not only be seen as a site that activates a past, but also as one that, in failing to produce a single cohesive picture of it, produces new legacies, and in so doing allows us to imagine other futures. As Hal Foster has described it, an "archival impulse," as pursued by artists, allows for "new orders of affective association," and "aims to disturb the symbolic order at large."[5] Utilized as such, the archive has the radical potential not only to unearth suppressed or untold narratives but also to bend time. Returns to the past can only happen in the present.

To this end, an important aspect of presenting Harris's *Ektachrome Archive*, particularly within the context of a book, is to foreground its generative nature by way of those who have encountered or will encounter it. The "chorus" of contributions, embedded in three sections into the plate section of this book, offers the reflections of sixteen figures who have intersected with Harris and his work over the past several decades. They are linked by the impact left by the events and individuals depicted, as well as by Harris himself; in reading their texts, one finds that his archive gives way to a multitude of intimate archives, each partially authored by the individual contributors. The voices here vary: they are assembled across generations, gender, race, sexuality, profession, and writerly style. They include old friends as well as more recent interlocutors. They evidence a broad range, from firsthand accounts of the pictures as they were being taken to encounters long after the fact, which testify to the ongoing impact of extant images (and experiences) as they become historical.

The incredibly diverse set of responses here is fascinating for the multiple lenses they provide a reader—suggesting, too, that there are as many lenses as lookers. Even beyond the spectrum of historical and contemporary analyses and contexts provided, this chorus contributes to and becomes part of the

archive itself. At once further substantiating (lending more information, giving more details) and deferring (such an open-ended archive is necessarily never-ending, too), these responses point to what Okwui Enwezor has highlighted in his seminal work about the role of the archive in artistic practice. If one prevailing idea of archives is that they "order" history, for Enwezor, the archive also offers the chance to throw such order into question, and, specifically, to interrogate the role of authority in every cultural history.[6] The implications here are particularly important when it comes to Harris's work, which has long considered —and refused—the marginalization and obfuscation of black bodies and queer bodies within representation. Harris's generosity and curiosity have led him to present his abundance of archival images in a series of reordering constellations—looking at himself looking through the lens, as it were, and taking stock anew not only of his pictures but also, in a sense, of his presence as someone holding a camera among his closest peers. In addition to his own constant shuffling-of-the-archive-deck, he offers the opportunity here for sixteen others to "read" his images—sometimes harmoniously, often discordantly. What results is a magical cacophony. Ironically, for so much difference between the reflections, there is also deft precision in them. What I am describing is not a collection of anything-goes accounts of history, but rather a shared acknowledgment, and a self-reflexive highlighting, of the fact that every subject necessarily changes what—and whom—it touches, and vice versa.

A number of pivotal situations, subjects, and ideas surface more than once in the accounts gathered here, from the *Black Popular Culture* conference and *Black Male* exhibition to the AIDS crisis and its debilitating effects, to more abstract meditations on pleasure, pain, melancholy, and militancy. Harris's circle of friends and families, including a number of distinguished figures, are centered within the photographs, and thus also are central in the texts you are about to read. But just as important are the things that stay in reserve—just as present, if not as immediately identifiable. They surface feverishly around the edges of the stories told here, tangible in their presence if not yet named, knowing their time, too, will come. As you read the words assembled in this volume, remember that in describing the archive, these authors have altered it, shifted its contours, and, in so doing, set the stage for many chapters to come.

1. See pages 277–78 in this volume. 2. See Michael Warner, *Publics and Counterpublics* (Zone Books, 2002). Warner usefully troubles the notion of a "common" public, calling attention to the ways people occupy shared space with others they do not identify with; ways in which those who exist outside of hegemonic norms can call attention to and pressure exclusionary and suppressive structures. 3. Jacques Derrida, *Archive Fever* (University of Chicago Press, 1996), p. 11. 4. Ibid. 5. Hal Foster, "An Archival Impulse," *October* (Fall 2004), p. 21. 6. See Okwui Enwezor, *Archive Fever* (New York: ICP/Steidl, 2008). Enwezor's exhibition examines how documentary photography can be used by artists to question or recast historical narratives.

When the Mood Takes Him
Vince Aletti

Looking through Lyle Ashton Harris's snapshot archive, I wonder, who does he think he is? Mr. Wonderful? Miss Thing? Man About Town? Star? Sidekick? Intrepid reporter? Even when he's ostensibly playing himself (whoever that might be), Harris's work has always involved performance—imagining and inhabiting a role, sometimes across gender lines, from Billie Holiday to a dazed and bloodied boxer. The candid quality of these pictures suggests a performer off duty, among friends, open but never exactly unselfconscious. The cum shot, at once voluptuous and clinical, is no accident. Harris invites us into his bed, into his bathroom, and into his carefully edited life. He's both on and off guard, a charmer and a tease. Is this a revelation or an exhibition? If nothing else, it's evidence of the busy social life of a member of an international community of artists, writers, academics, and curators that was, itself, finding voice and asserting power in the 1980s and '90s, when most of these pictures were taken. Harris is clearly more intimate with bell hooks, Iké Udé, Isaac Julien, and Marlon Riggs (who are usually seen in private rooms and in relaxed, if not half-dressed, moments) than he is with, for instance, Hilton Als, Carrie Mae Weems, Cornel West, or Greg Tate, who are found at more public gatherings: formal dinners, conferences, awards ceremonies. But Harris catches all of them—and himself— at a turning point, just as outsiders were becoming insiders and creating a radical, avant-garde alternative to the old establishments, both white and black.

Harris has described himself as being "on the border of multiple crossover points, such as race, sexuality, and gender." He's not alone in this space (and on the evidence of these images, it's a pretty lively locale), but carving it out can't have been easy. Refusing to be boxed in or narrowly defined, Harris and his circle of canny provocateurs have opened up a previously closed world. Ripples of this creative disturbance animate much of the material in the archive—a mash-up of public and private moments that is part memoir, part manifesto. Harris is often visibly absent from these moments, since he is busy recording and collecting them, but when he's in the frame he's always a striking figure. His eyes are big and avid; his body, loose-limbed and angular, ready to strike a pose. When the mood takes him, he puts on lipstick, but his androgyny is mostly held in reserve here—a secret weapon, ready to queer the scene at a moment's notice. Like Nan Goldin, who makes a signature appearance looking into a mirror, Harris opens the door to his particular world but doesn't exactly invite us in (pp. 186–87). If we feel seduced and abandoned, that's our problem.

Saint Michael Stewart, 1994[1]
Martina Attille

"You talking about flesh?"
"I'm talking about flesh."
—Toni Morrison[2]

"Oh, my daughter, I have heard your woes and your pains and tribulations, and in the depth of the wisdom of the gods I will help you find peace and happiness."
—Zora Neale Hurston[3]

On July 7, 1992, after meeting with Lyle and curator Marlene Smith during the London stop of Lyle's European tour, I wrote to my friend and confidant Michael Cadette: "This task of the 'Black Body' is an exciting proposal because it seems to have been the most contested territory for our generation of artists, critics, and advocates."

UK artist Sonia Boyce had introduced me to Lyle during my engagement at the University of California, San Diego, in the spring term of 1990. I was living in Tottenham, north London, when I received an invitation to the private viewing for *The Good Life* at Jack Tilton Gallery in New York in 1994, the first solo show by artist Lyle Ashton Harris.

I studied for a long time the featured image on the postcard invitation. It was a black-and-white photograph of Lyle as his younger self, looking straight into the lens. His folded arms were set in an arrangement typical of the attentive pupil seated front-row, facing an inspirational teacher; a long, finely woven scarf was luxuriously draped across his neck, then over one shoulder; the child Lyle poised front-stage right, seated on an item of soft furnishing, set against a polished wood floor. The photograph appealed to my appreciation of the family album as a narrative device for manipulating time and space, as employed in my film *Dreaming Rivers* (1988). The set of *Dreaming Rivers* included authentic photographs from the family albums of lead actress Corinne Skinner-Carter ("Miss T") and Isaac Julien, assistant director. Key "album" photographs of the sibling characters, Daughter (Angela Wynter), Sister (Nimmy March), and Sonny (Roderick Hart), as their younger selves were staged, modeled by my goddaughters and nephew, and photographed by UK artist Brenda Agard.

My London living space, back then, was a one-bedroom ground-floor flat in a terraced house, with a garden and a well-established apple tree. Although

situated in the London borough of Haringey, which boasts affluent electoral wards to the west, my home was situated in the east, where properties were generally cheaper than in most other London boroughs. The flat's location in West Green was one street south of the large housing estate Broadwater Farm, which had erupted into violence in 1985 in response to the collapse and subsequent death of Cynthia Jarrett, a mother of five, after a police raid on her home.[4] To map more accurately the haunting coordinates of my location, the flat was northeast of Crouch End, where in 1993 Joy Gardner, mother of one, fell into a coma while law-enforcement officers bound and gagged her for deportation.[5] She never recovered. Correspondence relating to the campaign for justice for Joy Gardner is housed in the Bernie Grant Archive in London. Holdings relating to letters of support for and against the campaign are closed until 2094.

The portrait of Lyle Ashton Harris as his younger self, taken by his late cousin Phillip Johnson Jr., reads as the embodiment of a much-desired privilege: to be loved deeply, protected, and made to feel secure. By contrast, Cynthia Jarret and Joy Gardner were black mothers of Caribbean descent who were visited in their homes by law enforcement brutally exercised, with horrible implications, including the encrypted dialectics of eroticism and violence. Saint Michael Stewart, pray for us.

Unable to attend the private view for *The Good Life*, I met up with Lyle in London at *Mirage: Enigmas of Race Difference and Desire* (1995), a multi/cross-disciplinary extravaganza curated by David A. Bailey and hosted by the Institute of Contemporary Art. I was expecting my first and only child. It was a good time. Brimming with optimism.

1. The title here refers to the work *Saint Michael Stewart* (1994), a unique Polaroid featuring the artist dressed as a police officer in front of a backdrop of a Pan-African flag. The work was part of a larger body of work called The Good Life, the centerpiece of Harris's 1994 show. **2.** Toni Morrison, *Beloved* (New York: Alfred A. Knopf, 1987), p. 255. **3.** Zora Neale Hurston, *Mules and Men* (Indiana University Press, 1935), p. 204. **4.** Tony Gifford, *The Broadwater Farm Inquiry: Report of the Independent Inquiry into Disturbances of October 1985 at the Broadwater Farm Estate, Tottenham, Chaired by Lord Gifford* (London: Karia Press, 1986). **5.** Benjamin Zephaniah, *Propa Propaganda* (Hexham, England: Bloodaxe Books, 2011), p. 12.

Untitled
Gregg Bordowitz

The archive is an ode to enthusiasm. Subjects smile, expressing deep affection. Intimate gazes are shared. There are glimpses of sadness, too. Mourning. The whole experience is immersive. Urgently, this is a call now to participate in the ongoing, shared project of persistence and flourishing, both individual and collective, of surviving stigma, exclusion, violence. Contemplating one image as singular, or the archive in total, all the senses are stimulated. A wide range of passions arises.

Images contain processes of waves, lights, loves, looks, all informed by dynamic excitements degrees of attractions affinities; all emotion cell emulsion gathering crystallizations varying densities energetic forces intensities.

In Essex Hemphill's poem titled "Commitments," the poet promises to always be present among the photographs of his family's album:

I will always be there.
When the silence is exhumed.
When the photographs are examined
I will be pictured smiling
among siblings, parents,
nieces and nephews.

With great precision and economy, Hemphill's poem evokes the familiar images of family picnics and holiday gatherings. Among the family's photographic record, his arms are "so empty they would break / around a lover." Still, he shows up for his family, he honors his commitments, and with a mixture of love, anger, loyalty, and sadness concludes—

I am the invisible son.
In the family photos
Nothing appears out of character.
I smile as I serve my duty.

In Lyle's pictures of Essex, the poet is very much at the center of his own life. There's the poet I heard read, whose compositions "When My Brother Fell" and "Now We Think" helped me compose my own fragile state. In *Essex Hemphill, Los Angeles Contemporary Exhibitions*, 1992, the poet is in what

appears to be the greenroom in preparation to take the stage, candid, caught in mid-sentence, cigarette casually dangling (pp. 124–25). In *Untitled (Essex at Getty)*, 1992, the poet is looking out directly at his audience, enjoying himself, a stack of papers on top of a copy of Joseph Beam's anthology *In the Life* resting beneath his joined hands. In *Tommy Gear and Essex Hemphill, Hobart Boulevard, Los Angeles*, 1994, two men are at ease with each other, Tommy in bathrobe, Essex in turtleneck, sock feet, cigarettes and ashtray on the table (pp. 202–3). He's resting on his elbows.

This is a vital archive punctuated by quizzical, introspective autoportraits of the archivist posing questions in varying states of velocity and rest. *Lyle Ashton Harris, Gay Pride Parade, San Francisco*, 1989 (pp. 14–15); *Tommy Gear and Lyle Ashton Harris, Vancouver, Washington*, 1994 (pp. 204–5); *Lyle Ashton Harris, Los Angeles*, early 1990s (p. 181); Lyle, Venice, Berlin, London, Guadalajara; *Lyle Ashton Harris by Tommy Gear, Hobart Boulevard, Los Angeles*, early 1990s (pp. 142–43) . . .

All effects are cumulative as first-person singular multiplicities. The observer is party to scenes rooms thresholds of oneiromancy's alliterations—contacts contexts—each and all return lineaments extensity—accord a chord—connective tissue effluvia—emulsion emotion.

In constant company of the camera, the photographer documents his wonder about figures in frames far away in calendar times; prints multiplying passages enduring moments; rods and cones preserving attachments fixity chemical combinations; as celluloid coating retinal processing neural thresholds reach cascading fire quickening blood flows.

Each frame is an acceleration of enthrallment, recognition, self-connections; like eye and I, I and I, me to you, us as extended collectivities overlapping arrangements of disclosures.

Compositions seriated movements are canticles offered to illuminations bounce.

How to make present—the present—gift and gratitude—people's eclectic prepositions—phrases showing direction location duration flow floe—an oscillation—motion and testament—every one image together all a medium.

Swerve
Adrienne Edwards

Contingency is foundational to the swerve as both a defining characteristic and a constituting force of the minutiae of everyday uncertainty, which is to say, life. The givenness of the swerve, the resolute fact that it is incidental, unforeseeable, precarious, and subject to chance, animates Lyle Ashton Harris's trove of 35 mm Ektachrome color-reversal transparencies taken between 1988 and 2001.

The swerve is always present: it is there at the moments of origination so that as we individuals begin life—indeed even before then, going along a certain path that ultimately leads to a chance encounter—it sets a new course in a moment so subtle that it could be missed entirely. Harris's images capture such flashes of the swerve when concerning black-queer voids-in-formation, if we understand the void as the aggregation and subsistence of bodies colliding in time and space. Harris's photographs exemplify these occasions as contexts, mutability imbued with the capacity to stretch and accommodate. Here we can locate a particular force of blackness and queerness, and, when taken together, their singular ability to shift shape and attain myriad forms.

Harris's inventory of sexual encounters—in name and image—solicits in its viewers a kind of speculative reasoning of the unique trajectories of each individual that have led to this assembly of titillating experiences. Harris entices us to not merely question the facts—the who, where, how—of these events but to search the images, even to imagine what is not present by engaging in a fantasy or erotic beholding. The viewers' gaps in knowledge— our infelicitous desire to connect first names with the obscured photographs of his conquests—are perhaps bridged in a range of portraits that display Harris's immortal charm. One portrait features the artist sweating in a wooden sauna in black poom-poom shorts, leaning into the cedar walls. In another image, he is lying in bed on pink-inflected printed floral sheets, wearing a Gran Fury "Read My Lips" T-shirt adorned with an image of two men kissing (pp. 34, 35). A green facial mask coats his features. ("No matter how late I was out . . . always wash the face!" Harris said recently.) In these portraits, the artist is there, readily available, "with eyes and full throat back-ward thrown, / Gazing, my Goddess, open-mouthed at thee, / Pastures on love his greedy sight, his breath, / Hanging upon thy lips. Him thus reclined."[1]

Nightlife (Urinal), New York, early 1990s, captures scenes of the swerve in the gay club (pp. 72–73). Diverse men gather around the plumbing in a bath-

room that despite being gendered evinces an infinitely variable, shifting assemblage of beings and desires, and the possibility of joy, care, and camaraderie. We see this as well in *Untitled (Kani), New York*, 1990, in which high-cut, brightly colored thong panties are barely cloaked by then-fashionable, baggy Karl Kani jeans, worn with a cropped tank top by a black man whose neck is draped in a large gold-link chain, transmuting all kinds of seemingly incongruent signifiers, and challenging easy legibility (p. 71). In both photographs, we see black queerness as a mode, means, and matter of the contingent as it concerns swerving slippages of space, time, and gender. Its original matter (as in residence, point of departure, natal scene) is the black-queer void, of which the gay club is but one manifestation. The men's room at Yerba Buena Center for the Arts is perhaps another, as M. Lamar, in a full-length black slip, applies make-up in the mirror under the gaze of a staring, gray-haired man who appears confounded that he is part of this dissonant scene (a different image from this scene is included on pp. 90–91).

Harris's images freeze instances of being as concatenations of existences, indulging in extravagant, dissolute, and intemperate pleasures as an everyday necessity. Harris's archive of black-queer thought, love, and gaiety is beyond chronology, antilinear and vertigo-inducing; it is a remarkable mode of capturing and preserving the unfolding of a process of durational connectivity.

58

For José Esteban Muñoz

1. Titus Lucretius Carus, *On the Nature of Things*, translated by William Ellery Leonard (Milwaukee: Greenbook Publications, 2010), p. 8.

A Letter
Malik Gaines

Dear Lyle,

I want to say something about your beautiful photo archive, which I first saw as a slide-show video, like memories of a family vacation, as part of a program hosted by Visual AIDS at the New Museum in 2014. It was very moving. The archive itself represents a lot of people and places: Los Angeles, New York, London, and locales further afield; artists, nightclubbers, families, friends. The context of the Visual AIDS program, organized around their yearly "Day Without Art" activities—that began in 1989 to draw attention to the crisis—put a profound emphasis on ideas of friendship and loss, and on the ghosts from that era that continue to haunt queer spaces.[1] Like a lot of gay guys of my generation, I've harbored a melancholic fantasy about all the mentors, friends, influences, and older boyfriends that I didn't have. My boyfriend and I were lucky to have amazing women mentors, but I've always missed those daddies and uncles and big brothers who were in a different position of risk during the early years of AIDS.

Your video shows some of what I missed in faces I don't recognize. But so many faces I *do* know, so glowing and full of promise; they remind me of how many amazing people did make it to now—and how beautiful that is, and important to mark. I see young you, in all your gorgeous glory; I see Glenn Ligon, Hilton Als, Isaac Julien, and others who are perhaps less celebrated but no less cute. In 1991, I came out and went to college in Los Angeles, where I immediately met my partner Alex. The kind of life I saw in your personal pictures would have been so exciting and promising to us then—if we had had access to it. But it was a little scary too. The only cool, gay men of color I had ever seen at the time were Madonna's dancers on TV. I still love those guys. They were actually very influential, in a highly mediated way. So was Pedro Zamora, the activist who changed the way people thought about AIDS with his MTV appearances. Our collective My Barbarian has done some work rethinking his contributions, responding to José Muñoz's brilliant text "Pedro Zamora's *Real World* of Counterpublicity: Performing an Ethics of the Self." We showed our video *Counterpublicity* (2014) at that same Visual AIDS program, alongside yours. As meaningful as those moving images were, these queers inside of screens stand apart from how I imagine you and your crew of fantastic artists and people living real life, being together, loving one another, and talking trash and making work and fucking around, with bodies in space taking up time—some of it too short.

Had I been a few years older, I might have been there with you all. I hope we would have been friends. But that would have been dangerous too; I would have lost friends and lovers or myself. By the time I came out, we always had sex with HIV prevention on our minds; we were terrified by it. Those of us who have contracted HIV since have lived in a different context, a "pharma-copornographic" situation, to adapt Paul Preciado's term elaborated in his 2008 book *Testo Junkie*.[2] This context has offered different possibilities, more effective pharmaceuticals, and importantly, less death. I know HIV-positive people in their twenties and think, perversely, I'm happy for them that it's now and not then. Dealing with the time of the AIDS crisis, from any position we encounter it, is a lifelong project. I don't know if there's a way to get it right. But your archive is so meaningful as part of that project.

Equally important, the archive paints a background for a major contribution your work has made: representing queer spaces within black spaces, and the other way around. From the opening of the infamous *Black Male* show (pp. 214–25) to the stylish scene in the back of a car with Marlon Riggs's family (pp. 232–33), to images of your own early work, this archive helps us hold black and queer production in the same frame, despite a powerful repertoire of images that attempts to render blackness straight, and gayness white. That attempt must fail, as you seem to insist by shooting the life you live. Thanks for that.

60

Love, Malik

1. The Visual AIDS/New Museum presentation was one of several early showings between 2013 and 2014 that also included digital projections at Yale University, the Guggenheim Museum, and the Studio Museum in Harlem. The audiences and contexts for each of these iterations were markedly different, as were reactions to the project. 2. The book was published in Spanish in 2008 and released in English in 2013. Paul Preciado, *Testo Junkie: Sex, Drugs, and Biopolitics in the Pharmacopornographic Era* (New York: The Feminist Press at the City University of New York, 2013).

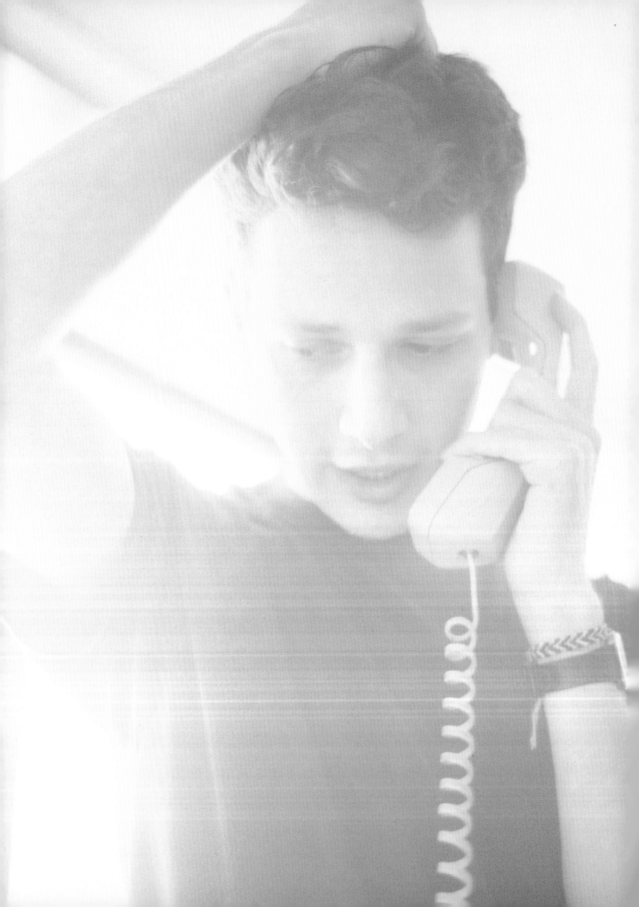

LEFT: Scott Falia, New York, late 1980s RIGHT: Untitled (Sandscape), unknown location, n.d.

63

LEFT: Neon, Vancouver, Canada, 1992　RIGHT: Wilhelmina Leinaeng, Martha's Vineyard, 1993　FOLLOWING SPREAD: Iké Udé and Lyle, Los Angeles, 1995

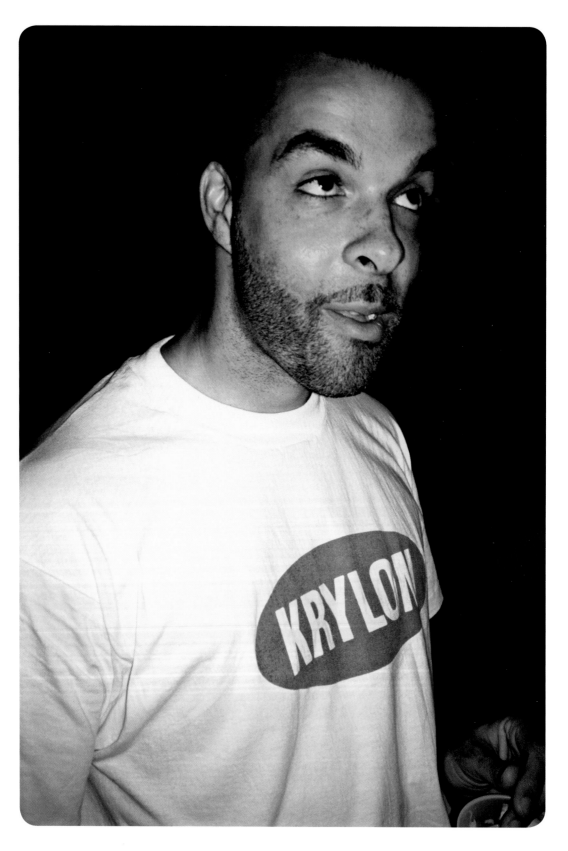

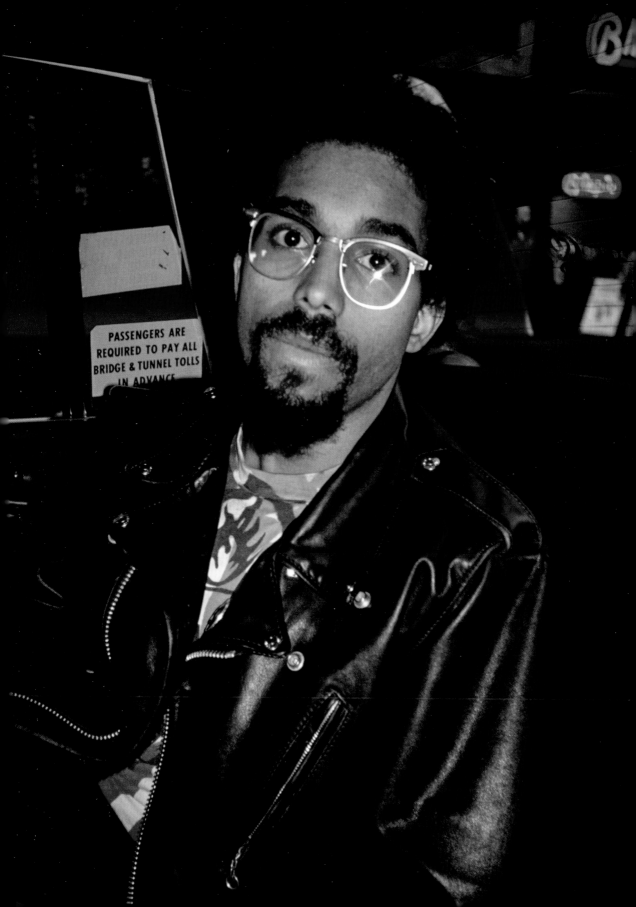

PASSENGERS ARE
REQUIRED TO PAY ALL
BRIDGE & TUNNEL TOLLS
IN ADVANCE

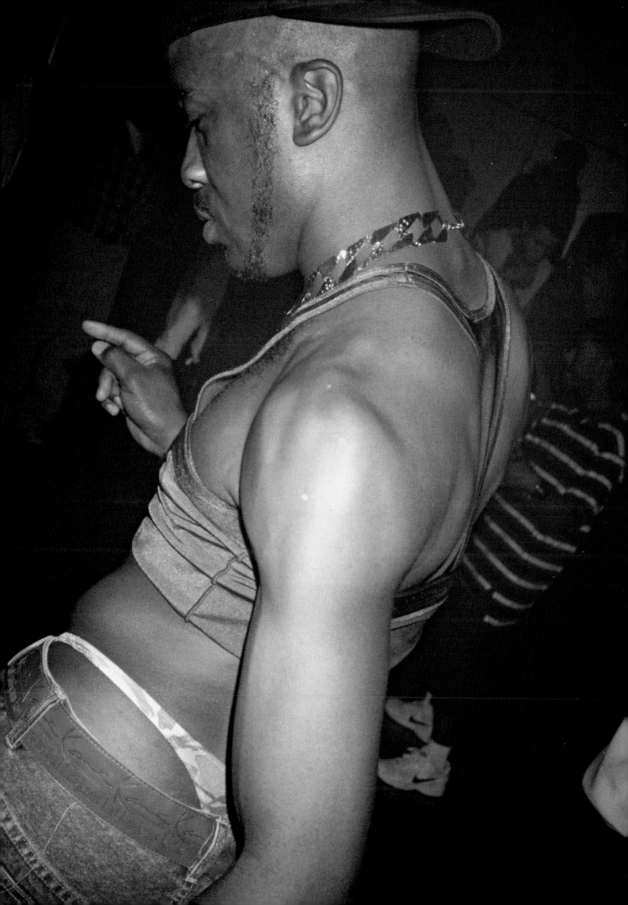

Lyle by Thomas Munke, London, 1992

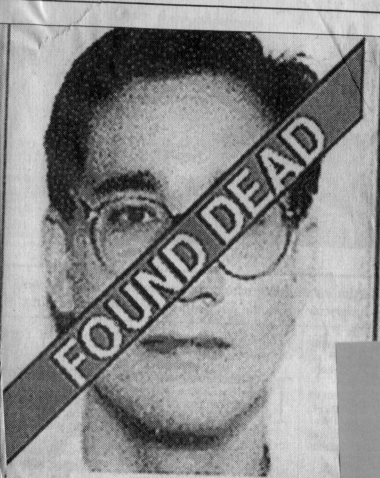

Andrew Phillip Cunanan

The Associated Press

ure shown on the FBI Web site Thursday after Mr. Cunanan's
was found. The site listed information on the suspected killer.

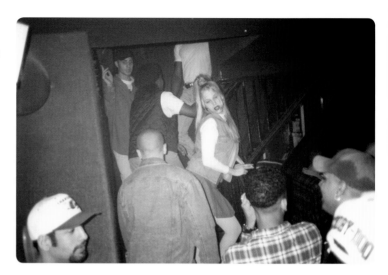

Nightlife, New York, early 1990s

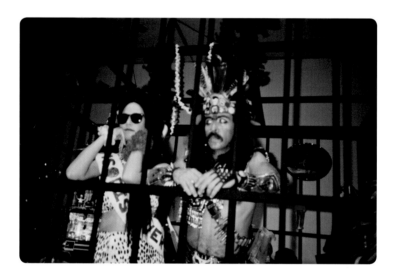

ABOVE: Coco Fusco and Guillermo Gómez-Peña, The Couple in the Cage performance, University of California, Irvine, 1992
RIGHT: Unknown clubber, Tracks, New York, 1990

RIGHT: Lyle, *Narcissistic Disturbance* exhibition opening, Otis Gallery, Otis College of Art and Design, Los Angeles, February 3, 1995
BELOW: Nightlife detail, New York, early 1990s

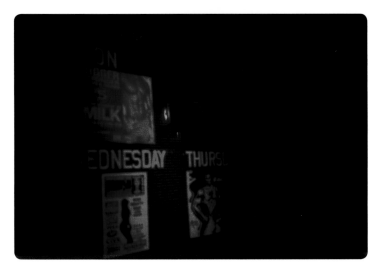

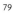

Iké Udé and Alex Epps, New York, mid-1990s

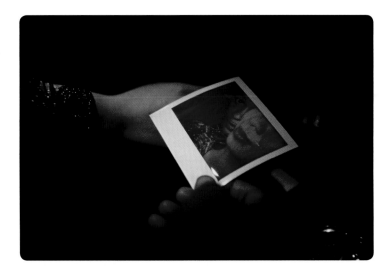

THE NEW YORK TIMES, SUNDAY,

Women Have Mor

PIN STRAIGHT
Dr. Lia

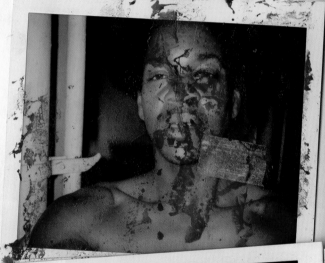

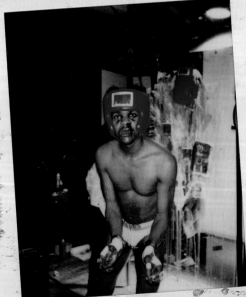

NEW

80 Cents STRAIGHT to HELL

The MANHATTAN REVIEW of UNNATURAL ACTS

No. 25

TIMES SQUARE STUDIO

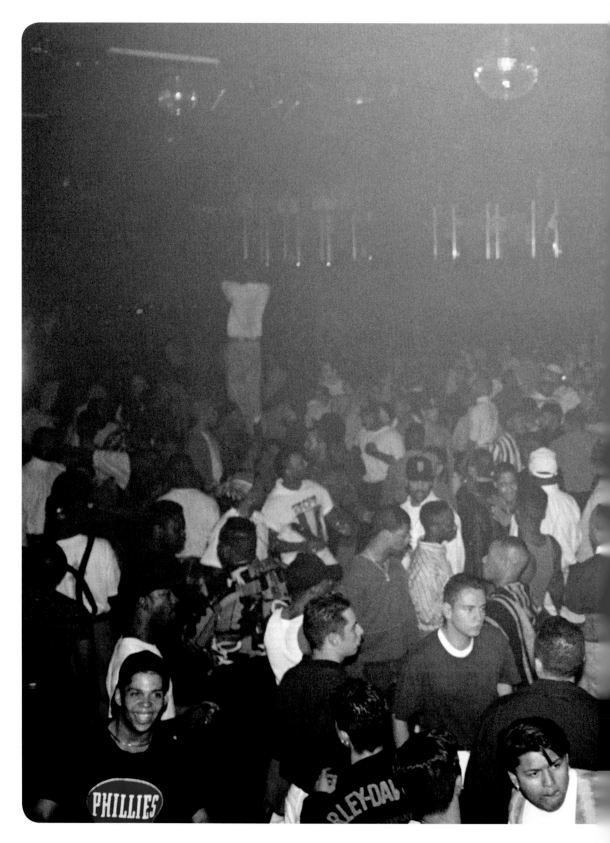

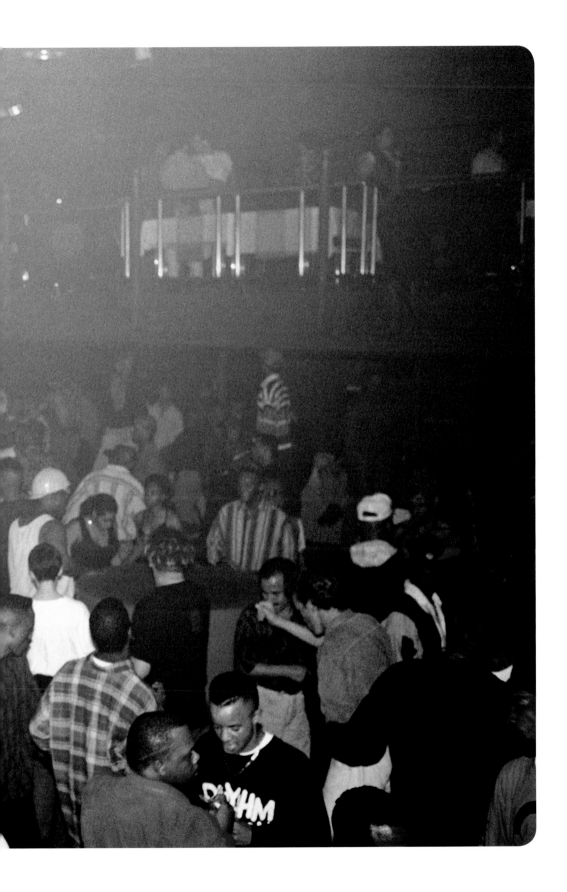

Nightlife, London, 1992

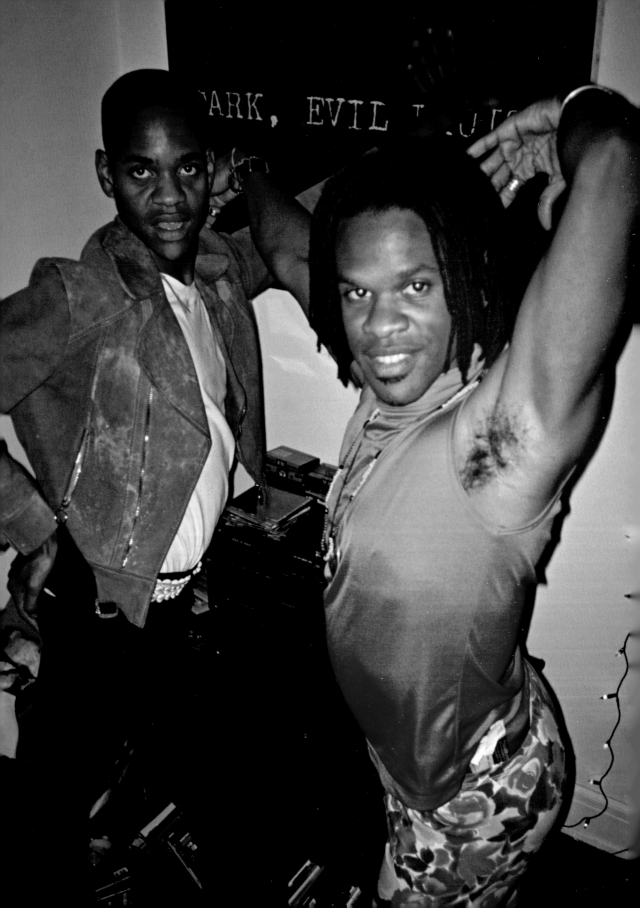

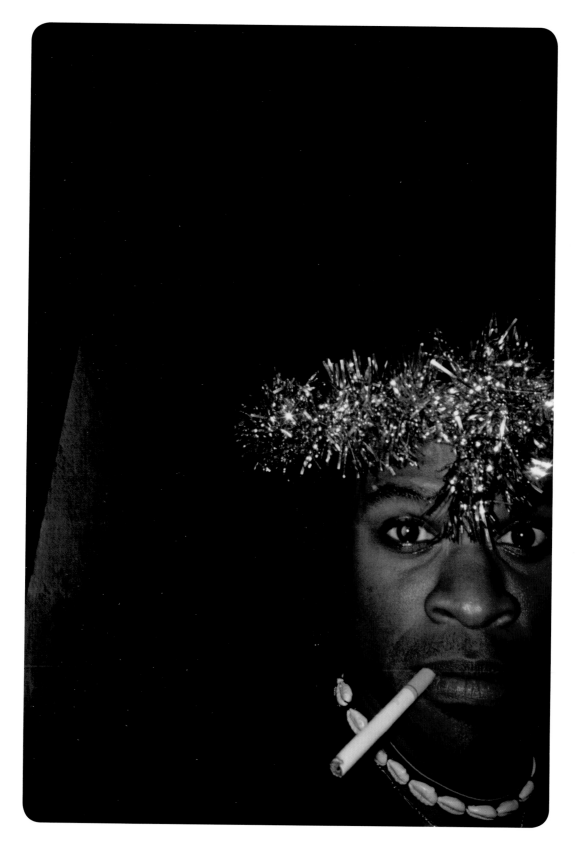

LEFT: Lyle and Thomas, Los Angeles, mid-1990s RIGHT: Thomas, Los Angeles, mid-1990s

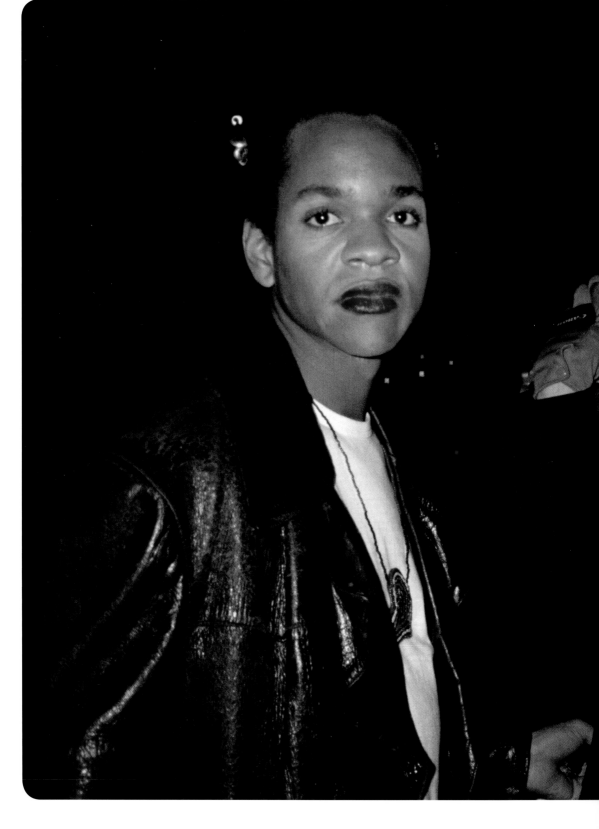

Lyle and Iké, *Narcissistic Disturbance* exhibition opening, Otis Gallery, Otis College of Art and Design, Los Angeles, February 3, 1995

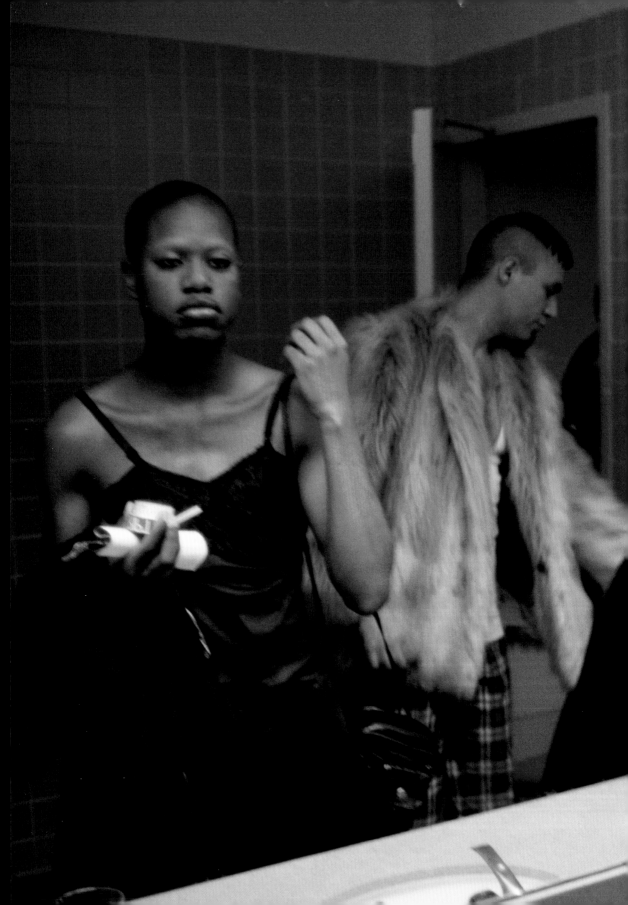

HX Magazine (Journal #76), 1999

Heal Me/Use Me: Lyle Ashton Harris's Journal, 1997
Lucy Gallun

In one of the most compelling spreads from Lyle Ashton Harris's small, orange diary from the year 1997, two Polaroids face one another across the book's gutter (pp. 32–33). On the left page, an evocation of comfort: warm sunlight glows behind the stems of an aloe plant, and two glass teacups sit side by side, wet tea bags resting within both. On the right, an unflinching command is set forth in stenciled letters against a red ground: "Use Me." At first take, the images seem quite distinct from one another. One is a still life, a quiet arrangement of everyday objects in a welcoming room. The other is a photo-graph of a text-painting, in which the mottled-white letters have been ren-dered through stencils set against red pigment. Upon further consideration, however, their presence together within the artist's personal journal offers a telling visual clue to his interior concerns and reflections. Am I to be loved and soothed, or to be used and exploited? This ambivalence and, indeed, ambiguity are typical of the entries in this journal, and of Harris's oeuvre.

Harris himself has noted that his work often embodies seemingly contra-dictory ideas, all at once. This coexistence of conflicting positions and feel-ings is found, for example, in the projects he presented in the years around 1997, when this particular journal was under construction: his 1996 montaged opus, *The Watering Hole*; his textual and visual essay "Drag Racing," which appeared in Jennifer Blessing's *Rrose is a Rrose is a Rrose: Gender Performance in Photography*, the catalogue for her 1997 exhibition at the Guggenheim Museum; and the 1998 performative multimedia series *Alchemy*, a collabora-tion with his brother, filmmaker Thomas Allen Harris. So the fact that these tensions are also present in the content of his personal diary is not surprising. The diary, one might argue, is a natural form in which simultaneous desires and repulsions can be worked through. Related to this, Harris may blame himself in one sentence and forgive himself in the next.

Alongside diary entries recounting financial anxieties, meetings with gallerists, insomnia, and sex, among other concerns, Harris pasted numerous unique Polaroids (like the two described above) directly onto the book's pages. The simple and handy instant-print is a format that the artist has used regularly in the construction of his work: these diminutive photos appear in montages and collages across multiple series, but they also document Harris's "behind-the-scenes" process, serving as pictorial notes during the prelimi-nary development of ideas.

The 1997 diary is just one of more than one hundred journals that the artist has kept over the course of his life. Each journal is unique and idiosyncratic, directly linked to the peculiarities of Harris's lived experiences in that period. Over the course of this particular journal, for example, Harris spent significant time in Los Angeles and New York (two cities in which he lived), as well as Paris, and Geneva (both of which played important roles in his artistic connections and networks).

Harris's relationship with his brother is another continuous thread that weaves through this journal. During this period, the brothers were deeply engaged in the development of their joint project *Alchemy*, and their creative and spiritual relationship was an intricately intertwined web. Still-life photographs of altars that they each composed separately (but within which they often both appear)—tableaux of votive candles, mementos, printed matter, and flowers—populate the journal's pages. Also present are postcards and letters from Thomas; Lyle's written descriptions of the brothers' telephone conversations; and photographic portraits of Thomas, both candid and staged. In this journal, Thomas is at once exalted as the intellectual, the poet, and the muscular strongman, but also clearly resented. The journal is where Lyle can mine the pain and affection that he feels in their complex relationship. Indeed, as noted in a quote scrawled on a page (and attributed to Firebird, a moniker used by Thomas), there is "no place untainted by the realness of our interaction."

The content of a personal journal is sometimes regarded as superficial or dull, a simple recounting of unremarkable goings-on or the mundane minutiae of a solitary human's daily life. Yet the personal journal is a form saturated with memory. To read and view Harris's entries from 1997 some twenty years later is to immerse oneself into his diverse visual and cultural influences; into his deepest relationships with family members, friends, and self; and into his essential artistic process.

Harris implored his journal to heal him: it provided a kind of catharsis as an emotional and intellectual space within which he could examine and purge (sometimes at once). And in return, the journal said: Use Me.

Newer Negroes
Rashid Johnson

"Harlem as a site of the black cultural sublime was invented by writers and artists determined to transform the stereotypical image of Negro Americans at the turn of the century away from their popular image as ex-slaves and as members of a race inherently inferior biologically and environmentally unfitted for mechanized modernity and its cosmopolitan forms of fluid identity—into an image of a race of cultural bearers. To effect this transformation, a 'New Negro' was called for—quite urgently, many black intellectuals felt—and this New Negro would need a nation over which to preside. And that nation's capital would be Harlem, that realm north of Central Park, centered between 130th Street and 145th."—Alain LeRoy Locke

In 1925 Alain Locke wrote "The New Negro," the lead essay for a book he edited, of collected writings and poems by some of the brightest minds working, thinking, and writing during the Harlem Renaissance. For me and for many others, looking back at this moment—with its particular focus on black exceptionalism—often invokes a pride of being. This pride stems from the opportunity to witness genius that simultaneously stands for an awareness and refusal of confines, or conditions of circumstance, and the full recognition that those confines are always present, and often violent. In other words, this creativity blossoms not merely in response or as a reaction to something, but is itself, in its very proposition, proactive and willfully autonomous. The idea of the black character in a constant state of reinvention leaves me wondering when this character will feel resolved. When will the very idea of blackness dispense with this newness, and no longer need to constantly reinvent itself in order to persist?

Lyle Ashton Harris's photographs, taken between 1988 and 2001, help shine a light on another generation of black thinkers, writers, and artists. That generation found its footing in similar concerns as those of their Harlem Renaissance predecessors, but in Harris's images they have undergone a tremendous metamorphosis. In front of his lens, these new heroes become universally human. The new characters are uninhibited and have brought with them a new set of concerns and values. They're no longer exclusively connected to Harlem or even to blackness; they're also women, gay, and queer; they've witnessed the AIDS crisis and embraced its scars. They are also not alone: they are joined by their Asian, Latino, and white friends and lovers. They are authoring culture with a confidence that cannot be qualified. No

longer new, these characters are determined to live as themselves. Here are figures such as Kinshasha Conwill, speculating on the very nature of black representation at the *Black Popular Culture* conference in 1991 (p. 118); and Stuart Hall, relaxing with John Akomfrah, Isaac Julien, and Sonia Boyce at 2 Brydges, a members' club in London's West End (p. 137). Two very different contexts, yet equally the stuff of lived, black experience.

In Harris's images I find many of my heroes: the people who have shaped the decisions and ideas that populate my world and work. Seeing them at peace, in discourse, and at play affords a more generous understanding. Harris, with his Zelig-like swagger, introduces us to his friends, colleagues, and contemporaries with an honesty that allows us to be present with them. It is not often that an archive like this one becomes available, one that captures a time period quite in the manner that Harris's does. It is this kind of resource that can change perspectives and allow us unprecedented access to the people who challenge our thinking. The intimacy of the images tells us not only about the people represented, but helps us understand a complex and intriguing time.

Child of the '90s
Thomas J. Lax

The legal pad placed on a green doily on a kitchen table in Lyle's photograph—shot when he was in Seattle visiting his then-boyfriend Tommy Gear's mother in 1992—reads "Things To Do" (p. 250). The things listed below collapse the professional with the personal and include: grant applications and reminders; bills and reimbursements; appointments to be scheduled; and errands as imperatives. Sitting alongside a roll of undeveloped film and a drinking glass partially filled with cloudy liquid, this profile of the artist's ambitions is at once particular and recognizable, part of the viewer's collective memory, even. Like the entire archive, this to-do list is a snapshot of the moment when it was taken and a reminder for the artist's future. It holds an implicit belief that lists can make things happen and that images can create habits.

While I was not there looking through Lyle's lens, my most lasting childhood memories also revolve around list-making and projected images. One of my primal scenes is centered on my parents' bedroom, where we would watch Bette Davis and Joan Crawford feud via our VCR and through our box television. Part of this family ritual included my dad's reference-checking in his bedside copy of the Hollywood almanac and piles of crumpled up legal-pad paper on which he made notes. Laundry lists don't always resemble family trees, but when I look at the *Ektachrome Archive*, I see a register of dads.

There are the white dads who take road trips to Roman ruins (Tommy Gear, p. 180) and the black dads who vacation at the Inkwell in Martha's Vineyard (the poet David Mills, p. 31) and live with their wives in Sugar Hill (Clarence Otis Jr. and Jacqueline Bradley). There are the trade dads who cruise-stare in your studio and the boy dads who slumber after fucking. There are the nice dads who recur—in multiple beds and at sun-drenched LA breakfast tables. Intellectual dads like Cornel West lecture at the Studio Museum (pp. 118–19), while Stuart Hall sits relaxed and engaged over a meal (p. 129). Art dads like Robert Rauschenberg, who also used photography as a structural suture, and James Van Der Zee, who made an album of another elite black village, appear unwittingly in Lyle's archive: dads are perhaps best understood as a proxy for the authority to make meaning.

If a search for fathers holds out the sense of longing that gives the archive its pulse, Lyle renders himself most visible through images of women: butches and femmes, high and low, and the viewers who are invited

to look at them. bell (hooks), Cathy (Opie), and Nan (Goldin) are constants: self-reflexive big-ups for the archive's ideology, ethos, style. Lyle and his photo-sister Iké Udé celebrate birthdays, drink espressos, and read magazines in round-framed sunglasses, bloodred lipsticks, and dangling cigarettes that annotate their '90s glamour. Of course, the person who is always there—caught informally in her home, adorned in a fur hat; on the verge of sleep, at the edge of her couch; at Aquinnah's red rocks, in her bright bathing suit and braids—is Mother. Rudean Leinaeng appears in the archive, but she is more than a witness; she is its accomplice (p. 30). Looking after these transparencies in their interregnum between memento and art, she was there all along. Mother's there next to Marlon Riggs as Jean Riggs, sitting solemnly in the backseat of a town car or hearse, next to her mother and with her arm around her son and her hand in his (pp. 232–33). There She is in Essex Hemphill's 1986 cruising manifesto, "In the Life," when he wrote to Her: "If one of these thick-lipped, wet, black nights, while I'm out walking, I find freedom in this village. If I can take it with my tribe I'll bring you here." Lyle's pictured his village; She can testify that freedom's been found.

Incendiary Acts[1]
Sarah Elizabeth Lewis

Unalloyed desire is often just a fiction. It is, like everything else, frequently related to its opposite. As a benevolent Janus, Lyle Ashton Harris shows us how desire can be the shadow of devastation, that any desired tomorrow will come if we fully examine any losses of today. For some, Lyle's body of work seems to be about specificities. His studio-based photographs begun in the late 1980s through to his collages and performances appear to be about a particular identity, a critique of masculinities and the performativity of gender. In short, some reductively read his works as about bodies. Yet the true scope of his address is more capacious and asks what it will take, in a world in which individuals often feel atomized from one another, to understand that the other could be you.

A blaze has recently burned in Lyle. After years of scopic investigation, he has committed incendiary acts in order to illuminate the world around him. Having relinquished any investment in imposed categories, he has done the last performance of any masquerade. As long as I have known Lyle, I have seen this smoldering fire. He has been a living testament to Alice Walker's stated truth:

When life descends into the pit
I must become my own candle
Willingly burning myself
To light up the darkness
Around me[2]

Lyle has been willing to descend into the pit into which life has fallen for us all. This form of generosity does still exist. This form of honesty does exist. He says that it came at a point when he had to get in his own face. It came with a willingness to admit that he might be, that we all might be, complicit with the very acts that dim the lights.

. . .

"With collage, I was able to address the mutiny, the multiplicity of conflicting ideas that we embody," Lyle tells me about his nine-panel collage installation *The Watering Hole*, 1996, a work the artist himself suggests is nearly "too tough."[3]

In it, he created polyphony: What could produce dissonance—magazine ads of male models with mug shots of Jeffrey Dahmer and pictures of his victims—became consonant with each other. A jagged-edged full-page magazine tear-out of a young muscular white man pumping iron wearing only jean cut-offs, an ad for the all-male sauna The Hollywood Spa, is next to a picture of a young smiling Laotian boy killed by Dahmer. A tightly cropped picture of Dahmer's apartment door is below. To the right are the actual police reports showing dismembered bodies. A United States flag, upside down, is beside it all.

How we enter our epic tragedies, Lyle tells us through these images, is connected to what we fetish. "There is a relationship between this fantasy and this fantasy," he says as he points first to found postcards of anonymous African men from mid-century, then to police reports of Dahmer's victims. Stephen. Steven. Jamie. Richard. Anthony. Eddie. Ricky. David. Curtis. Errol. Tony. Konerak. Matt. Jeremiah. Oliver. Joseph. Ernest. All Asian, Native American, Latino, and black save one. Longing for another that you see only as an other has led to massive destruction. All were lured back to Dahmer's home by his offer of payment to take their pictures. In some cases, sacrificing love for a desire to be loved can lead to our end. In the strongest possible terms, Lyle shows us that there are risks to not examining our collective selves from all sides.

How compassionate, how strong is the mind capable of holding two opposing ideas at the same time. This level of consciousness allows Lyle to get in his own face and ours.

. . .

"I think it's important that I myself don't fall out of this," Lyle says of *The Watering Hole*, titled after an element of Narcissus's favorite pastime. "I am equally implicated in notions of consumption of the body, you know, as a consumer or as one who offers myself up on the auction block." Indeed, alongside images of Dahmer's victims and anonymous models from ads, Lyle has sampled some pictures from his own *Ektachrome Archive*—indispensable images representing the most intimate circles and encounters in and around the artist's life.

. . .

To be fully comfortable where you stand, you have to accept how things look from your position. "A man is not a man," said James Baldwin, "until he is able

and willing to accept his own vision of the world."[4] Lyle's photographs, collages, and performances derive their power from having accepted both his stance and his vision of the world early on, and speaking to us as an elder would, and with unending force. Coming to this point has been a journey. A younger Lyle wrote in the text of his 1991 CalArts MFA graduate show, "At what point will I be able to produce work for me? At what point will I get over the fear of acknowledging my own needs? How long will I continue to play the game of mastery of the false self? When will the performance end? I long for that."[5] His wait is over.

He is in a place of surrender to his own new season. When I see him, it often feels like the beauty of autumn, the knowledge that something new, in its own time, will spring forth and that now is a time for thanksgiving. It feels like "Autumn in New York," Billie Holiday's rendition, where a certain performance was over, or, as he would say, another of sorts began. Would that we could all live our seasons with his grace and intensity. Let us be willing to try for that.

1. This text has been excerpted from a longer version of "Incendiary Acts," which first appeared in the catalogue accompanying *Lyle Ashton Harris: Blow Up*, curated by Cassandra Coblentz, Scottsdale Museum of Contemporary Art (New York: Gregory Miller & Co., 2008), pp. 93–103. 2. Alice Walker, "When Life Descends into the Pit," in *By the Light of My Father's Smile* (New York: Random House, 1989). 3. Lyle Ashton Harris in conversation with the author, New York, August 20, 2007. All quotations in this essay from Harris are cited from this conversation. 4. James Baldwin, "The New Lost Generation," in *The Price of the Ticket* (New York: St. Martin's Press, 1985), p. 312. 5. Lyle Ashton Harris, "Drag Racing," in Jennifer Blessing's *Rrose is a Rrose is a Rrose: Gender Performance in Photography* (New York: Solomon R. Guggenheim Museum, 1997), p. 191.

The Queen Unleashed
Catherine Lord

Lyle remembers Marlon Riggs doing a runway walk in a dazzling white T-shirt with black letters that spelled "UNLEASH THE QUEEN." Lyle has the photograph to prove it (pp. 110–11). I have no photograph and no memory of the T-shirt but am nonetheless certain that Marlon wore a black jacket, stood behind a podium, and daringly read a text straight from his laptop screen. Lyle didn't photograph *that* performance, and so he doesn't remember the laptop, or, for that matter, the text, which soon became the widely published "Black Macho Revisited: Reflections of a Snap! Queen." Lyle remembers Marlon fierce, Marlon fabulous, Marlon laying claim to public space for the *young* and queer and black at an event for public intellectuals that leaned distinctly away from the arts toward academic discourse. I remember Marlon's nerve. He had written his talk on the plane and had no way to present it but to read from a screen. I'd never seen a fellow procrastinator pull off that trick. It was 1991. People still used paper. Laptops were heavy. There was no easy way to scroll down a text. Marlon held his laptop in the air and managed, though his hands were a little shaky and so, just at the start, was his voice.

Same event, two performances (at least). Although Lyle and I are just little slices in each other's archive, Marlon's performance was a formative moment in our respective and respectful creative lives. It was at the *Black Popular Culture* conference organized by Michele Wallace and held at the Dia Center for the Arts in SoHo. I punctuate Lyle's photographic archive as a terrible haircut on a middle-aged white woman in the audience, listening to Kinshasha Conwill, then director of the Studio Museum in Harlem. I was in row ten or so, not back row and not front either, trying to learn—which I did—while being a present but non-colonizing ally. Besides, I'm shy and I wasn't in the in-group of speakers. Neither Lyle nor I remember exactly what Conwill said, just that she bluntly and boldly addressed some questions and discontents on the relationship between queerness, race, and representation, and that whatever she said caused a buzz of resistance. The year 1991 was a turning point for queer and for black and for mixing up those labels to contest fixed identities with a spectrum of practices, skin hues, ethnicities, and nationalities. We had gone through some of those changes together, Lyle and I. When I met him, around 1987, he had just graduated from Wesleyan and though he'd spent the summer at a well-known photography workshop program in Maine, he wasn't yet an artist but rather a promising snow queen.[1]

While everyone else devoted themselves to rocks and the zone system, Lyle stayed in his motel bathroom screwing around with whiteface and a tutu. Those antics alone, I figured, were worth the price of admission to CalArts. As I was the dean then, I saw to it that Lyle was admitted, despite the fact that the photo faculty, then rather conservative in their distaste for anything documentary, and perhaps for young black queens with a mouth on them, was less than enchanted. In his few years as a CalArts student at the end of the 1980s, Lyle created the space he needed. As a young student, any number of clueless comments by white faculty or by other students could have stopped him in his tracks, but Lyle's photographs show him collaging another world—rigorous in its politics of race and sexuality, insistent that pleasure was the point of the project, and cognizant that sociality was not only the way to get there but in itself a method of working that could be documented. The photographs in Lyle's archive—which weren't what Lyle showed faculty as his Work—were a way of offering narrative and representation to the inhabitants of the world he was helping to invent. The snapshots construct a universe of queer and color, of joy and heartbreak, haircuts and T-shirts, meds and books, beds and pets, doorknobs and drinks. Such lists put flesh on gossip, give the backstory that drives and cements subcultures. The photographs and the act of celebrating through photographs *are* cultural resistance.

This is what intellectual history looks like.

1. "Snow queen" here refers to a series of works the artist produced while a graduate student at CalArts. His works *Snow Queen #1*, *Snow Queen #2*, and *Snow Queen #3* were produced in 1990, and were in conversation with his earlier series Americas.

Myself as to what goes on for
me.

In a way I am tired of all
the analysis. It is okay Just
to be still.

886
505-
989
5667
8542
595-
753
2462
55
625-
9465

BALTHAZAR
~ R E S T A U R A N T ~

Reservations 965-1414
Bakery & Restaurant 965-1785

80 Spring Street ~ NEW YORK ~ NY 10012

Lyle, unknown location, early 1990s

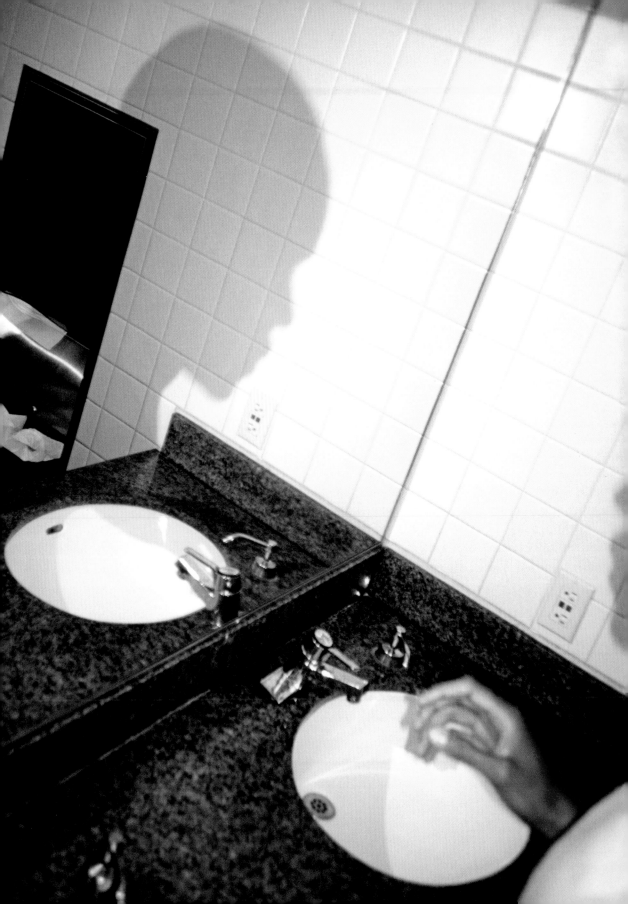

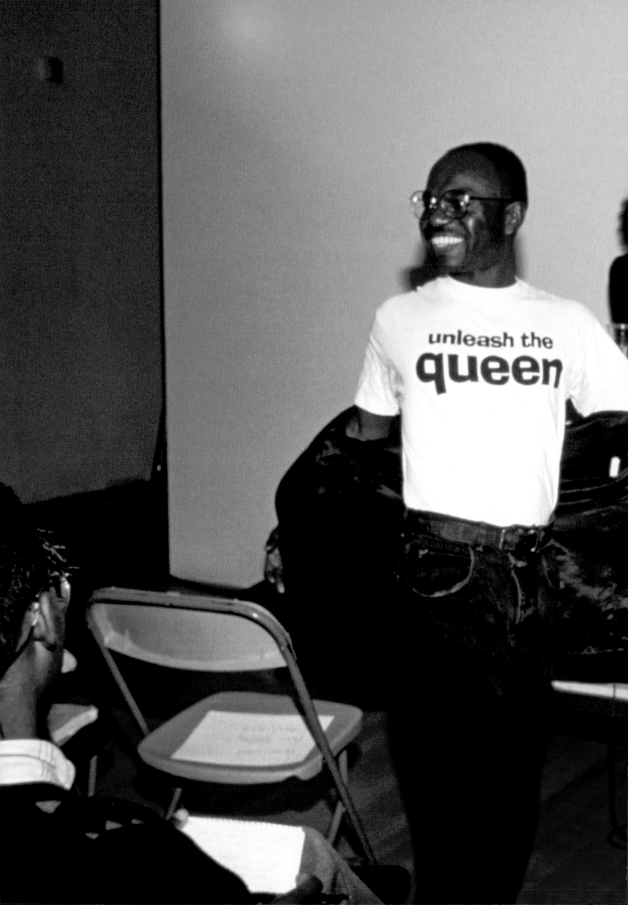

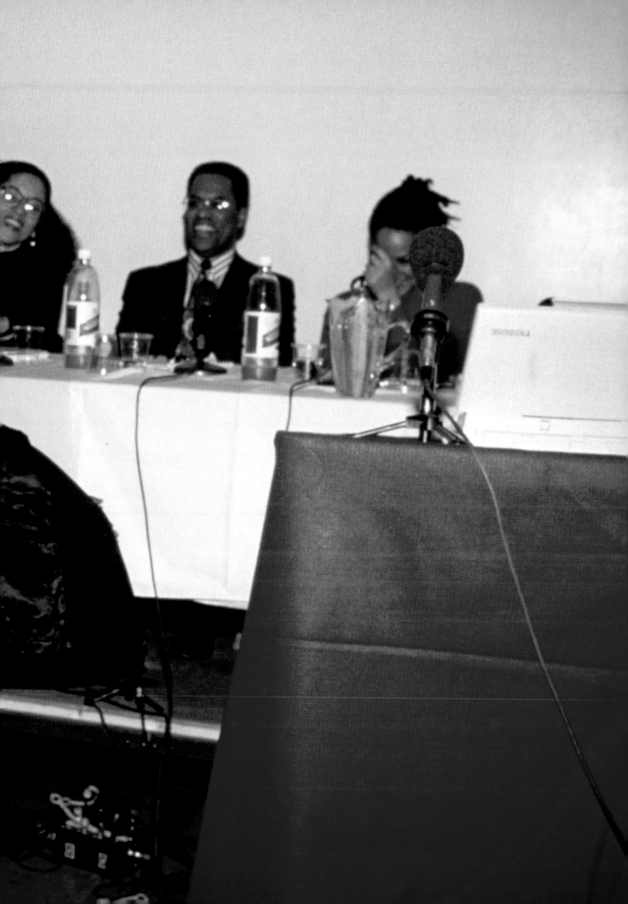

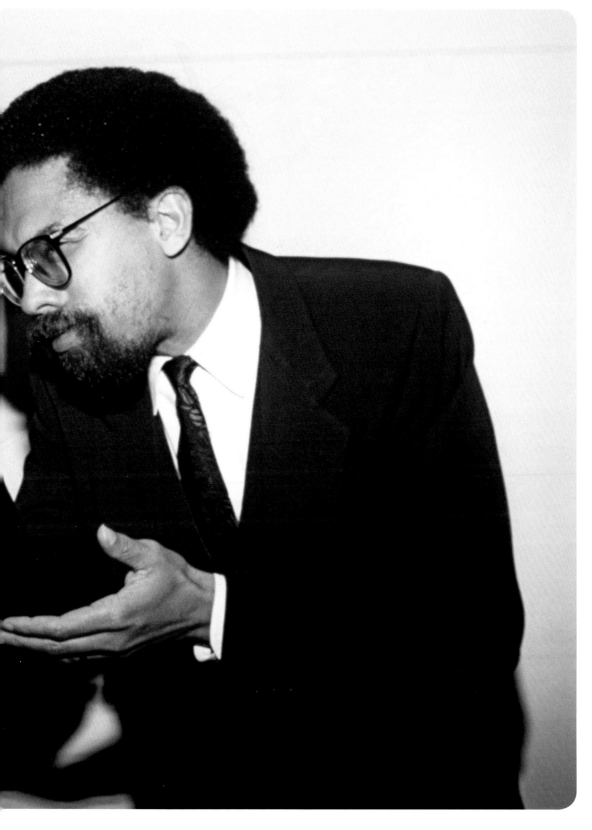

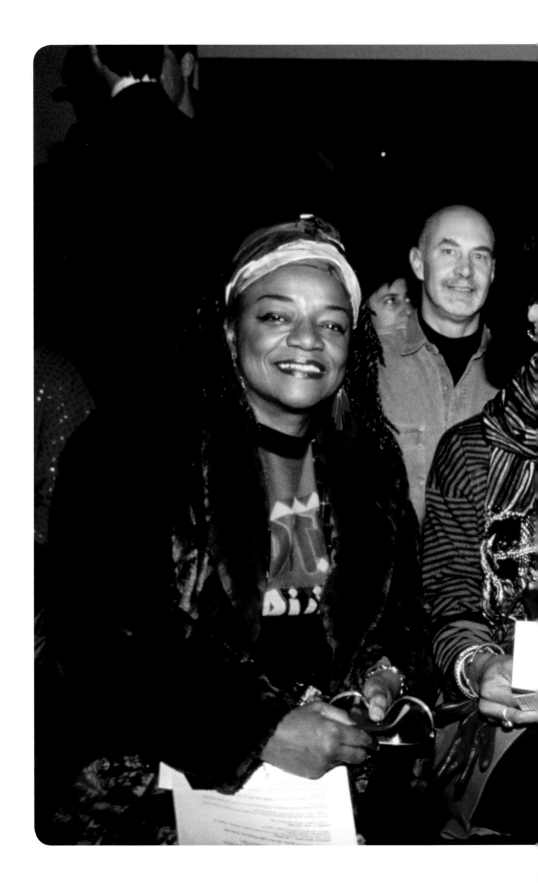

Faith Ringgold, Douglas Crimp, Crystal Britton, and Faith Childs, *Black Popular Culture* conference, Studio Museum in Harlem, New York, December 8–10, 1991

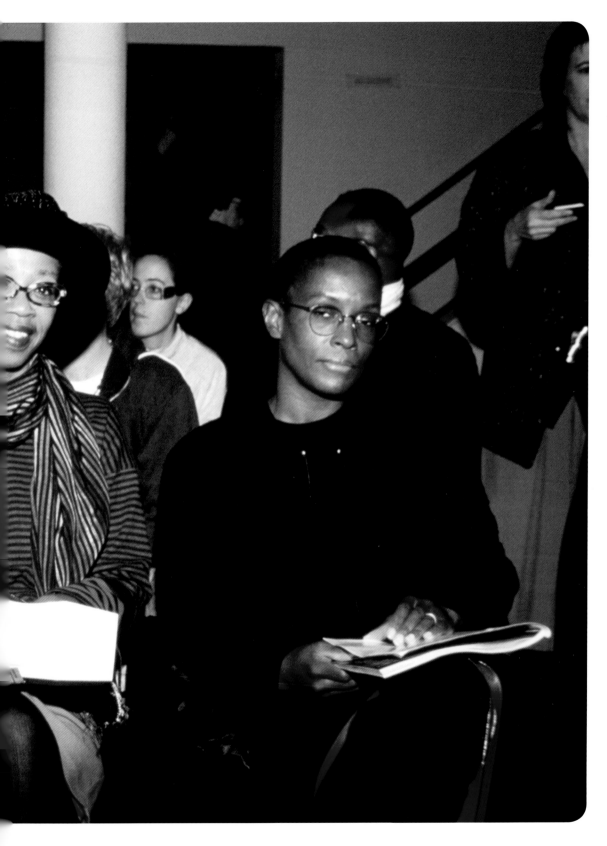

Wednesday 9/20

Just woke up. Feeling
a little ill. A bit congested.
A little anxious. Sleep down
stairs last night for what
is probably the first time
in 7 years, since I've
lived here. Or perhaps not.
For some reason I took a
peek[?] at the scene of the
crime review in the weekly
and once again I was not
mentioned. Business as usual.
usual. But what else is up?
Feeling nervous, anxious.
Perhaps all the uncertainty
as to what is going on in
my life. I do thank God to
be alive. But I am still
scared. My faith needs to
be in God only yet
I am troubled too

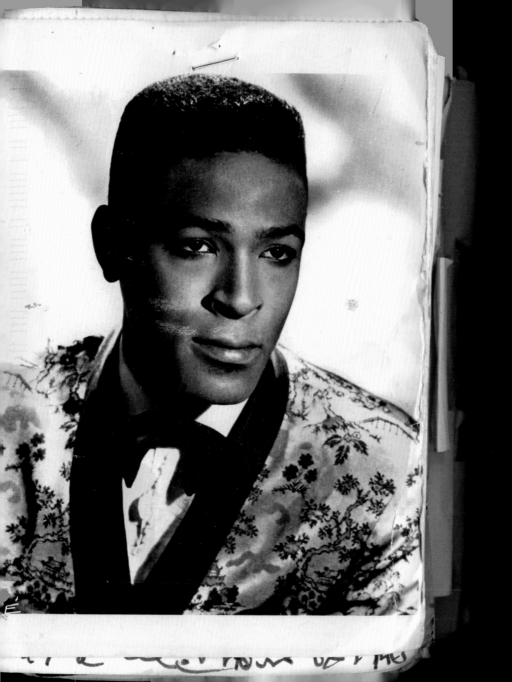

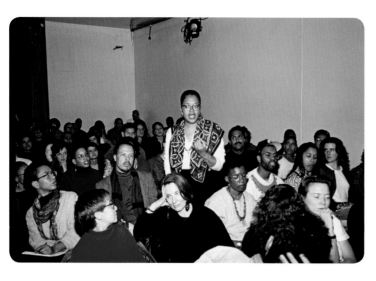

Kinshasha Holman Conwill, *Black Popular Culture* conference,
Dia Center for the Arts, New York, 1991

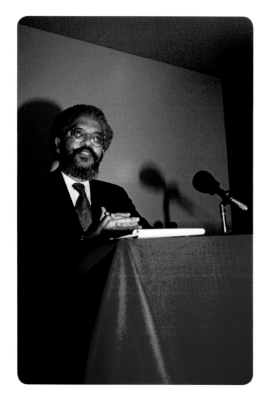

 RIGHT: Gary Simmons,
Thelma Golden, and
Scott Poulson-Bryant,
New York, early 1990s

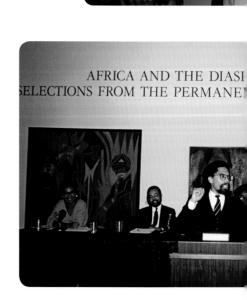

Manning Marable, *Black Popular Culture* conference,
Dia Center for the Arts, New York, 1991

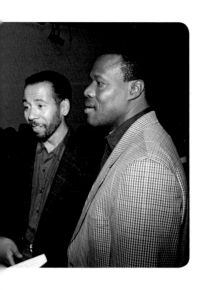

Angela Davis, Ed Guerrero, and Manthia Diawara, *Black Popular Culture* conference, Dia Center for the Arts, New York, 1991

BELOW: Isaac Julien and bell hooks, *Black Popular Culture* conference, Dia Center for the Arts, New York, 1991

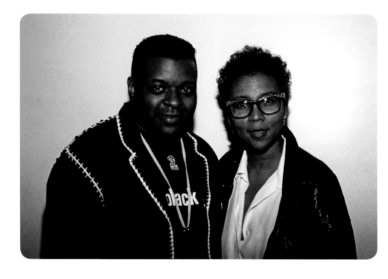

BELOW: Herb Boyd, Michele Wallace, Henry Louis "Skip" Gates Jr., and Jacqueline Bobo, *Black Popular Culture* conference, Dia Center for the Arts, New York, 1991

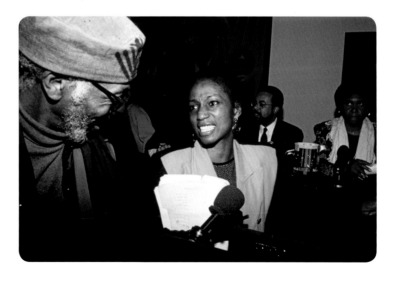

LEFT: bell hooks, Henry Louis "Skip" Gates Jr., Cornel West, Valerie Smith, and Michele Wallace, *Black Popular Culture* conference, Studio Museum in Harlem, New York, 1991

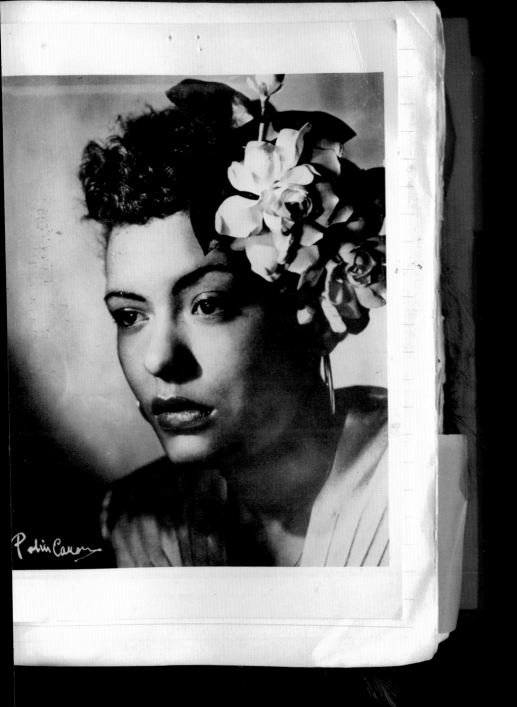

122

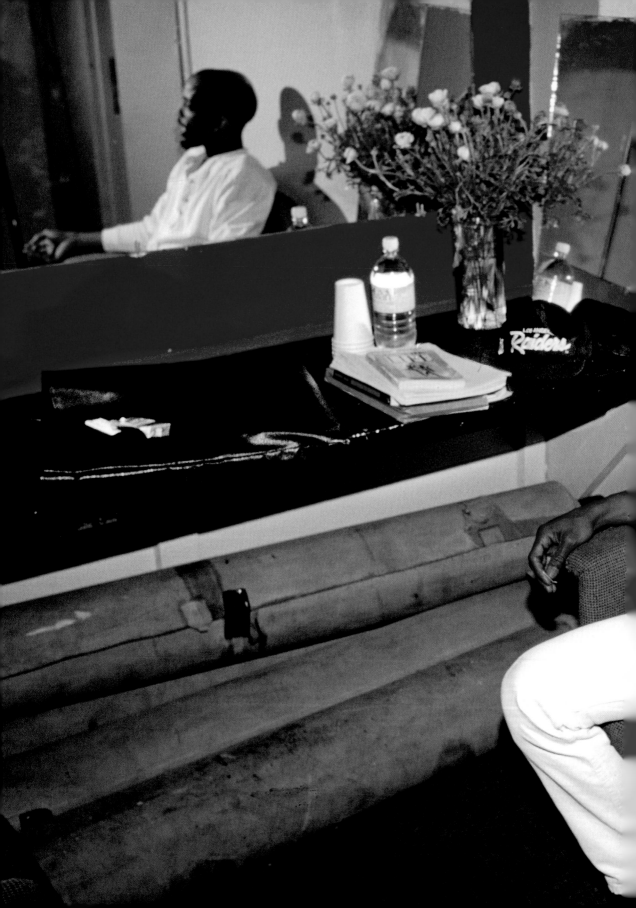

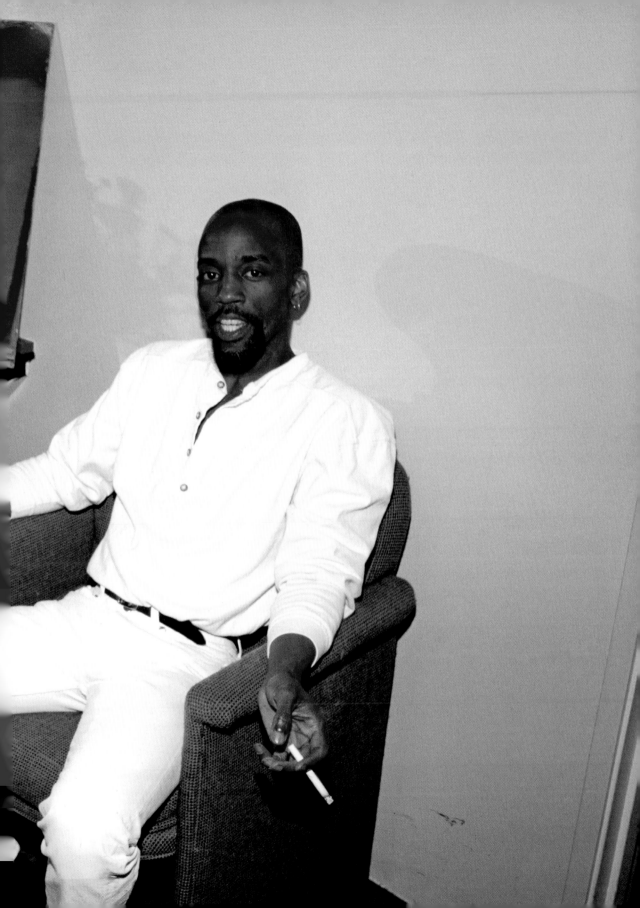

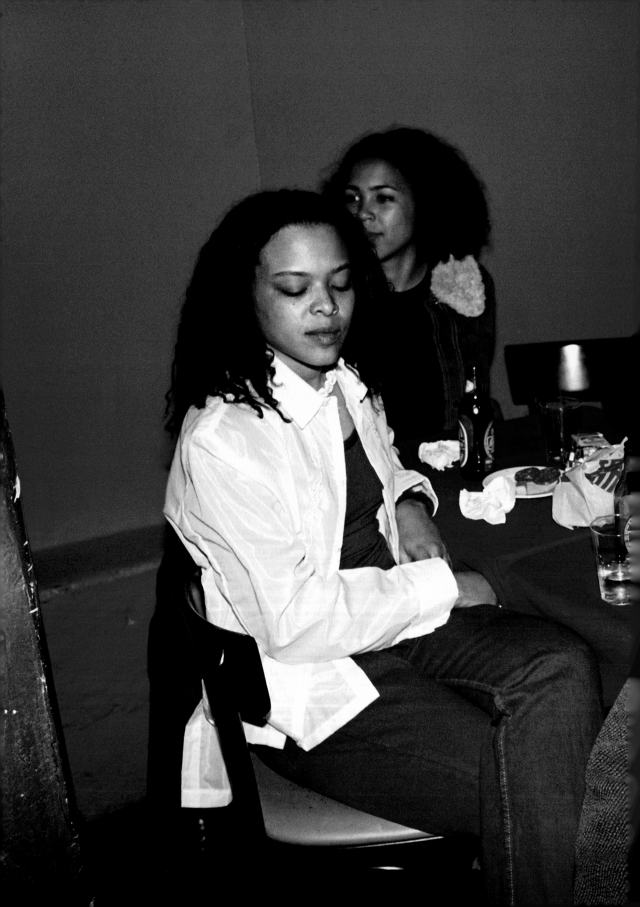

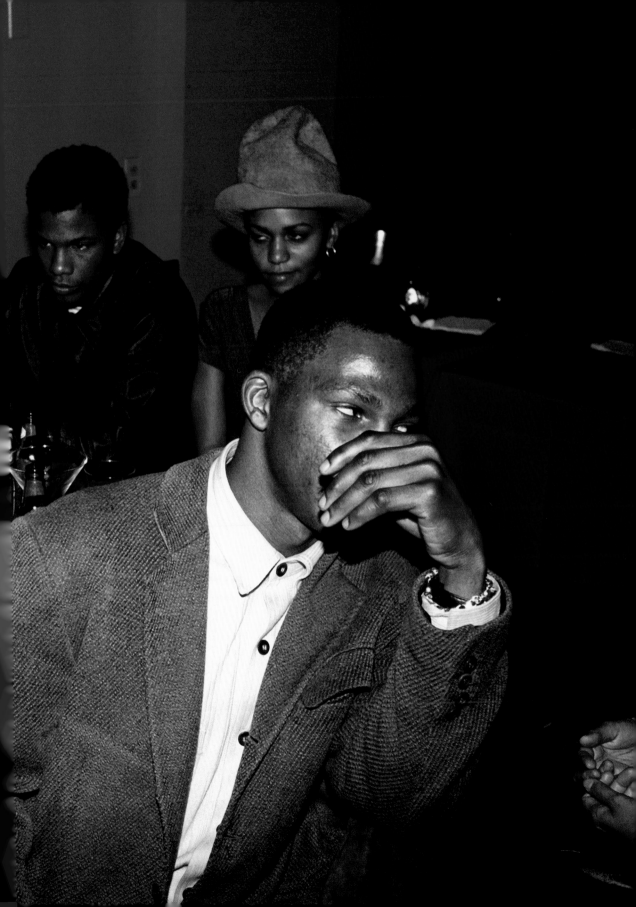

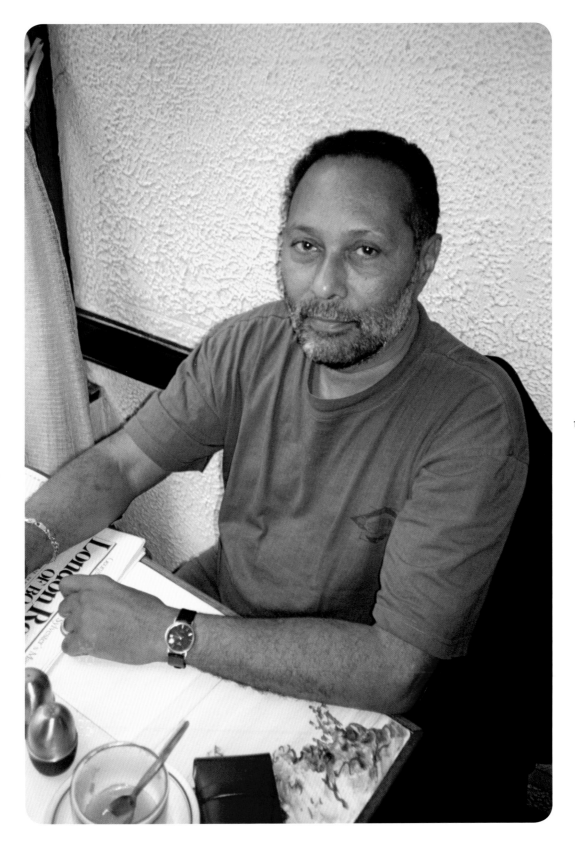

PREVIOUS SPREAD: Barron Claiborne and friends, New York, mid-1990s LEFT: Bouquet, Hobart Boulevard, Los Angeles, early 1990s RIGHT: Stuart Hall, London, 1992

129

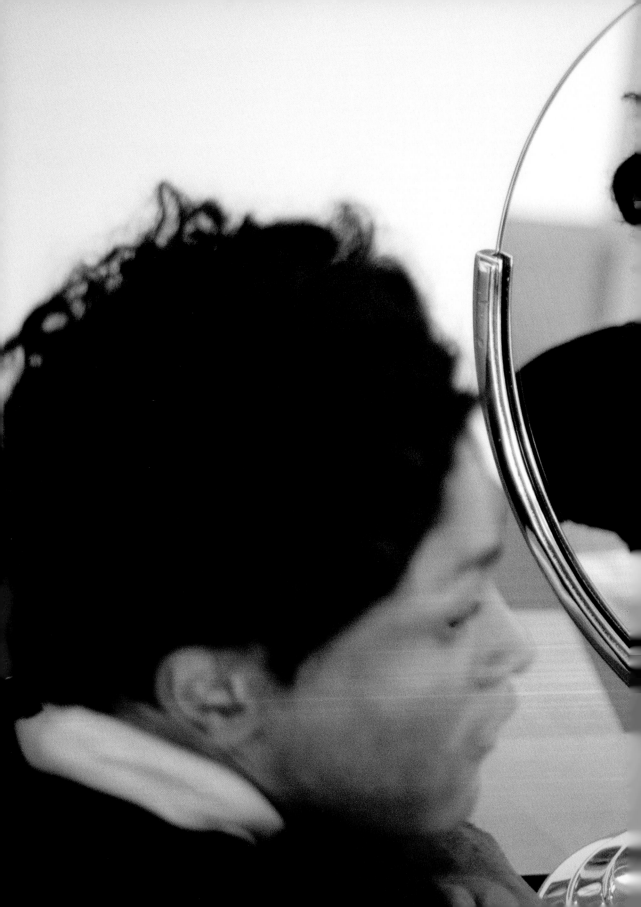

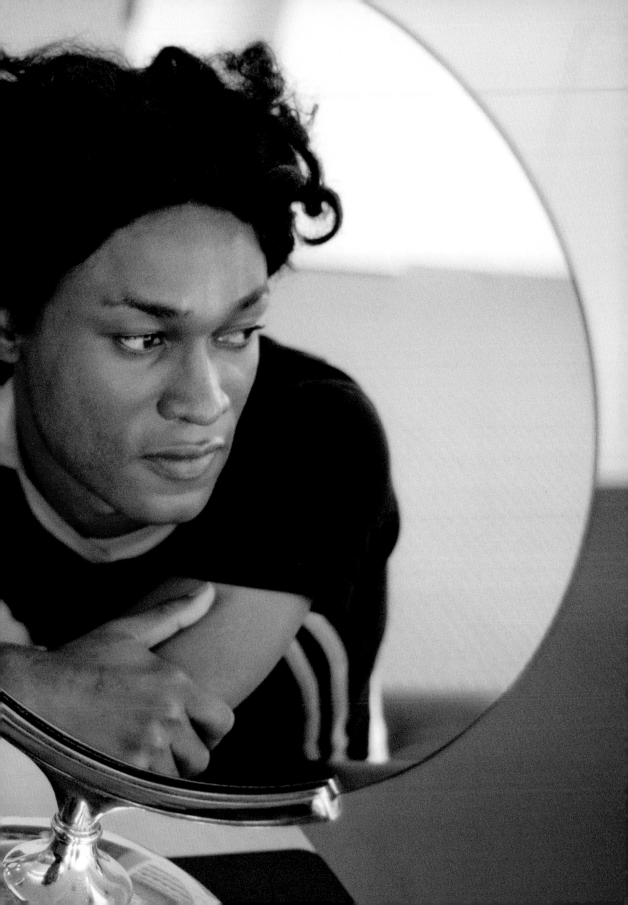

Enemes — three more th
I snuld have. Anyway I
am Feelig a littled (lopec

I have decided to say in LA
in the Fall. Have a lot if
Feelig about this Part of me
resents myself for not have
any money. I Peel that I
I took have taken any

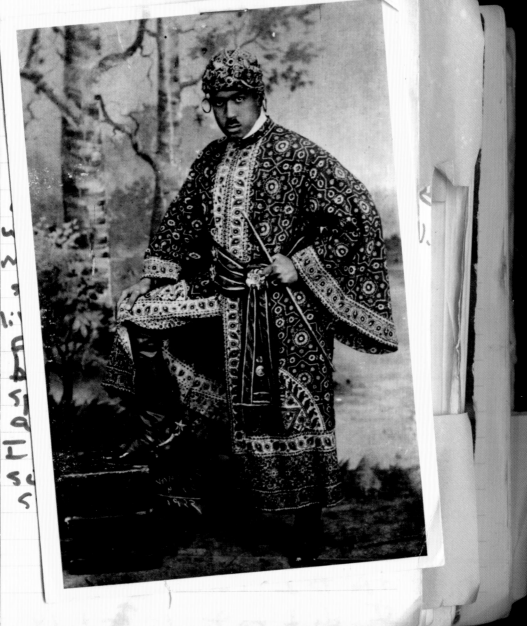

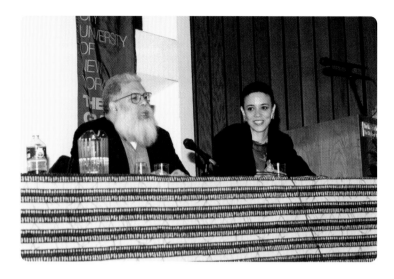

Samuel R. Delany and Coco Fusco,
Black Nations/Queer Nations?:
Lesbian and Gay Sexualities in
the African Diaspora conference,
Graduate Center, City University
of New York, March 9–11, 1995

136

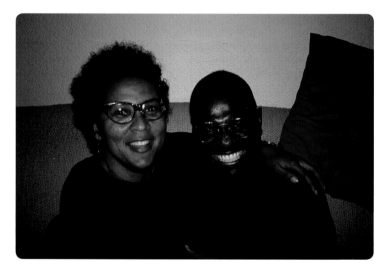

RIGHT AND BELOW: bell hooks
and Marlon Riggs, New York,
early 1990s

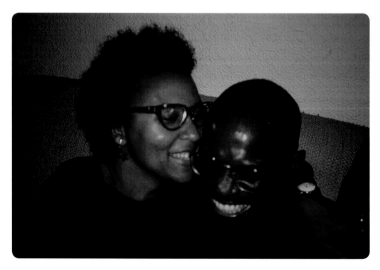

Barbara Smith and Isaac Julien, *Black Nations/Queer Nations?: Lesbian and Gay Sexualities in the African Diaspora* conference, New York, 1995

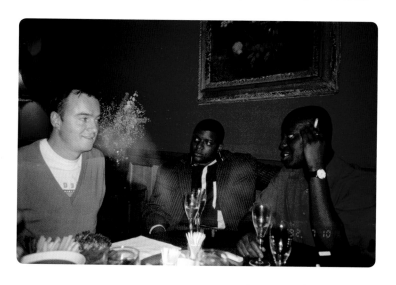

ABOVE: Mark Nash, Isaac Julien, and John Akomfrah, 2 Brydges Place, Covent Garden, London, 1992
RIGHT: Sonia Boyce, Stuart Hall, and Isaac Julien, London, 1992

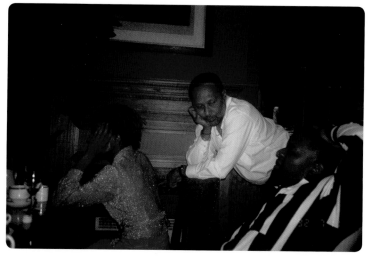

8/3/97

Dearest Lyle,

As we move together through the darkness & light may we continue to guide one another with compassion, honesty & strength.

I AM SURE THAT THIS NEXT YEAR WILL BE A FINANCIAL COUP FOR ALCHEMY Productions As well as LAH + TAH. I look forward to that journey AS WELL

YOUR FELLOW ALCHEMIST
FRIEND +
BROTHER
FireBird usa TAH

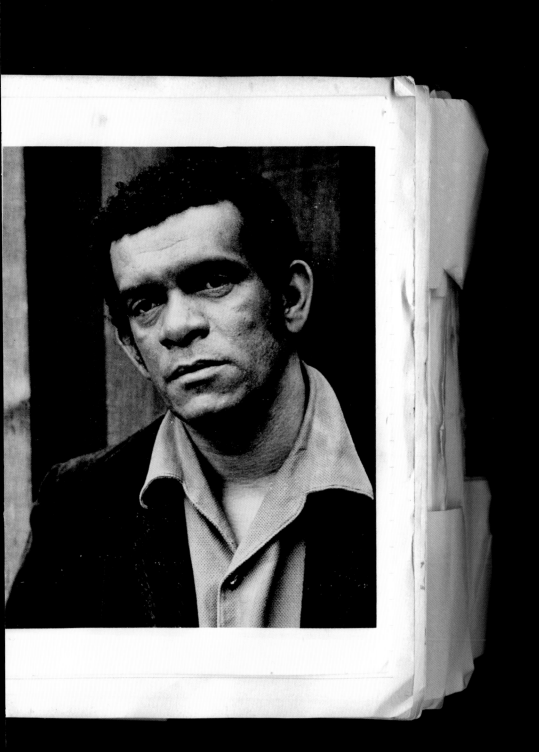

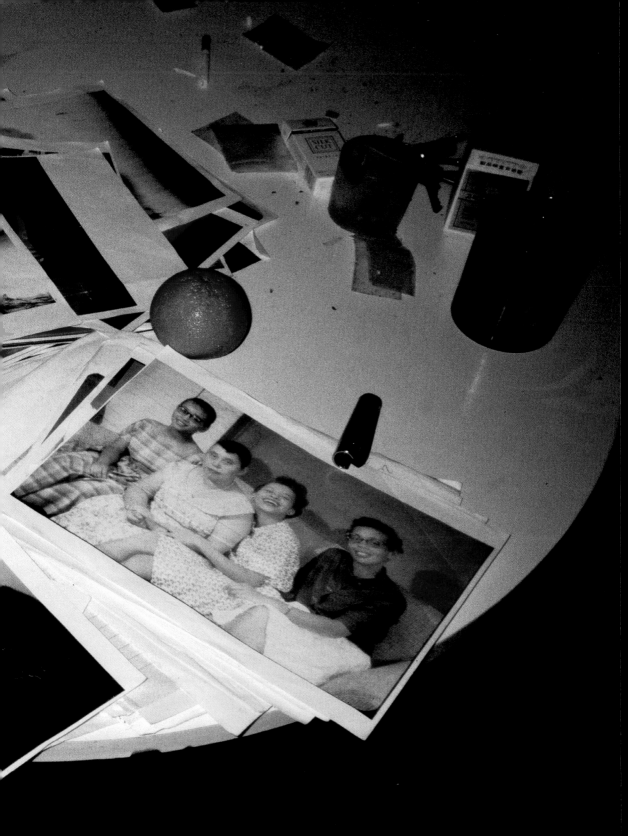

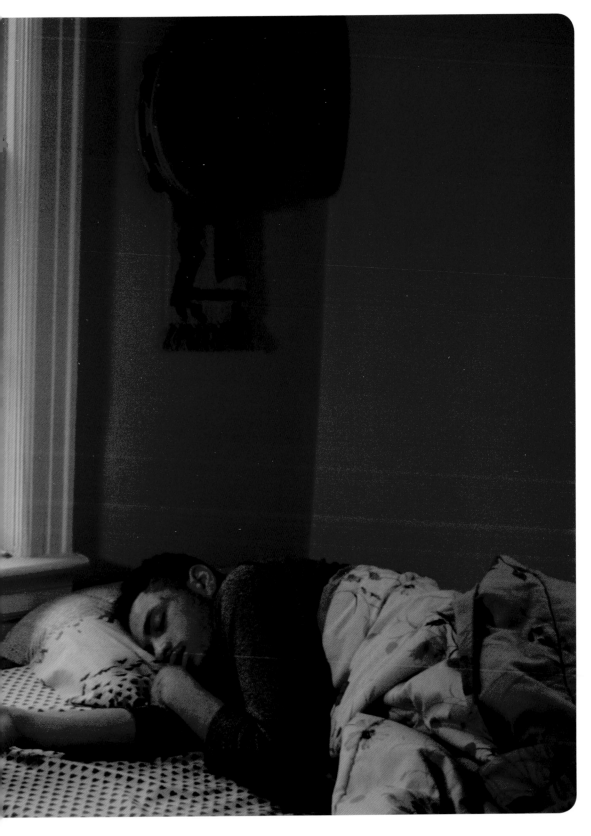

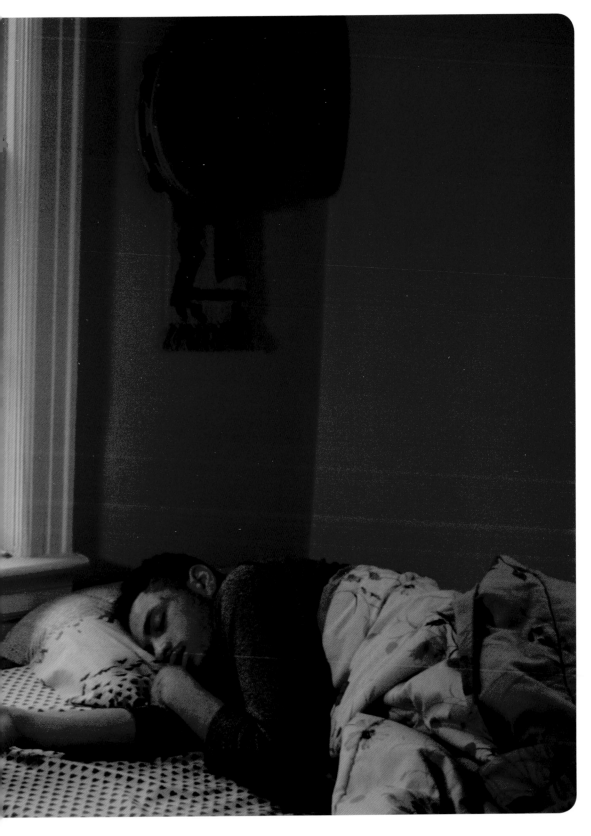145

La Natura Morta II, Rome, 1992

148

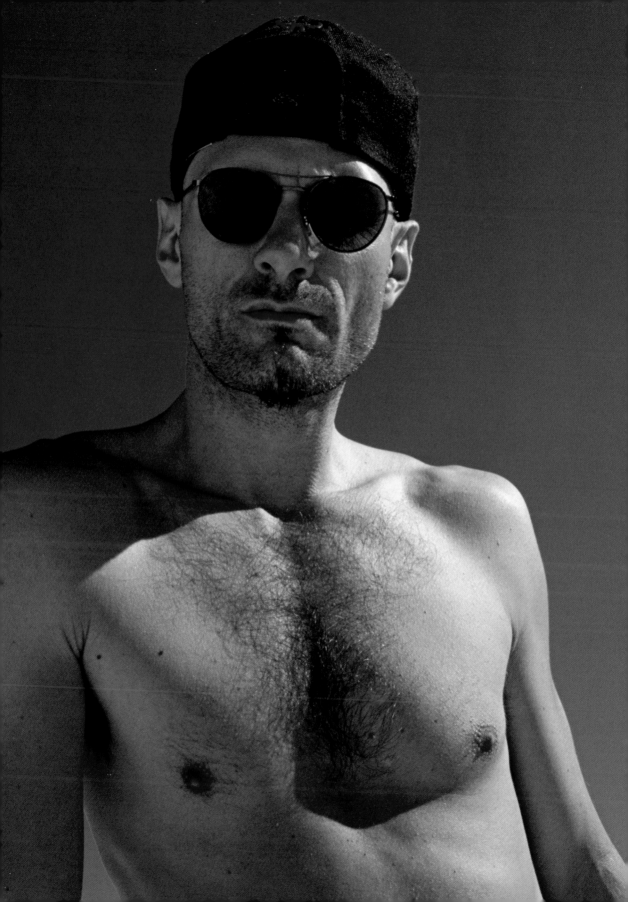

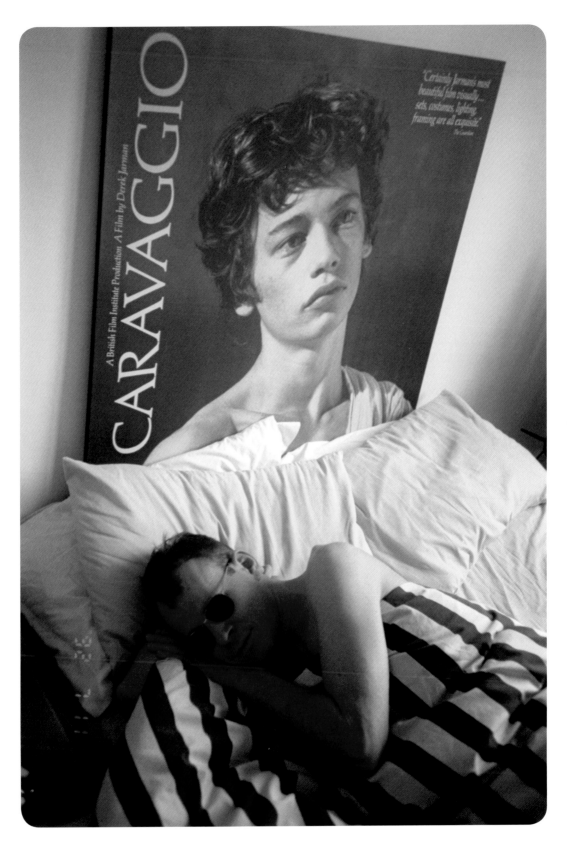

151

Queer Affect: Lyle Ashton Harris's Ektachrome Archive
Roxana Marcoci

Comparing Eugène Atget's detailed study of ancien régime interiors and outdoor scenes with the descriptive analysis of French society in Honoré de Balzac's *La Comédie humaine*, Berenice Abbott wrote that Atget was "an urbanist historian, a Balzac of the camera, from whose work we can weave a large tapestry of French civilization."[1] The tapestry to which Abbott is referring included series of pictures in the neighborhoods of Paris and its suburban environs. Atget's editorial albums would have a lasting impact on subsequent artists, notably Walker Evans, who became familiar with his photographs in 1929 through Abbott. Atget's example helped Evans to realize that the potential of photography resides not in individual pictures but in the conception of an open-ended archive that reflects one's vision of contemporary society. Evans's *American Photographs* (1938), August Sander's *People of the 20th Century* (the monumental collection of Weimar types that Sander worked on over most of his life, from 1892 to 1954), Robert Frank's *The Americans* (1958), David Goldblatt's *South Africa: The Structure of Things Then* (1998) and *Intersections* (2005), and Zoe Leonard's *Analogue* (1998–2009) all articulate to different degrees the particular value of photography as a means to define the shifting politics and intellectual situations of their time.

153

Lyle Ashton Harris's 35 mm Ektachrome archive project holds a place in this genealogy as a document aimed to examine the relationship between art, sexuality, and identity politics at the end of the twentieth century. Begun in the late 1980s, Harris's *Ektachrome Archive*—an active repository of over 3,500 images, video recordings, illustrated journals, and related ephemera— provides an aperture on Harris's rich personal history, subjective interests, and passions in the wake of multiculturalism and during the rise of a global queer culture. Performative self-portraits are interwoven with diaristic snapshots of Harris's fellow contemporaries—Nan Goldin, bell hooks, Isaac Julien, Catherine Opie, Glenn Ligon, Iké Udé, etc.—as well as candid pictures of chance acquaintances and strangers. Harris invites us to reengage with historic events and personal narratives to affectively influence the present. Among the most arresting: the opening of Thelma Golden's controversial *Black Male* exhibition at the Whitney Museum in 1994, which introduced Harris's series of self-portraits in drag to larger audiences (pp. 214–25); a 1989 Gay Pride parade in San Francisco, during intense LGBT activism in the context of the "culture wars" (pp. 14–17); an image of Harris lying in bed in

London, a glorious film poster of Derek Jarman's *Caravaggio* hanging above him (p. 150); the *Black Nations/Queer Nations?* conference in 1995 (pp. 136, 137).

In the *Ektachrome Archive* there is no hierarchy of images, only layers of private and public societal relationships. The collection's structure oscillates between the feel of a narrative thread within both local and translocal contexts and the total disruption of linear storylines, which is implicit, for example, in the unruly, antirelational potential of this image repertoire to be recombined in different photographic montages. A poignant exploration of what constitutes an image—of how an image functions in different fields, whether aesthetic, activist, or documentary; and of how it proliferates technologically and socially—the *Ektachrome Archive* amplifies critical considerations of the post-black movement, queer desire and politics, and the AIDS crisis. Harris's freely and productively associative approach to image-making and nonlinear presentation invites the question: *What is the most salient quality of a documentary project: the discursive potential of images, or their latent regimes of emotion?*

1. Berenice Abbott, *The World of Atget* (New York: Horizon Press, 1964), p. xxxi.

Centering Marginalized Memory
Pamela Newkirk

The ephemera of black life—the letters, snapshots, and other traces of particularized experiences—have rarely been accorded importance in American history. The devaluing of black artifacts—and, indeed, of black life—has created a seismic void, erasing even some of the most seminal movements and moments from both personal and recorded memory.

So it's significant when an artist as attuned to visual culture as Lyle Ashton Harris unearths more than three thousand images of the people, places, and pivotal events that helped expand and redefine the possibilities of black and queer identity over the last three decades. Throughout the 1990s, the artist who became known for self-portraits that upended prevailing ideologies of race and masculinity also turned the camera on the larger subversive world of which he was a part, documenting landmark conferences and exhibits that challenged the marginalization of multidimensional black identities in politics and art.

As both chronicler of and participant in a series of urgent dialogues that informed his work, Harris captured scenes from what came to embody a new Black Arts Movement[1]: The *Black Popular Culture* conference in 1991; the *Black Nations/Queer Nations?* conference in 1995; the Whitney Museum's *Black Male* exhibition in 1994; and the filming of Marlon Riggs's last film *Black Is . . . Black Ain't*, also in 1994 (pp. 132–33, 234–35). Harris was in Los Angeles documenting the truce between the Crips and the Bloods (pp. 236–37) and on the streets in the aftermath of riots following the police beating of Rodney King.

Harris's *Ektachrome Archive* grants us privileged access to his iconoclastic universe of friends, lovers, family members, scholars, activists, and fellow artists. From the margins of the mainstream, a steady stream of thought leaders from across the African diaspora command center stage: British social theorist Stuart Hall; Cuban American artist Coco Fusco; Nigerian-born artist/trendsetter Iké Udé; filmmaker Marlon Riggs; artists Renée Cox, Fred Wilson, and Glenn Ligon; scholar/activists Angela Davis, bell hooks, and Cornel West; and curator Thelma Golden.

Captured in mid-speech, hands clasped, his iconic Afro a defiant halo, the bespectacled late scholar and activist Manning Marable is depicted addressing the 1991 *Black Popular Culture* conference (p. 118). The Columbia University professor is perhaps best known for the Pulitzer Prize he received posthumously for his biography of Malcolm X, in 2012. But Harris reminds us

of Marable's intimate and longstanding connection to black cultural, social, and political movements beyond the ivory tower.

We're left to ponder whether a fledgling Lyle Ashton Harris knew then what his snapshots would mean for us today: how the fleeting moments he recorded would unlock memories that might otherwise fade, or the ways in which his life and its many intersections with those of others would enlarge and enrich our collective history.

Harris's images seduce us, evoking the intimacy of shared desire and of a restless quest for something just outside the frame.

1. This Black Arts Movement is distinct from but in direct conversation with the Black Arts Movement that began in 1965 after the assassination of Malcolm X and ended in 1975. As a discrete initiative, the Black Arts Movement of the 1960s and '70s was pioneered by poet Amiri Baraka and summoned black poets, artists, and cultural producers in the wake of the Black Power movement to affirm an autonomous black cultural nationalism.

Truce between Crips and Bloods, Los Angeles, 1992
Clarence Otis Jr.

Growing up in Watts, Los Angeles, in the 1960s and early 1970s, meant being there when the Bloods and their rivals, the Crips, were born. It meant getting a letter from my mother in 1973—my freshman year in college—saying a family friend had started a new gang called the Bloods. It also meant having a sense of why these communities of young people—these gangs—simply had to be. Finally, it meant being spellbound by Lyle's work from the moment I first saw it and met him, in 1986 in New York, far from Watts.

For many young, black people from marginalized neighborhoods, who had little encouragement from the adults in their lives, forming or joining the Bloods or the Crips was an expression of confidence and self-love. "Despite what you may think, I know where and who I am, and I like it," was their declaration. While obviously with a different outcome, so it is with Lyle Ashton Harris. In his practice and with his images, Lyle doesn't ask the art world or the black community for understanding. Nor does he ask anyone to make a place for him or to endorse him. He simply presents his often complicated, sometimes ambiguous, yet always self-affirming world, and challenges us to come to terms with it.

Truce between Crips and Bloods, Los Angeles, 1992, brings all of that together (pp. 236–37). Lyle is an artist who had to be there, in Los Angeles in 1992. He was uniquely prepared to enter this community of young people at that particular moment in time. As the Rodney King drama unfolded and Los Angeles's black and Latino gangs reached a critical inflection point in their histories by cementing a truce between the Bloods (red) and the Crips (blue), Lyle was documenting people who were and remain our kindred spirits. More important, with his incredible creativity, skill, and insight, Lyle presents us in this image with a kind of family that may be very different from our own. In doing so, he demands that all of us come to terms—intellectually, culturally, and emotionally—with the young people shown here, and so too with ourselves.

This image also resonates deeply with me because of the body of work it belongs to today. Lyle was part of a community of visual, literary, performance, and other artists who were all challenging norms about personhood and family. We now have the luxury of taking for granted so much of what they fought for, and, as a result, can too easily forget important truths: These pioneers were engaged in an artistic and cultural battle. And while it was at times thrilling, creatively and emotionally, it was also all too often debilitating.

It's hard for me to forget, for example, the ruckus surrounding the Whitney's *Black Male* show, the condemnation that greeted Lyle's work in particular and how deflating that was for him; the show's curator, Thelma Golden; and others, myself included.

As I think about that history, this current body of work—with its candid presentation of and reflection on many of those who participated in and drove what we now know as an important artistic and cultural revolution— feels very much like a family reunion. It reminds me of the reunions I share with my high-school classmates from Watts every five years. We celebrate making the arduous journey from dysfunction and chaos to some level of accomplishment and self-actualization. We do so because many who weren't there, on the frontlines in communities like ours, take our journeys for granted. We don't. Some of us were Crips or Bloods, but most of us were not, yet we have a shared battlefield experience that we treasure. I'm hoping that, like Lyle, myself, and many of the others he documented, the young people in *Truce* survived their journey. That they, too, used the family and community they found in 1992—the family and community this image captures so vividly—as a platform for creating a life of enduring fulfillment.

Art and Survival Amidst the Great Scything
Robert Storr

There are worlds within worlds, and then worlds that overlap, partially but never entirely subsuming one another; worlds in the margins of larger worlds that by incompletely intersecting create their own margins; worlds that may indeed touch at only one point but are nonetheless powerfully charged by that contact. I prefer such language to the prejudiced terminology of "dominant cultures" and "subcultures." For no matter how accurately such terms reflect power relations among people who may, when push comes to shove, appear to be primarily defined by any one of the communities to which they belong, they cannot fairly account for the bonds they have with more than that community, or for the intimacy that exists among members of several communities circumstantially connected by a single (nevertheless plural) individual who seems at home everywhere. Not as a chameleon does, but as only a multidimensional, polyvalent being can. That is, a fully self-aware cosmopolitan.

Scrutinizing the archive of my friend Lyle Ashton Harris prompts these thoughts. Lyle has lived life to the full—while continually cheating death—as an African American HIV-positive gay man with deep roots on both continents stipulated by his hybrid heritage. The images contained in this book document Lyle's peripatetic life and that of his immediate family (both his grandmother and grandfather, and his mother as well as his brother, Thomas, a filmmaker). They also recall the prematurely short lives of some of his brothers and sisters by other fathers and mothers. Lyle's family, however defined, is—or was—a tight-knit and remarkably accomplished group. Some members succumbed to the ordinary perils of risk-taking youth. Nan Goldin (in front of her vanity mirror), who appears among his photographs—an example of the overlaps cited above—is another witness to such hazards (pp. 186–87).

Meanwhile some of his elder role models lived long lives, dying of the natural causes that commonly claim the aged. However, many of those now gone succumbed to AIDS during the first years of the plague. In my own social circles the heaviest toll of the first phase of the epidemic was among musicians, beginning in 1982 with gifted pianist, concert producer, and dear friend Tom Johnson. Many more followed. Yet despite their grim fates and the suffering and humiliation inflicted upon them, these undaunted souls left behind a vibrant record of their all-too-brief existences.

But none more so than these pictures. Guided by an irrepressible, irresistible stylishness, sexiness, polymorphous self-invention, and pathos, Lyle's

camera scans the fluid field of compound, ever-shifting "otherness." Photographically, that flux is anchored in unique attributes and gestures. *Marlon taking pills (with Jack Vincent), Oakland, California*, 1994 (p. 251), for example: The title specifies a medical routine performed as a daily ritual of survival. It also specifies the subject, though only by his given name, addressing him in the familiar, whether or not we've ever met him. Riggs was his surname. He made the 1989 film *Tongues Untied*, which was instrumental in breaking the silence on AIDS and race and became one of the flash points of the culture wars of the 1990s. Other leading lights of queer blackness figure prominently —Samuel R. Delany, Essex Hemphill, Isaac Julien, and Fred Wilson among them—as well as cultural luminaries of different kinds, including all-around museum professional Thelma Golden, patron Eileen Norton, writers Stuart Hall, bell hooks, and Greg Tate, and fellow photo artists Lorna Simpson and Carrie Mae Weems. Plus many more.

Lucky is the person who can in part see himself, herself, or themselves mirrored in these potent images. Lucky are we who can bear witness to their reality and celebrate, not just mourn, its passing.

Gail and Peggy, Fort Greene, Brooklyn, Late 1980s
Mickalene Thomas

"The precise role of the artist, then, is to illuminate that darkness, blaze roads through vast forests, so that we will not, in all our doing, lose sight of its purpose, which is, after all, to make the world a more human dwelling place."
—James Baldwin

I moved to Fort Greene in my twenties, in 1995, to attend Pratt Institute, over five years after Lyle Ashton Harris shot this photograph of Gail and Peggy (pp. 42–43), who I imagine were themselves in their twenties at the time. Fort Greene in the 1980s was dealing with the ravages of the crack epidemic; drugs were a major issue across America. My own mother had her battles with drug addiction. When I arrived in Fort Greene, it was near the end of the epidemic, and the slow beginning of gentrification. Like Gail and Peggy, if one generation younger, I was black and queer in Fort Greene, Brooklyn.

From the moment I saw them, it was as though I knew these young women—Gail and Peggy, twenty-somethings—now three decades on. They look similar to other members of my "chosen family"—the lesbian, gay, boi, genderqueer, bisexual, transsexual, questioning, intersex, two-spirit family members that are woven together in order to create a safe environment for growth and love without limits. This photograph reflects in a deep way and calls upon that community for me; it embodies a place that has had a major impact on my life, that taught me how to love and challenged me. There are many of these stories; some are told in books like Audre Lorde's *Zami: A New Spelling of My Name*, which demonstrates the significance of chosen family in the queer character's life. But it's the familiarity of comfort and family dynamics that this photo conjures; they are feelings that I want to hold on to. Our spirits feel kindred, Gail and Peggy. Depicted here, facing the viewer, I see you. Are you lovers? Sitting in a room, one in front of a purple curtain, composed in a red turtleneck shirt, holding a cigarette; the other, stud, genderfluid, boi, hands in hair, blue silk robe, raw and visceral.

Lyle captures the reality of these roles in a manner so true to the moment; they are lovers or friends, "Sister Outsiders" (drawing from Lorde again), preparing to go out or stay at home. These are photos of real people and their mundane daily activities, but they represent the intersection of art and exemplify queer life in the act, depicting the social climate of that particular

time and space. The inclusiveness of both their gazes provides comfort and gives voice to queer bodies.

The beauty of *Gail and Peggy* is that it harbors a sense of responsibility to reimagine and represent Lyle's world through his work, as it plays with representations and perceptions of black transgressivity and intersectionality. This photograph's myths and its embedded notions of raw and real life capture race and gender in a single moment. It is richly layered, giving the viewer permission to enter this bold, diaristic photograph with a queer lens.

Lyle: The Quotidian and Precious Moments
Iké Udé

The ticking away of time is a constant: eternal, merciless, amoral. Sometimes, the passing of precious moments is preciously captured, but this seems to be the case less than more often.

How time has passed since Lyle and I were inseparable! We were, once, literarily soul brothers who connected beautifully in ways that are truly rare. This was in the 1990s.

Lyle, American born and bred, and I, Nigerian born and bred, were both New Yorkers and Africans in equal measure and in sympathies. And from the get-go, Lyle was on a mission fueled by an insatiable, flame-like passion. He took on that mission and passion with knowing casualness—and applied a casual rigor to the documentary impulse. Lyle's method became a potent, transgressive act of interrogation that in effect interrogated the relatively conservative history of black/African representation at large.

Poring through some of his snapshots of yesteryear startled me with their ghostly presence and acknowledgment of time past: acknowledgment of lost youth, of youthful beauty once bountiful, elastic, and full of vigor. And as important is the *how*: how Lyle elected to use his camera as a mode of intervention, inquiry, investigation; to make pictures that are question marks, fruitful fill-in-the-blanks, etc. He was able to delightfully, even mischievously, undermine the stultifying conservatism characteristic of representing (and not representing) *our folks* in general.

By turns furtive, casual, a shade mean, judicious, calculative, poignant, poetic, sly, and charming, Lyle whipped out his camera to get these images. The narrowed, hawkish gaze in his eyes tracks and locks a subject (or victim, if you like). Camera already cupped in hand, he fires away and then resumes or altogether changes the conversation: from the profound to the blah-blah-blah, but with that *knowing* satisfaction of what his camera has captured.

Having been certified HIV-positive when such a health status was tantamount to a death sentence, Lyle worked alternately with alacrity, alarm, and the urgency of a man about to face death at a moment's notice—and who, to that end, wanted to make such a death heroic. I recall one overcast spring afternoon: Lyle, his brother, Thomas, and I were walking down the then rarely trafficked Crosby Street in order to avoid the maddening Broadway pedestrian traffic. Suddenly, the fear of death clung and seized him, and in a moment of sublime catharsis, he had a French moment, *la petite mort*. He

mentioned something about us overseeing his estate in case of his untimely death and then spoke almost in tongues for a few moments. Miraculously, he collected himself and we continued our walk. This momentous event would have a residual, but no less profound, effect on me, for it gave me a sense of urgency in getting things done. It made my sense of mortality, and those of everyone for that matter, all the more poignant. That was perhaps one of the lasting gifts that Lyle gave me and to boot, it wasn't by design but instead divined.

Does the impulse or inspiration to take a photograph come before the actual shot? This was sometimes the case with Lyle. I think that some of his captured moments were pre-registered, while others were impulsive. At a restaurant, disco, vernissage, or private/public event, however jolly or solemn these occasions, Lyle knowingly employed his camera to capture folks at various stages of preparedness or unpreparedness. In a sense, he used his camera to document moments that eluded language and even context—just to mark the merciless and cruel passing of time, especially youth and beauty.

I was keenly aware that everyone was subject to his insatiable, wicked, transgressive lens. Ah, did he not capture bell hooks moisturizing or drying her smooth, wet body in the privacy of her bathroom, but with the door considerably ajar, totally nude but not naked? This photograph caused, without exaggeration, a seismic stir amongst the literati—from New York to London and Los Angeles. As a result he was temporarily excommunicated; he was near pariah status but I relished this rebelliousness and deviancy with total sympathy. In turn he was at my side when, at a party hosted by Manthia Diawara in honor of legendary Senegalese filmmaker Ousmane Sembène, I mischievously and gamely asked the filmmaker the color of his underwear. When an interpreter finally told Sembène what my question was, he erupted, rose, punched me, and geared for more fight. Lyle and I, forthwith, left the party in rapturous fits of laughter that hurt pleasingly.

Did I not see him capture many a folk dozing off, their mouths ajar, and looking like shadows of their woken selves? These are perhaps examples of perfectly inspired mischief, curious voyeurism, anxious sympathy, and charming cruelty.

Because he is a visual diarist, Lyle's snapshots have the charmed linguistic economy of haikus. They are, by turns, observed, reflexive, impulsive, deliberated quotidian moments—pregnant with meanings, with question marks, open to interpretations, yet with perpetually deferred conclusions.

Book
money
and
monsters

Ike and Ike

Where were you born? I think in
Nigeria. I always say. It might be true.

How old are you?
I shall not answer it not because
I can't, not because I won't, it
is simply because I'm too present
to answer it. I think that it's
only death — which I'll not be
aware of — can answer that
question with the uncertainty that
my life had ~~much~~ permitted to
create during the moments I
lived.
Do you like the area of being
happy?
Pleasure is better. Happinness insra

s Road

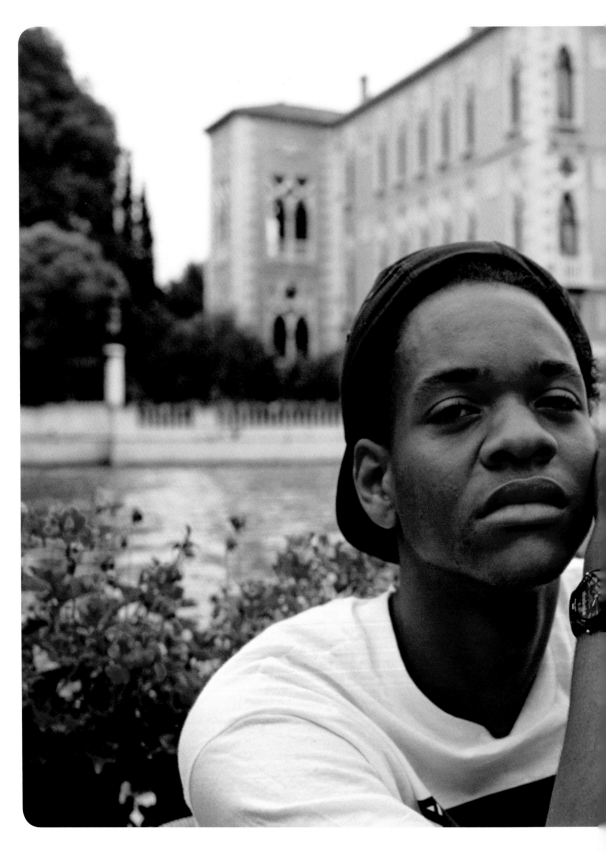

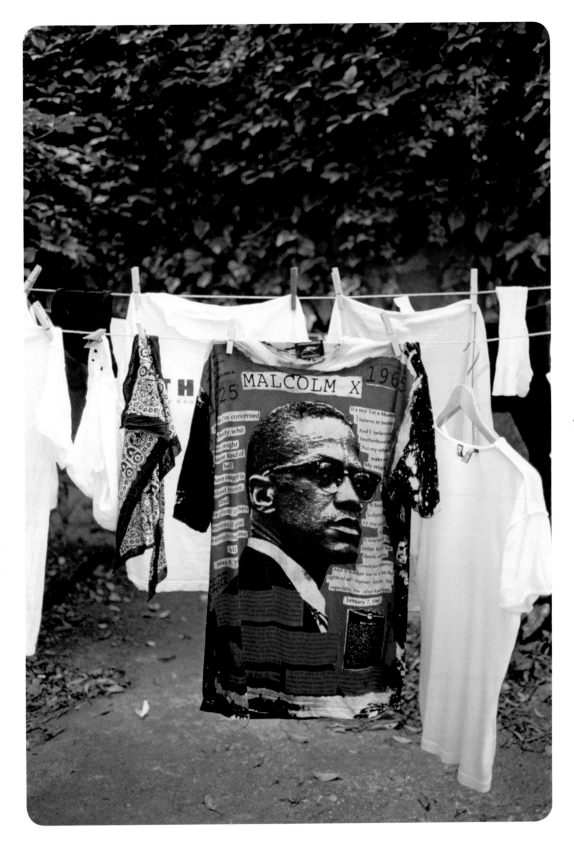

LEFT: Doorknob, Venice, 1992 RIGHT: Malcolm X T-shirt, Rome, 1992

FOLLOWING SPREADS: Still Life (Spill), Berlin, 1992 ⟨⟩ Tommy Gear, Vatican City, 1992 ⟨⟩ Lyle by Tommy Gear, Vatican City, 1992

En Route to Paris (Journal #1), 1997

10 pm around)

On my way to Paris.
Successful 1 day trip to
Frankfurt. Met with Peter W.
A Bit nervous but I think
it went well.
We met for about
1½ hrs. He was busy I
could tell, but he was trying
to be as generous as
possible. He was vague
about what we could do
together. The T is a curious
way of prasing it.
Because he was clear on
staying that it would
be a good idea to bring all
of my works together.
He asked of my plans
in NYC in fall because
he would like to meet me

Self-portrait, Berlin, 1992

RIGHT: Lyle and Tommy Gear,
approaching Rome, 1992
BELOW: Lyle and Tommy,
Venice, 1992

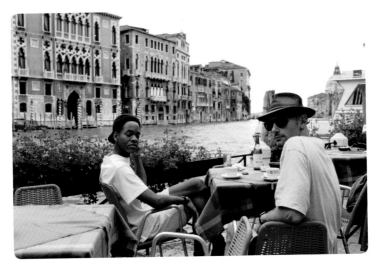

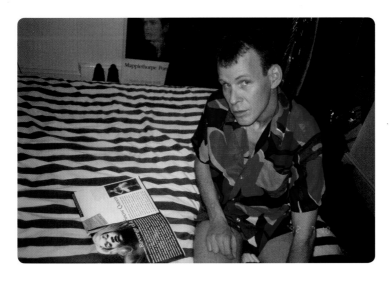

Thomas Munke, London, 1992

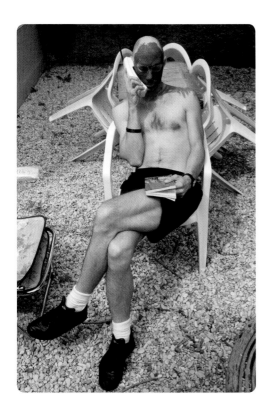

Tommy, Bronx, New York, early 1990s

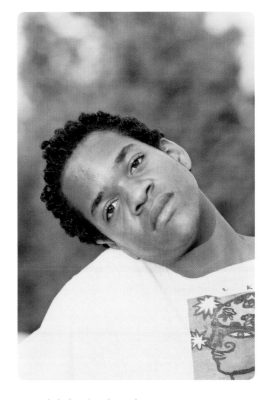

Lyle, Los Angeles, early 1990s

AmericanAirlines
BOARDING PASS

NAME OF PASSENGER
HARRIS/LYLE
AA 753JJ02 ADV
X/O FROM SAN JUAN PR
X/O TO ST KITTS
AMERICAN AIRLINES

CARRIER FLIGHT CLASS DATE TIME
AA 5426 M 17MAR143P
REVALIDATION

GATE BOARDING TIME SEAT SMOKE
14 1258P 13B NO
ADDITIONAL SEAT INFORMATION
CN CK N
PCS. CK. WT. UNCK. WT. SEQ. NO. PCS. CK. WT. UNCK. WT.

BAGGAGE ID NR.

COUPON AIRLINE FORM SERIAL NO. CK

62V /JFK ELECTRONIC

ROUGH TRADE

True Revelations and Strange Happenings Vol. 7

Edited by
John Dagion

184

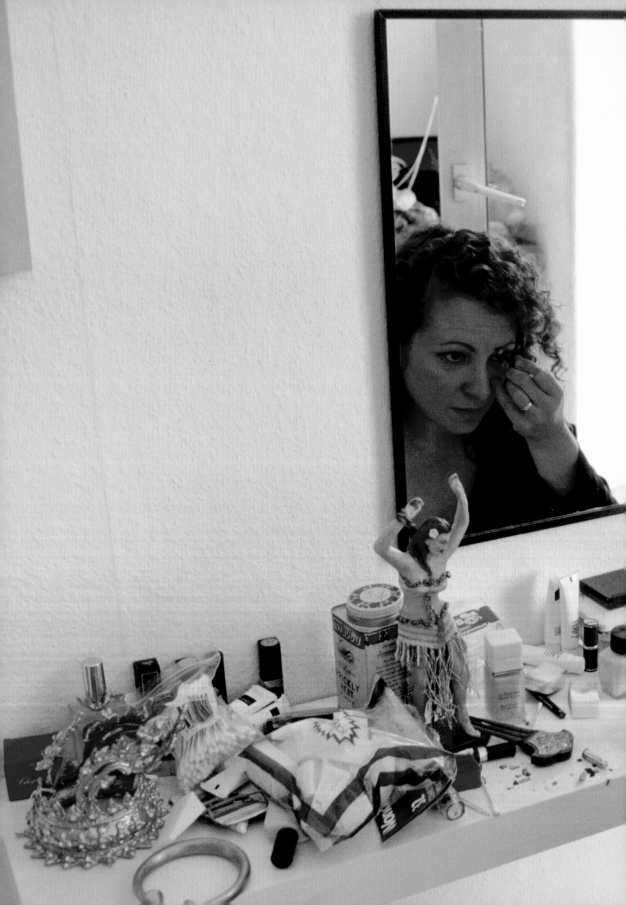

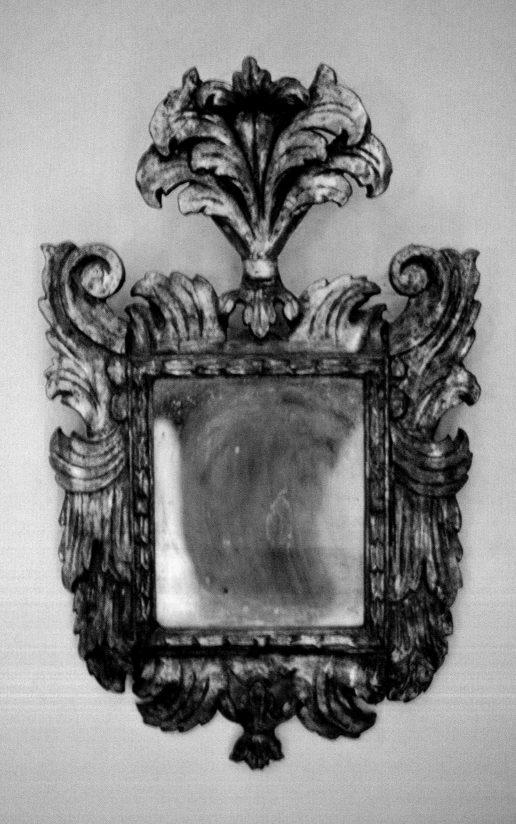

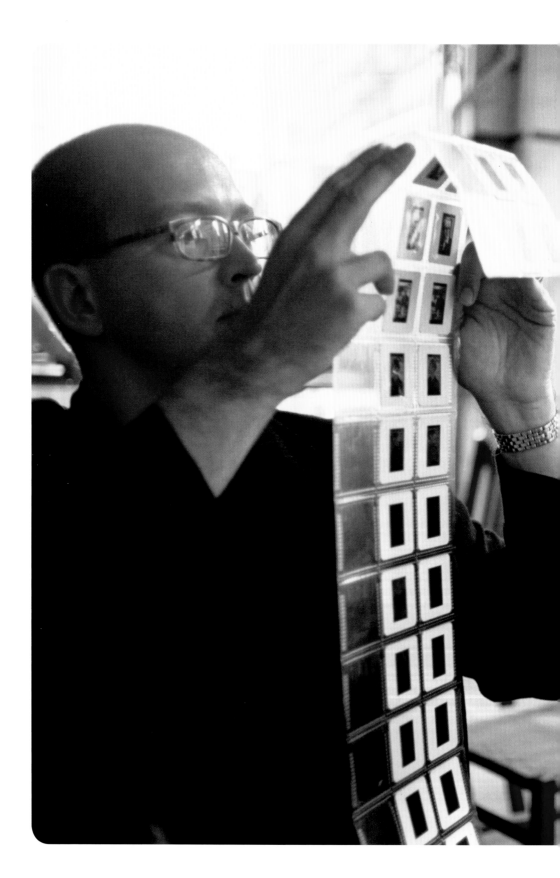

Laurence Rickels and William Stern, SoHo, New York, mid-1990s

Thursday — 9:30 Am. ish

Don't think that this
postcard corresponds to
this image. Well in a
way I guess it all flows.

At Melrose Baking co.
waiting to have dang
picic me up. I've dropped
my car off at Stokes Auto
For Tune up and to check the
radiator. Oh the difficult
of my feelings. Trying to
move through a lot of
emotions and fears. Afraid.
I am now writing to you
trying to get at what I
don't know. I am feeling
a little bloated. I have been
having digestive problems. Problems
with the total ~~evaluation~~
I think have taken three

DE
26
MA
FR
15
SA
16
SU
18

what i want to write.
i will write myself into existence
i am sensing that i could be dying, slowly
that i have begin to disintegrate.
that i am worthless.
as least gary fisher had the nerve to drink piss!
i wish i had the nerve to face my desires,
desecrate myself.
perhaps i'm a closet slave, a closet masochist.
what is it all about?
at least jesus had the nerve.
i wish it was over.

Stockholm, 17 October, early morning

is there other ways to know thyself?
I guess in a sense I am still waiting...
peaking through
i cry
fear, wondering, what, if I let it go,
to discover, to unveil another, to write,
to share myself with another, to trust myself.
i am still, that little boy.
Will death be that final frontier

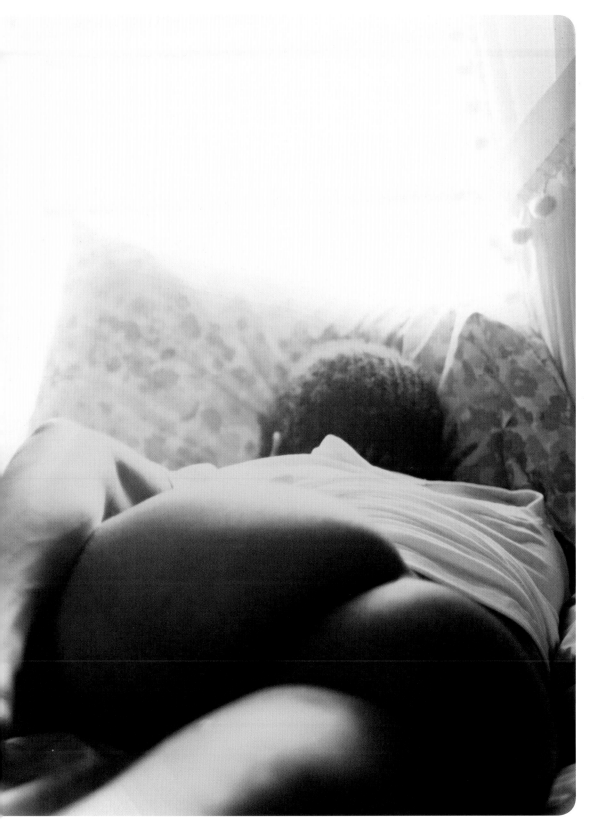

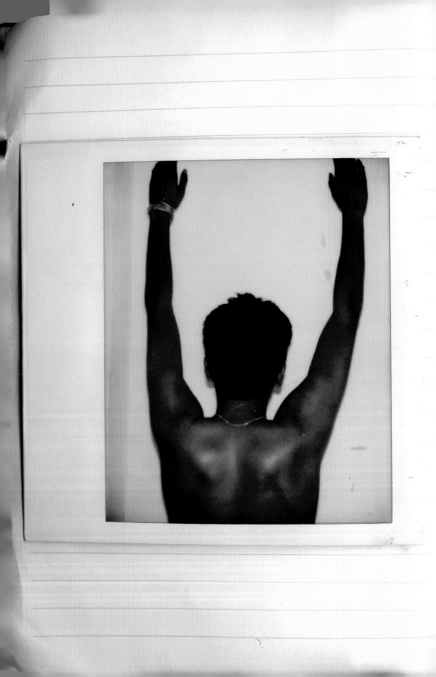

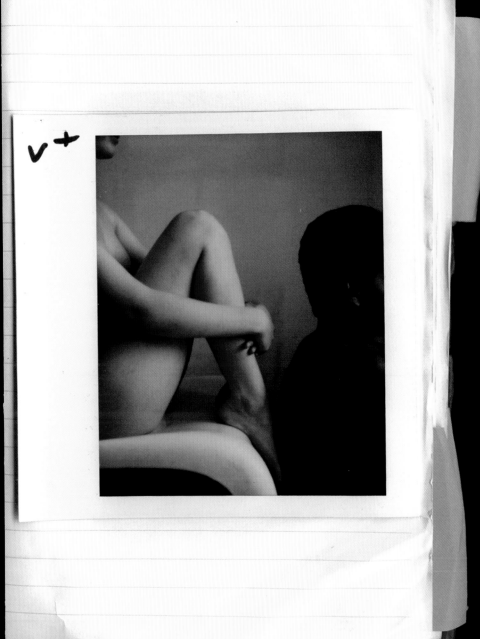

Tommy Gear, La Jolla, San Diego, mid-1990s

210

ABOVE: Production still for *Vintage—
Families of Value* (1995), Tommy and
Thomas, Los Angeles, 1990
RIGHT: Self-portrait, Hobart Boulevard,
Los Angeles, 1991

Production still for *Vintage—Families of Value* (1995),
Lyle by Thomas, Los Angeles, 1991

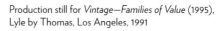

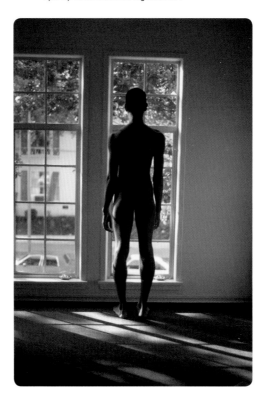

Lilies, Hobart Boulevard, Los Angeles,
early 1990s

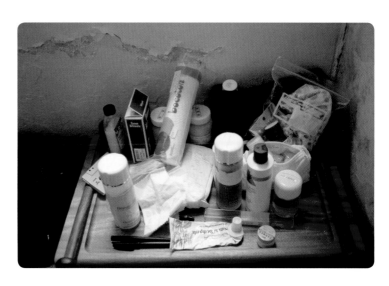

La Natura Morta, Rome, 1992

The

Anxiety

around

Beauty

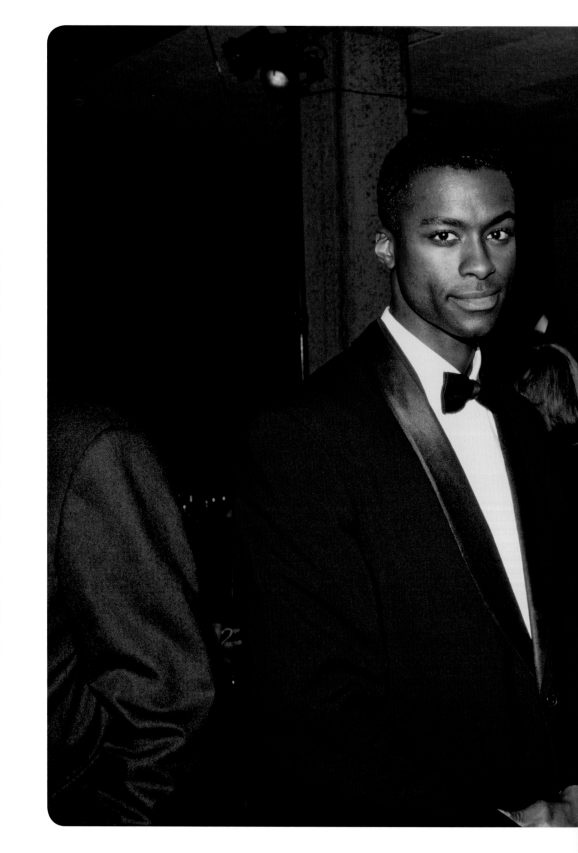

Waiters, *Black Male: Representations of Masculinity in Contemporary American Art* exhibition dinner, Whitney Museum of American Art, New York, November 9, 1994 FOLLOWING SPREAD: Carrie Mae Weems and Sharon Bowen, *Black Male* exhibition dinner, New York, 1994

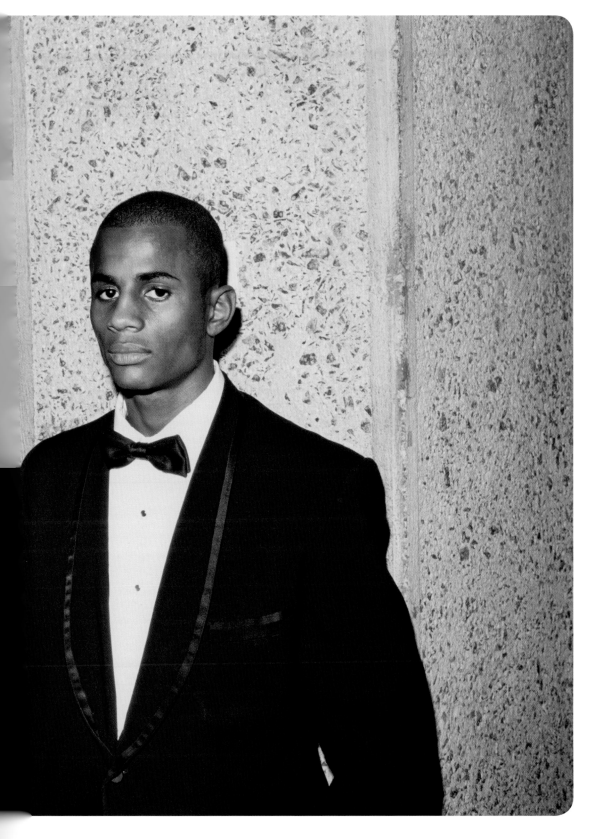

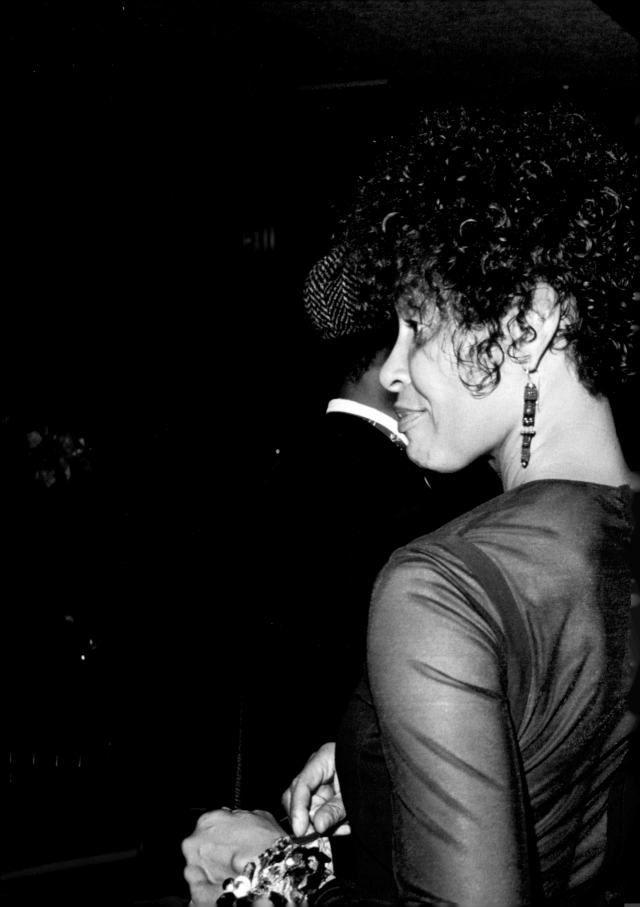

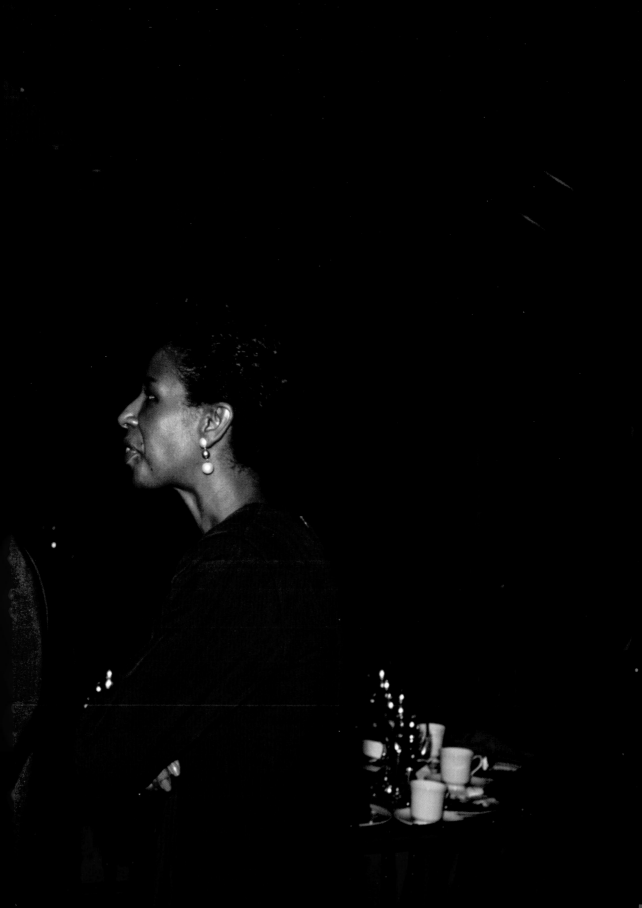

Thomas Allen Harris, Renée Cox, and Iké Udé, *Black Male* exhibition dinner, New York, 1994

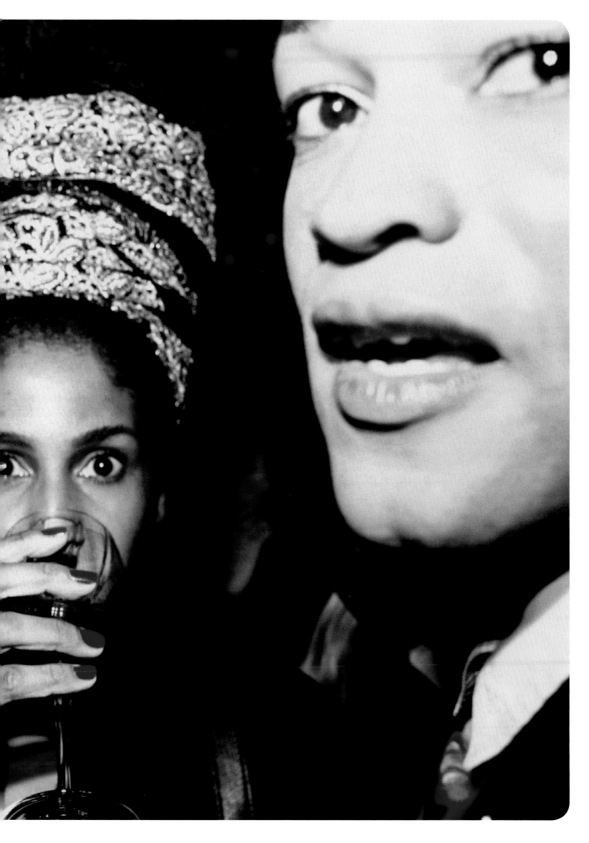

Thelma Golden and Ray McGuire, *Black Male* exhibition dinner, New York, 1994

an educated heart and
health system. Who am
I to judge another? I
am scared but moving forward

8/12/97 WED evening
in San Diego with Thomas
now. Indian food. long
Drive down here. Much traffic.

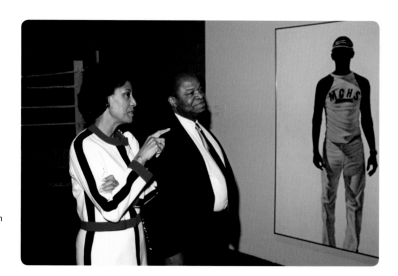

Suzanne Randolph and Dr. Ronald
B. Brown with *Tuff Tony* by Barkley
Hendricks (1978), *Black Male* exhibition
opening, New York, 1994

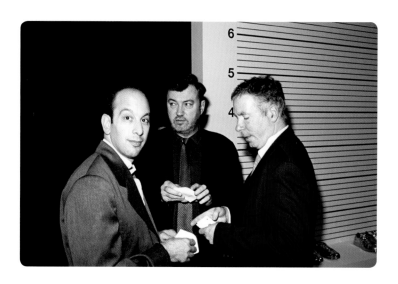

ABOVE: Larry Warsh, Diego Cortez, and unknown
man, *Black Male* exhibition opening, New York, 1994
RIGHT: Glenn Ligon and Arthur Fleischer, *Black Male*
exhibition opening, New York, 1994

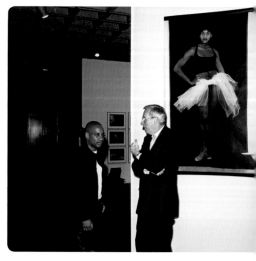

Peter Norton, bell hooks, and Suzan-Lori Parks, *Black Male*
exhibition dinner, New York, 1994

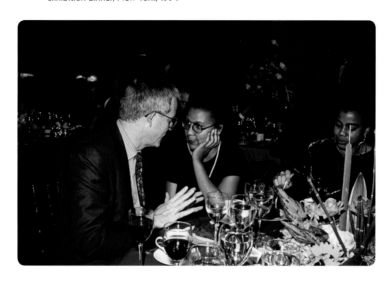

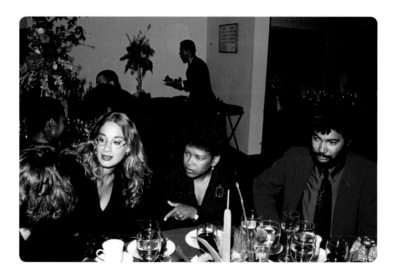

Fran Siegel, Eileen Norton, and Fred Wilson, *Black Male*
exhibition dinner, New York, 1994

amen

Death by Lynching

The walls of a room at the New-York Histor
Society are now lined with small photograph
American lynchings. The victims are mainly bl
mainly Southern. Some of the photographs
postcards and some are souvenirs that were pri
by the dozens and hundreds by commercial pho
raphers who had been at the scene. This exhibi
which chronicles an epidemic of lynchings in
country between 1890 and 1930, is called "Wit
Sanctuary: Lynching Photography in America
runs until July 9.

Ordinarily museums are eager to spread
images they show on their walls. They pu
posters and postcards. They print T-shirts
scarves. But there will be no postcards from
exhibition, even though it is, in part, an exhibiti
postcards. One kind of viewing — very diffe
from the kind that these photos originally elicit
is being sanctioned here, as it is in the accomp
ing book, and it is worth thinking about the mea
of that difference.

After all, at this exhibition we are a c
looking at a crowd looking at a lynching. And w
looking at the lynching too. Again and again, a
mob looks back at us. Its members smile or po
prod the corpse, or they merely settle for lo
grim and purposeful. In one extraordinary ca
black man about to be lynched — a man n
Frank Embree, naked, bound and whipped

...eeding — looks back at us, beyond us too, challeng-
...g our moral imagination across the years.

This exhibition supplies knowledge of a fact
...at, though public, was still historically hidden.
...ese lynchings took place in public and were often
...mented by public men. These photographs were
...blicly taken, openly owned. They usually show a
...dy hanging in a public place — in a courthouse
...uare, from the largest tree in town, off a newly
...ilt bridge. They evince no shame and only the self-
...nsciousness the camera causes. But as a genre, a
...tegory of images, they had largely retreated from
...ght until now. They can be made public again only
...cause now we ask them to carry an utterly
...fferent meaning than they once did — an outcry
...ainst racism rather than a reinforcement of it.

It is too simple to say that in our time and on
...ese walls these photographs embody shame, be-
...use they do not. Again and again, a viewer looks to
...e what is in those white faces gathered beneath
...e naked feet of a hanging dead man who was
...deously innocent. It is mostly satisfaction. The
...ctims of these lynchings were killed out of race
...tred, out of loathing, out of blood lust. But ulti-
...ately they were killed out of false knowledge, out
... what a mob thought it knew about guilt and
...nocence, law and justice, white and black. That is
...e horror of these photographs. False knowledge
...ways seems so true at the time.

Iké Udé for *New York Times Magazine*, SoHo, New York, 1992

BOMB

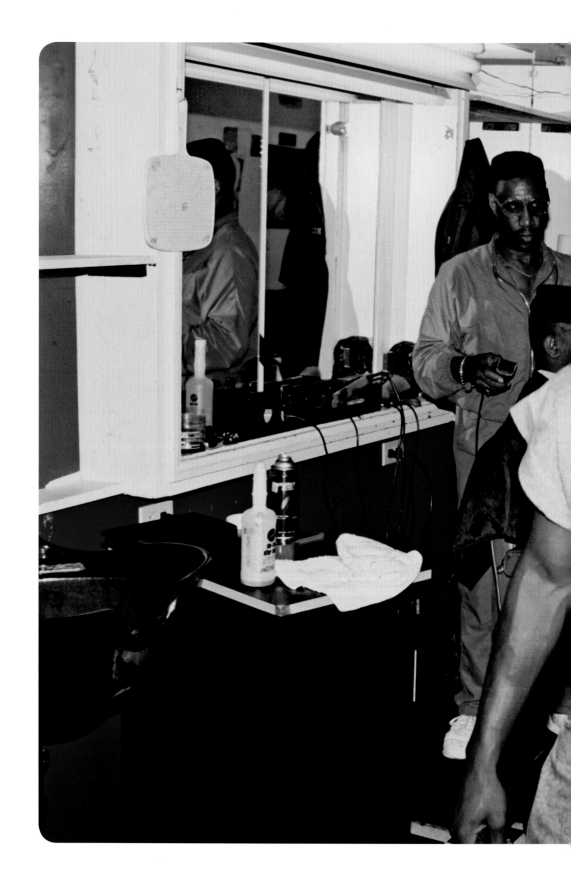

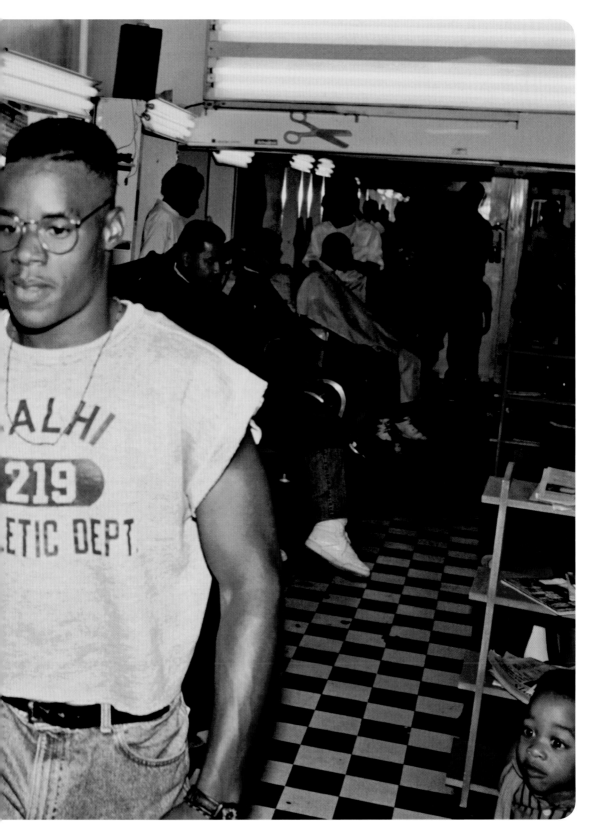

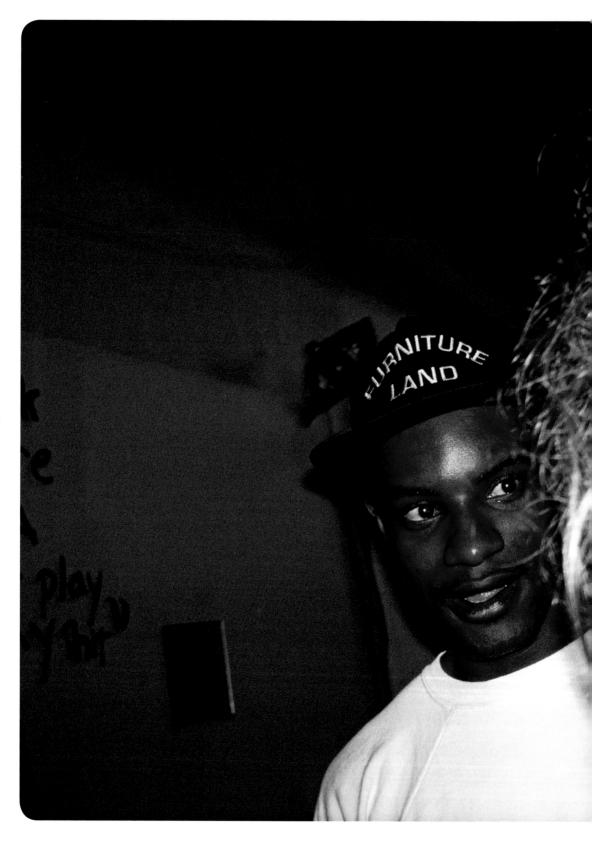

238

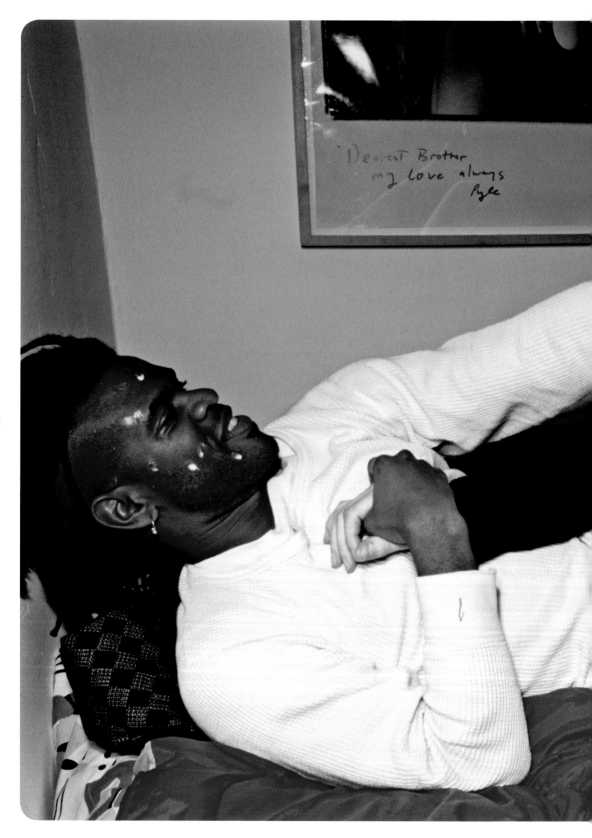

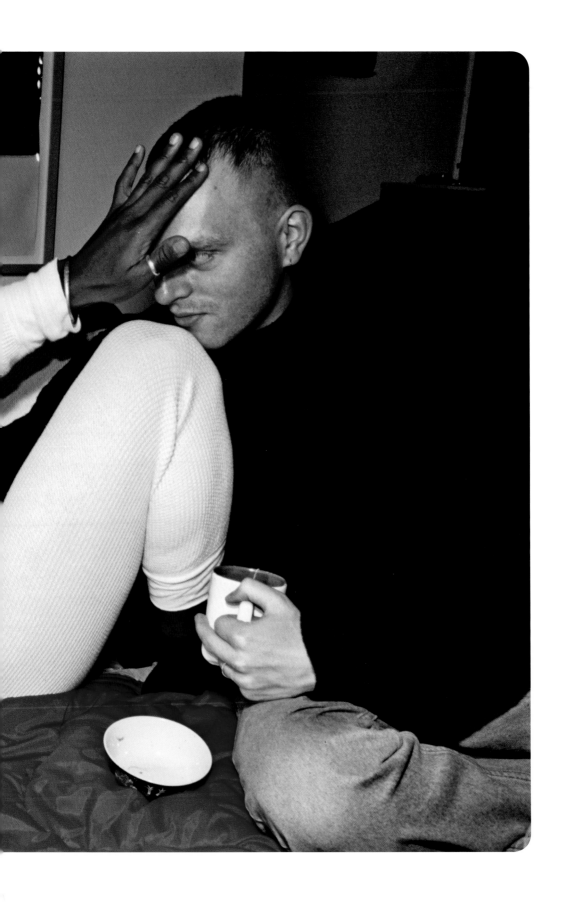

Thomas Allen Harris and Christopher Khurt, San Diego, mid-1990s

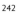

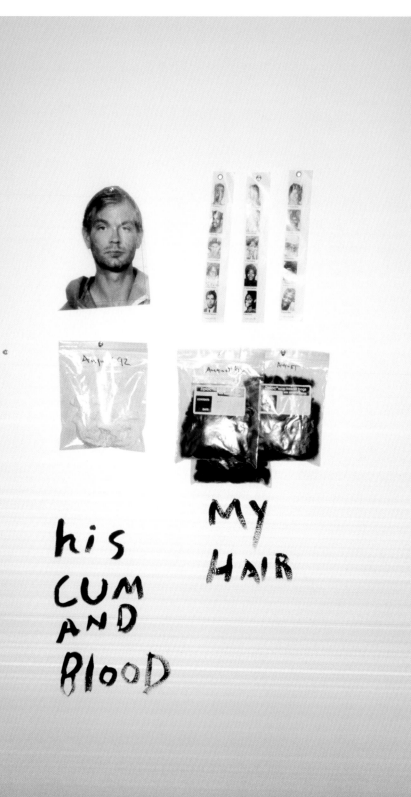

LEFT: Prelude to the *Watering Hole II*, Whitney Independent Study Program, New York, 1992 RIGHT: Self-portrait, Los Angeles, early 1990s

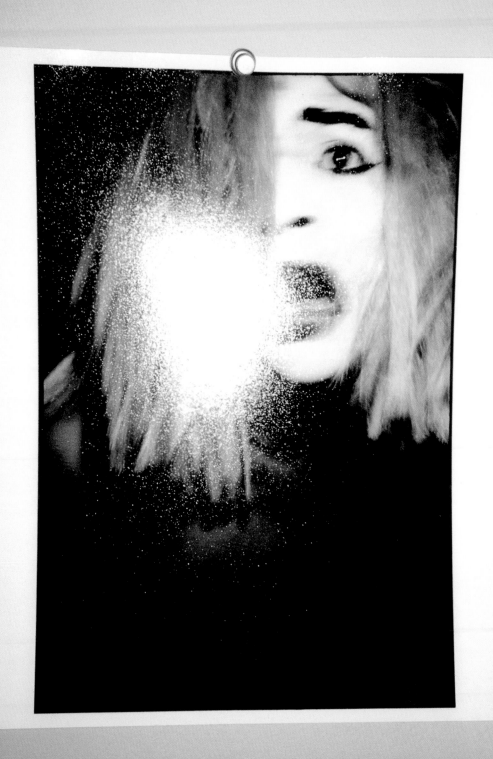

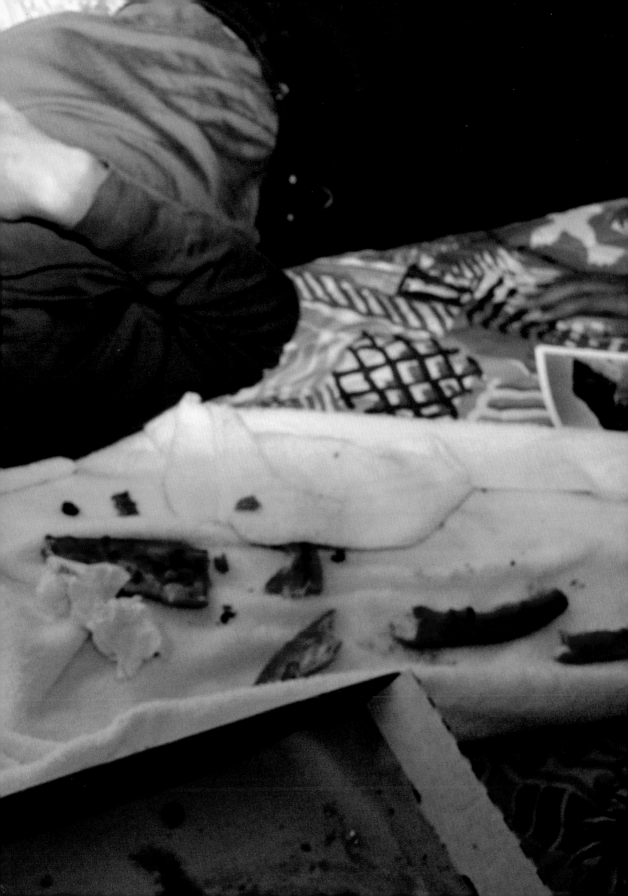

I LIKE PENTHOUSE PARTIES • THIS
IS MY LIFE • I WAS BORN THIS
WAY • I'M GONNA LET YOU KNOW
THAT I AM FOR REAL • I'M
GONNA LET YOU KNOW THAT I AM
FOR REAL • I'M GONNA GET BACK
TO YOU • I BELIEVE IT WILL GET
WORSE BEFORE IT GETS BETTER ? •
PUT SOME LOVE BACK IN YOUR/MY
HEART • OH, YOU MADE ME FUNNY •
YOU'LL GO TO HELL • IF YOUR MIND
LIES IN THE DEVIL'S WORKSHOP,
YOU'LL GO TO HELL • AS LONG AS
YOU'RE LIVING • THESE ARE TRYIN'
TIMES • IS THERE SOMEONE WHO
CARES ABOUT OUR SITUATION • WE
GOT TO LOOK SO DEEP • DON'T WAIT •
DON'T WAIT UNTIL YOU'RE SORRY •
DON'T WAIT UNTIL THERE'S NO ONE
THERE • WHAT IS HAPPENING TO
OUR FUTURE • WHERE IS OUR
FUTURE • WE'VE GOT TO SHOW

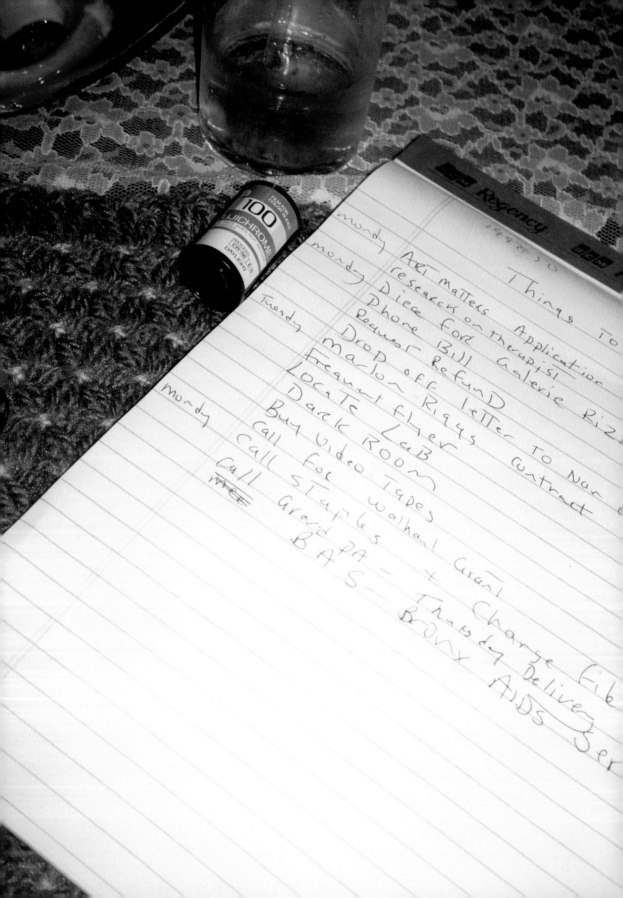

Things To

Mondy ART matters Application
Mondy research on therapist
 Diece for Galerie Riz
 Phone Bill
 Request Refund
 Drop off letter to Nan
 Marlon-Riggs Contract
 Frequent flyer
 Locate Lab
 Dark Room
 Buy video Tapes
 Call for Walhal Grant
 Call Staples + Charge Fil
 Call Grand PA - Thusday Deliven
 B A S - Bronx AIDS Ser

LEFT: To-do list, Seattle, 1992. RIGHT: Marlon taking pills (with Jack Vincent), Oakland, California, 1994
FOLLOWING SPREADS: Lyle by Tim Street-Porter, Santa Barbara, California, 1989 ❦ Redemption, Martha's Vineyard, early 1990s

251

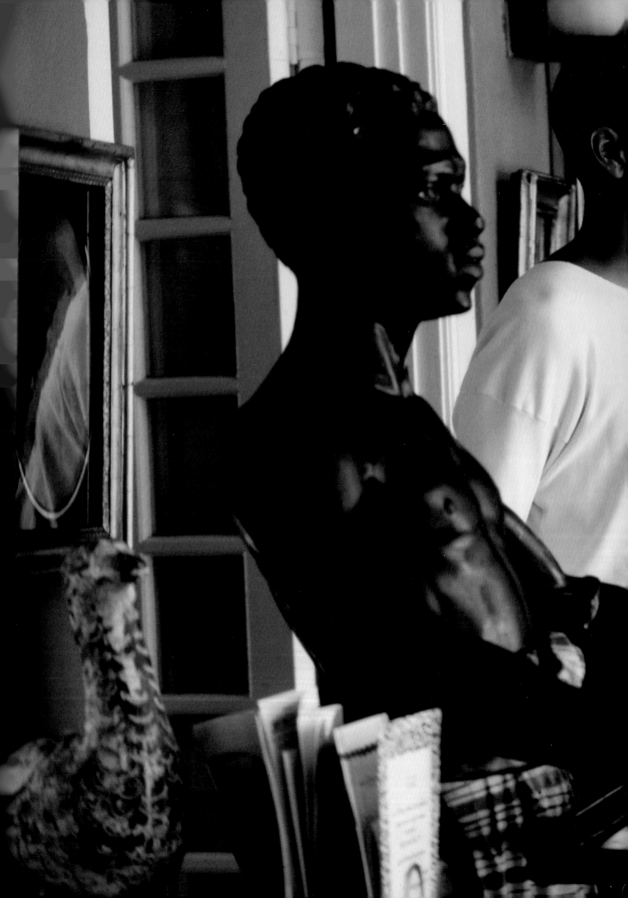

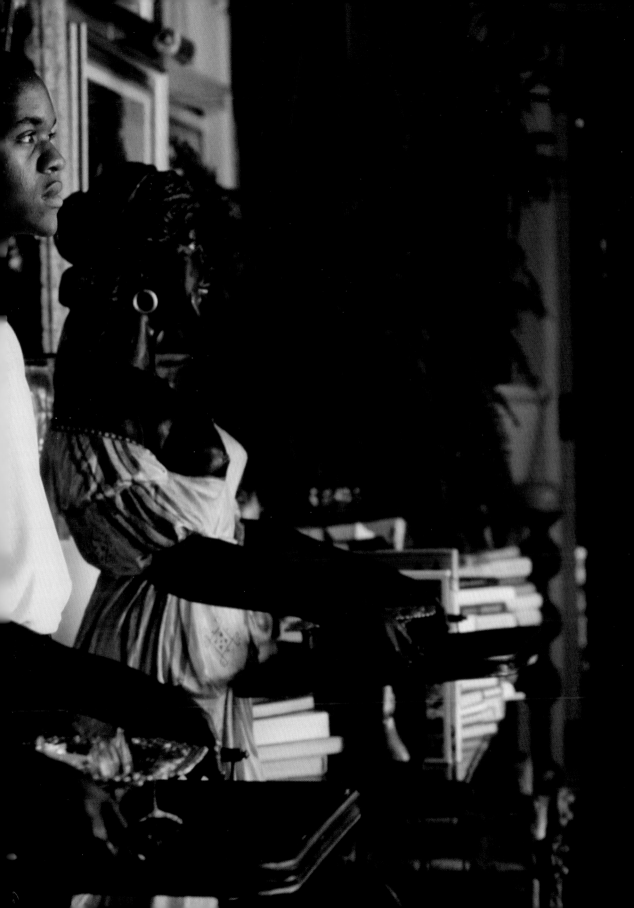

I am
a
collector

Early April

The Sovereign Contingency of Love
Ulrich Baer

What is the link between desire and time? Desire is the wish to enter fully into a moment by connecting with or possessing a desired object without the nagging awareness that everything we possess at some point we will lose. The fulfillment of desire, as Oscar Wilde's Dorian Gray and the Greek myth of Narcissus explore, aims to suspend time. To fulfill one's desire is then less about having this or that particular object, but about momentarily halting the flow of time that keeps us from ever being truly satisfied. That is why desire can be so powerful, and why it is also possible for humans to lose interest in a desired object as soon as they have obtained it. Desire is thus at once directly linked to our experience of time (the satisfaction of desire is experienced as the momentary suspension of time), and thwarted by time (we cannot hold on to the moment).

The practice of image-making can be another way of holding on to an object against the passage of time. Lyle Ashton Harris's *Ektachrome Archive* contains images that try to preserve people and places against the ravages of time. But in the context of Harris's work, the awareness of the passage of time is heightened by the fact that these images were taken when the AIDS pandemic changed desire, especially but not only what can be called gay desire, in the West. For someone like Harris, who came of age in the 1980s, coming out meant learning immediately that acting on one's desire could prove fatal. Making pictures of this moment meant for Harris to act on his desire via the camera, thus preserving some of the people and places that he intuited, and was taught through bitter experience, would disappear.

In art, the promise of suspending time has often been made via the portrait of a beautiful youth. Harris's images from the 1980s, some of which we would call queer today, are important because they preserve the joyful vibrancy and immediacy of people whose death we have not properly mourned. They were the first generation of truly politicized gay people in history who demanded their rights, needs, and wants be recognized, only to die in great numbers of a disease that mainstream society would not acknowledge or commit to fight. When one of my uncles died of AIDS in 1987, at age forty-four, several of his colleagues refused to shake my grandmother's hand at his funeral because his male partner was publicly acknowledged and his homosexuality, which they had known about for decades, thus publicly confirmed. It is hard to recall this level of hatred directed at a bereaved mother who is grieving for

her son. It is hard, not because we do not know that people can be cruel, but because it leaves us with the burden of completing the unfinished labor of mourning, while we also want to honor and preserve those lives.

Harris's images are the urtext for some of this work that remains to be done today. It is the work to honor lost lives, and not only to mourn. Gay and black activists in the 1980s demanded legal and political rights but they also demanded to be seen on their own terms. Many of the people pictured in the *Ektachrome Archive*—among them major writers, theorists, filmmakers, artists, and photographers—worked to create a new grammar and vocabulary for what it means to be American. Harris's *Archive* enacts this political and cultural work. In a beautiful chiaroscuro portrait taken against a dusky sky, framed by a window opening, Harris drinks in the open air with closed eyes. The picture shows him *imagining* (rather than seeing) what the present is and the future may be. As viewers we are allowed a peek at this private moment in which Harris hovers between looking beatific and sad.

Other images in the *Archive* are more blunt and confrontational. But like the moody portrait practically humming with silence, they *imagine* new identities and ways of being, and thus bring us into contact with a kind of social progress that had not yet been fully realized. In the wake of Diane Arbus, Nan Goldin, and also Garry Winogrand, Lee Friedlander, and others, Harris shows that being seen on one's own terms, in public, can be a political act. At their best, Harris's pictures open up a space where mainstream ways of looking —none of which have completely disappeared between the 1980s and today— are momentarily suspended. In these sly, provocative, and subtle images, Harris charts new and still precarious ways of presenting oneself. His insistence on visual presence is not self-indulgent but a mechanism of survival.

The *Ektachrome Archive* captures the impulse for these radical reimaginings of established identity, where heightened visibility becomes a sharp weapon in the struggle for political and social recognition. The pictures still pack a punch, confronting us with the gazes of individuals who escape the narrower frame that characterized Diane Arbus's work (which Susan Sontag famously critiqued as feeding off the tension between "the lacerating subject matter and their calm, matter-of-fact attentiveness"[1]). Rather than matter-of-fact, Harris's photography is engaged and invested. Arbus became one of the best-known photographers to explore the aspects of American life which mainstream society considered deviant. Harris rejected this approach. There is no normative, mainstream perspective against which he works; his images stage and capture rather the unapologetic assertion of an identity that no longer accepts being subjugated to a margin. It is tempting to describe this

identity more specifically, but such backward projections of contemporary labels, no matter how inclusive, miss the point. Harris's pictures open up a space where identities had few specific labels or names but were no less powerfully visible.

What turns Harris's work into something far more enduring and powerful than a political concern is the force of desire. Desire is at the heart of these images as an energy that cannot be exhausted even by political victories and recognition. It is desire not conceived of as lack but as a central driver of our actions to be more alive. "No one in love really believes love will end," writes Anne Carson in her 1986 book, *Eros the Bittersweet.*[2] I would like to hear the word *love* here, and apply it to Harris's work, in the sense used by the judge when speaking of Angela Davis: "Her behavior is explicable only by the fact that she was in love."[3] The judge meant to dismiss Davis's actions as deluded by love. But what if love, as Carson also writes, in the very different context of her analysis of desire in poetry, is in itself revolutionary? It's possible to say that Harris's pictures were made in the delirium of desire and love. It is the delirium that allowed him to see a reality that took another two decades to receive its names and concepts.

Only when you're not really in love can you conceive of an end to love. What we desire in another person is not only the satisfaction of our desires (which may happen) but the affirmation of our aliveness, which is the prolonging of desire through and against time.

Like love, photography's eternal present tense also preserves people and places against time's ravages of loss and forgetting. We look at photographs of people to get more than a simple confirmation that they existed. We look beyond the frame to a place where they mattered in what Roland Barthes called, in his 1980 *Camera Lucida*, "the absolute excellence of a being where body and soul are fused."[4] This "sovereign Contingency," in Barthes's formulation, is the condition where someone absolutely matters without reason or a need for justification.[5] It is an unapologetic mattering, strikingly exemplified in Harris's loving portrait of bell hooks. She is seen through the filters of radical love.

In the 1980s, critics largely dismissed Barthes's *Camera Lucida* as subjective, associative, and insufficiently rigorous. The book was fueled by a son's love for his mother, and by his melancholic musing that photographs preserve their referent against the passage of time. *Camera Lucida* refuses the fantasy that we will be remembered via our real or metaphoric offspring; it does not take the generational transmission of experience for granted. All of these points together made the book, simply put, too gay. It should not be difficult

to recall the hatred, indifference, suspicion, and scorn heaped on homo-sexuals in the 1980s, simply because much of it still rests close to the surface of today's embrace of queer identity as a chic label of tame protest. This context lets us see the radicality of Harris's work in the *Ektachrome Archive*. He pushed against a culture that privileged white, straight existence, but in nonconformist ways.

Harris's photography—not just the images that have become known as the *Ektachrome Archive*, but the work he created concurrent to the accumula-tion of those images—became a medium to represent gay desire at a moment when for many it had been driven back into a place of guilt, shame, and deadly fear by the AIDS crisis. If the 1970s had seen political advances for gay Ameri-cans, the 1980s returned a stigma to gay desire as immoral behavior since it now put others, if not the entire population, at fatal risk. Lyle Ashton Harris's *Ektachrome Archive* performs this eruption of private desire into the public sphere as the fullness of lived experience. In his irreverent deconstruction of conventional binaries such as public/private, personal/political, staged/accidental, and mundane/spectacular, Harris launches his viewers' desires to a place beyond the frame, where love is stronger than the passage of time. In a self-portrait with a handsome young waiter at a dinner held for the 1994 *Black Male* exhibition, Harris undermines the opposition of a deliberately staged, self-conscious performance of black identity and the mere facticity of someone's existence. Harris twice photographs the waiter; the second portrait includes another server from the event (pp. 214–15). Neither is part of the show titled *Black Male*. But as two black males who caught Harris's eye at an ancillary event, they are both inside and outside the art world which Harris challenges to examine its blind spots.

Love could not halt death, loss, or forgetting, just like the camera cannot really keep people near. And yet. Harris pressed the button on his camera to capture moments that were sometimes lived outside of the conventions of the majority, but represented them always in full view, and always as part of our human world. For over a decade, the slides silently informed Harris's work like a bag of precious seeds carefully stored away from life-giving water. With the exhibition of *Ektachrome Archive*, these images appear again before our eyes, coming into view against the flow of time that ultimately tries to pry everyone and everything from the memory of hearts and minds.

What is the link between desire and time? Without desire we don't live fully in time and perhaps even in fear of its passing. When filled with desire we dip into and are also strangely immune to the abyss of time, similar to those momentary fusions of ecstasy and loss opened up by photography's

eternal present. The image that appears from a larger sequence of pictures of *Sleeping boy, Bronx, New York*, late 1980s (pp. 144–45) is driven by this longing to be outside of time, to be as close as possible to the beloved for a moment from which he will never wake up, since it has been made eternal by the camera. Some of the individuals in the *Ektachrome Archive* fell prey to AIDS, others to the passage of time. Others are alive. Harris did not succumb to melancholia but turned the camera into an instrument of activism. He created images that tremble with potential—some of it realized in his or other photographers' and artists' projects, some yet unrealized.

1. Susan Sontag, *On Photography* (New York: Picador, 2001), p. 35. **2.** Anne Carson, *Eros the Bittersweet* (New York: Dalkey Archive Press, 1998). **3.** Quoted in Gilles Deleuze, "Capitalism and Desire," in *Desert Islands and Other Texts, 1953–1974* (Los Angeles and New York: Semiotext(e), 2004). **4.** Roland Barthes, *Camera Lucida: Reflections on Photography* (New York: Farrar, Straus & Giroux, 2010), translated by Richard Howard. Translation modified. **5.** Ibid.

4/13/89
Allan by Lyle

What Remains
Robert Reid-Pharr

In witnessing the breadth of Lyle Ashton Harris's *Ektachrome Archive*, I am confused. I waffle between sensations of regret, anger, fear, awe, gleefulness, and joy. How strange to see images of friends and heroes displayed in all their vibrancy while knowing well what sacrifices many of them made. Looking at these photos brings into focus some basic realities: in the wake of the most remarkable and enduring moments of progressive cultural and social upheaval, only some of us (the protected, the lucky, the timid) ever survive long and comfortably enough to experience nostalgia. The photos of the archive recall a time of remarkable action while also operating as indices of the unceasing culling of our most committed and gifted intellectuals and activists.

The social and cultural environment of the 1980s and 1990s is often remembered as a time of excess and despair, a period scarred by the twin scourges of the crack and AIDS epidemics. It was a time when African American and LGBTQ communities regularly sustained calamities and defeats, while much of the rest of the country looked on with hostility and indifference. Ours was the generation that came of age in the wake of Ronald Reagan's election to the presidency in 1980 and the subsequent, angry lurching turn to the right that has structured American politics and public discourse ever since. We were the heirs of the Civil Rights, Black Power, Women's, Gay Liberation, Anti-Colonial, and Labor Movements of the fifties, sixties, and seventies, the very children whom a hesitant America reluctantly vowed to judge by the content of our characters. As young adults, however, we encountered a world in which the liberal rhetoric of American openness and fair-mindedness never squared with the lived reality of our lives, and in which the conceptual tools available to us—the apparatuses bequeathed by our forebears to confront silence, exploitation, and erasure—seemed somehow inadequate.

Yet, even in the face of the daily loss and defeat that many of us faced, we also witnessed perhaps one of the twentieth century's greatest periods of cultural renaissance. Not only was there a grand flourishing of work by Black LGBTQ individuals (Barbara Smith, Essex Hemphill, Assotto Saint, Samuel R. Delany, Cheryl Clarke, Cheryl Dunye, Jewelle Gomez, Marlon Riggs, Isaac Julien, and Lyle Ashton Harris, among many others); we were also actively constructing and utilizing new conceptual tools to examine and appreciate ourselves, our communities, and the larger world. An entire generation of progressive intellectuals turned to the work of Black lesbian and feminist

activists and intellectuals—Audre Lorde, Michele Wallace, Pat Parker, Michelle Parkerson, bell hooks, and others—in an effort to gain new ways of naming the complexity of identity, politics, and affect. We attempted to recognize ourselves as diasporic subjects, returned with gusto to the fundamental works of Frantz Fanon, and found ourselves enraptured by the theorist of diaspora Paul Gilroy, whose magisterial 1994 work, *The Black Atlantic*, helped define the critical standards of our generation. We also worked to make plain some of the complex combinations of race, gender, and sexuality, creating ever-more elaborate articulations of legal theorist Kimberlé Crenshaw's concept of intersectionality.

Here, however, is where the story gets difficult, and the narrative messy. One of my favorite images in this archive is of the great Stuart Hall, often regarded as the founder of Black British cultural studies and one of the finest minds of his generation. Looking at the photograph of Hall—leaning on a chair, his Oxford shirt open at the collar, a gold chain dangling from his neck, gazing with hooded eyes at the filmmaker Isaac Julien—I find myself surprised, startled really, by the memory of how sexy I once found him (p. 137). In the many acts of official mourning that followed his death in February 2014, there was much ado about both his intellect and his unwavering commitment to progressive politics. What I missed, however, was acknowledgment of the fact that he was also kind and funny, stylish and hot, heroic and flawed. Perhaps this is just another way of saying that the price for achieving institutional success is a sort of necessary flattening of both emotion and style. We give to the coming generations two-dimensional representations of the movements we helped to create. The taste, the smell, and the heat are lost.

Some of Harris's most evocative images were taken at public events. They demonstrate how cultural institutions became key sites for the articulation of novel arrangements of identity and community. It is vital to remember that these events, even as they helped open the way for fresh modes of politics, criticism, and art-making, were also spaces in which new forms of discipline and fresh types of hierarchy were introduced and rehearsed. They helped us not only to generate novel conceptions of progressive community, but also effective styles of myth making and pretense.

In the fall of 1991, the feminist cultural critic Michele Wallace organized the famed *Black Popular Culture* conference at the Dia Center for the Arts in Manhattan. It was a one-of-a-kind event that drew together—and named—a self-consciously progressive, contemporary Black intellectual elite: Cornel West, Valerie Smith, Henry Louis Gates Jr., Lisa Kennedy, Houston A. Baker, Hazel Carby, Tricia Rose, Greg Tate, Arthur Jafa, Coco Fusco, Manthia Diawara,

Manning Marable, and Paul Gilroy were all in attendance. The sessions brought both new rigor and new flexibility to the increasingly prominent field of Black cultural studies while also announcing a staunch rejection of the many masculinist, homophobic, and heterosexist tendencies within Black political and cultural production.

Again, however, there is the question of what remains unsaid, of what could not be adequately represented even within the conference's companion volume *Black Popular Culture*, edited by Gina Dent and published by the Bay Press in 1993. As one can imagine, the messiness of human interaction was very much on display at the event. Interspersed with many moments of genius were also moments of ridicule, recrimination, and tearfulness. We understood that we were in the process not only of naming the complexity of the social and cultural movements in which we participated, but also of ratifying the ascendency of a new elite. Here I am reminded of Hortense Spillers's trenchant analysis of both the conference and the edited volume. Spillers argues that even though the event was designed to overcome the troubled masculinity of earlier generations of black intellectuals, it was nonetheless inaugurated by one great Black father, Stuart Hall, who was followed by another, Cornel West. Spillers reports that both the conference and the accompanying volume possessed "an overwhelming maleness of tone and appeal" buffeted by undertones of "the male ego-investment and . . . panicked vulgar bullying that silenced quite a few of us black intellectuals, especially the women . . . during the late '60s and early '70s."[1] That is to say, the conference's radicalism was underwritten by a sort of capitulation to the (Black intellectual) status quo.

These questions of respectability and institutionalization were also very much on display at the March 1995 *Black Nations/Queer Nations?* conference in which hundreds of Black LGBTQ activists and intellectuals gathered at the Graduate Center of the City University of New York to hear Urvashi Vaid, Barbara Smith, Kobena Mercer, M. Jacqui Alexander, Simon Gikandi, Essex Hemphill, Samuel R. Delany, and many others discuss the future of Black queer life and identity. Again, the focus was on complexity and multiplicity. Not only did the speakers come from the United States, the United Kingdom, South Africa, the Caribbean, and elsewhere, but the very title of the occasion—the plurality of the word *nations*, the slash at once separating and binding the concepts of "Black" and "queer," and especially the unsettling question mark at the end—pointed to a spirit of probing and questioning that suffused the remarkable gathering as well as the entire Black avant-garde cultural scene.

What unsettles me, however, is that I cannot easily separate my recollection of this conference from tender and precious memories of poet/activist/performer Essex Hemphill, one of the main speakers and easily one of the most gifted Black gay intellectuals of his era. The fact that Essex died of AIDS only eight months after the close of the event pushes me toward a vexed appraisal of the presumed gains, both cultural and political, that came out of that historic moment. It is stunning to find more than twenty years later that Essex's comments touched precisely on the questions of race, gender, sexuality, and representation with which we are still so concerned:

> I stand at the threshold of cyberspace and wonder, is it possible that I am unwelcome here too? Will I be allowed to construct a virtual reality that empowers me? Can invisible men see their own reflection? . . . As always, I am rewarded accordingly when I fulfill racist fictions of my aberrant masculinity. My primary public characteristics continue to be defined by dreads of me; myths about me; and plain old homegrown contempt.[2]

It is simple enough for us to understand Hemphill's basic claims, his belief that long-established white-supremacist protocols are hardly relaxed when the platforms are updated. Whether digital or analog, the loathing and disrespect accorded to Black individuals and communities remain the same.

What I suspect is more difficult to understand is that all of us participate in the continuation of these inelegant and pernicious modes of imaging race, gender, sex, and sexuality. Our regard for the past, our techniques for looking and remembering, are not simply forms of celebration and rejuvenation but also forms of policing and control. Our poets' voices might be heard and their images reproduced, but even these celebratory and recuperative actions are established by and within well-established protocols of myth, contempt, and dread. Harris's own photographs of Hemphill expose the remarkable poise and courage that he offered us. What spoils these images, however, is the knowledge that the valor we see in Essex's generous face is supported and framed by the fact that there are no images of the man in middle age. The beauty on display is at once a mark of promise and a record of defeat.

My point here is not so much to undress heroes as to remind us that memory making is always a profoundly messy—and deeply politicized—process. One of the most surprising things that one confronts when considering the recent history of race, gender, sexuality, and representation is just how little structural change has taken place over the last three decades. In 1994, the Whitney Museum of American Art made history when it mounted the wildly

influential exhibition *Black Male: Representations of Masculinity in Contemporary American Art.* Curated by Thelma Golden, the exhibition featured twenty-nine extraordinary individuals whose works examined the iconic nature of Black masculinity in American culture. Participants included David Hammons, Robert Mapplethorpe, Pat Ward Williams, Jean-Michel Basquiat, Andres Serrano, Gary Simmons, Robert Colescott, Adrian Piper, Carrie Mae Weems, Lorna Simpson, and of course, Lyle Ashton Harris. The sheer scale of the show was a surprise to its audiences. The range of works and artists on display sought to bury antique and overwrought ideas of Black male identity in favor of truly complex depictions of Black form, style, affect, and personality.

Considering the *Black Male* show in the long arc of representations of Blackness within modern visual culture, one is immediately forced to examine the exhibition in relation to the various controversies surrounding race and gender that have dogged the Whitney Museum in recent years. During its 2014 biennial, the museum announced the participation of nine African American artists among the 103 included in the event. One of the names listed was Donelle Woolford, a "black" character created by the white artist Joe Scanlan, portrayed by two female African American actors, Jenn Kidwell and Abigail Ramsay. The ensuing critique, the charge that the Whitney—and much of the mainstream "white" art establishment—were insensitive to and biased against African Americans was both swift and fierce. The museum countered that "the Whitney Biennial has always been a site for debate—no matter how contentious or difficult—of the most important issues confronting our culture."[3]

True to their word, yet another race controversy was sparked in the 2017 biennial with the inclusion of *Open Casket* (2016), a painting by the white artist Dana Schutz, depicting the mutilated face of Emmett Till, a fourteen-year-old African American lynched in Mississippi in 1955 for allegedly whistling at a white female store clerk. The photographs on which Schutz based her painting were taken during Till's funeral service. His casket was left open at the request of his mother, Mamie Till, who wanted her son's mutilation to be seen and noted. The images taken at the service were eventually published in the African American periodical *Jet.* They proved singularly important in galvanizing Black resistance to segregation and white supremacy. Till is considered a martyr of the movement and his visage is understood to be precious. It should have come as no surprise that on the first day of the exhibition, Parker Bright, an African American male artist wearing a T-shirt with the message "Black Death Spectacle" written on it, stood in front of the *Open Casket* painting for hours, partially blocking it from view and provoking a heated debate about racial representation and artistic license.

What Bright was doing—or at least what he thought he was doing—was stopping the desecration of a relic. Indeed, his action remarked on a strange slippage in the iconography surrounding Black people. The message at the heart of Till's mother's demonstration of her son's desecrated body was: our people will have their freedom and their voice. The message at the heart of Schutz's reframing of the image was more complicated. It said, all at once: look at this history of suffering. It is a history that all of us, black and otherwise, share. It is, moreover, a history that reshaped, repackaged, and perhaps monetized can be made valuable again.

The photographs presented by Lyle Ashton Harris in his *Ektachrome Archive* operate on exactly this treacherous cultural/historical/ideological/ political terrain. I began this essay by noting my confusion as I witnessed the images. They document many moments of community, struggle, radicalism, hope, and joy that continue to be precious to me. They bring me comfort, if not exactly peace. They also remind me of the nature of damage and forfeiture. Not only do they trouble that sensitive, not-quite-healed space left in me by the loss of friends and heroes—Essex Hemphill, Audre Lorde, Pat Parker, Marlon Riggs, Assotto Saint, Melvin Dixon, Barbara Christian, Donald Woods, and Stuart Hall, among many others—but also, as with Schutz's reimaging of Emmett Till's tortured body, they force one to consider closely the politics of our image management, the ethics of our remembering.

The archive that Harris has passionately built is a remarkably intimate portrait of a progressive intellectual class in the act of coming to recognize itself. Harris's achievement is that he assembled such an extensive and compelling record of a key moment of cultural and social renewal, consciously or not. One wonders, if he was aware of just how fragile that moment would prove to be. As we delighted in the flowering of youth, we were confronted with the harshest and most unforgiving reminders of frailty and mortality. Those of us invited to experience the images in this archive are thus asked to attend to the call for both celebration and mourning. We must endeavor at all cost to avoid the trap of sentimentalism. The quite palpable fear that one's friends and loved ones might disappear is as alive now as it was in 1990. We must learn, therefore, to use these documents as vibrant and necessary tools in our contemporary debates and struggles, around not only gender, race, class, and sexuality, but also religion, place of origin, language, and legal status.

The archive offers no real instruction in how to separate exultation from lamentation, no prepackaged cheerfulness, no sanitized messages of hope and nobility. What Lyle Ashton Harris invites us to do is to help create new

and innovative forms of ceremony. We must continue to struggle assiduously against the tendency to forget or to romanticize our recent past. The struggles that secured our limited rights and freedoms were always dynamic. They were not designed simply to ensure our institutionalization, to make us more content and pliable subjects of government and industry. Our efforts are intended first and foremost to encourage our survival, to keep as many of us alive and well as possible. Perhaps just as importantly, however, our art and activism were part of a messy process of announcing new modes of identity: messy because we never know when—or how—to stop.

1. Hortense Spillers, review of *Black Popular Culture*, by Michele Wallace and edited by Gina Dent, *Black Macho and the Myth of the Superwoman*, by Michele Wallace, and *Invisibility Blues*, by Michele Wallace, *African American Review* 29, no. 1 (Spring 1995): p. 126. **2.** Quoted in Jafari Sinclaire Allen, "A Picture's Worth: Toward Theorizing a Black Queer Gaze in the Internet 'Pornutopia,'" *Nka Journal of Contemporary African Art* 2016, no. 38–39 (2016): 98. **3.** For more on this controversy, see Caroline A. Miranda, "Art and Race at the Whitney: Rethinking the Donelle Woolford Debate," *Los Angeles Times*, June 17, 2014, http://www.latimes.com/entertainment/arts/miranda/la-et-cam-donelle-woolford-controversy-whitney-biennial-20140609-column.html.

3/26/89 - My brilliant, talented nephew
Lyle - You will be famous and
recognized and <u>wealthy</u> some
day - Love Aunt Shirley

In Conversation
Thomas Allen Harris and Lyle Ashton Harris

Thomas Allen Harris: *Typically one thinks of a family album as reflecting a community of people that are genetically related to one another. The intersecting communities portrayed in this book and throughout your* Ektachrome Archive *project are open to other kinds of relations beyond the strictly familial—networks of relationships, ones that have more in common with our grandparents' church community or the many close friends reflected in the hundreds of photographs taken by our grandfather, Albert Sidney Johnson Jr., the extended family of our childhood.*

Lyle Ashton Harris: You know that our grandfather began shooting Ektachrome slide film as early as the 1940s, to document life with his "Tulip Bud," our grandmother Joella, which revolved around the historic Bethel AME Church in Harlem, where they were married in 1932. We've inherited over ten thousand of his slides as well as Super 8 films that document several generations of the Johnson family who've grown up in that church, where for almost forty years he was treasurer and Grandma served as the leader of the young people's department of the church's Missionary Society.

Thomas: *Our grandfather always took photographs to document special occasions, such as Easter or Christmas, or family gatherings when everyone looked their best. But he wasn't a snapshot photographer. There was always an element of performativity involved, and we became quite familiar with the ritual of being photographed by him. It wasn't over until he got the perfect shot. A lot of the people portrayed in his photographs were not genetically related to us— friends of our grandparents from the Bethel AME Church with whom they had a spiritual connection—many that we didn't know personally. In that sense he created his own kind of family album consisting of those who had mentored him as well as the generations that followed. I feel like a similar idea is also at play in the* Ektachrome Archive.

Lyle: It's clearly about documenting community. Among our family's next generation, there was our stepfather, Pule Leinaeng, whom our mother met just before we moved to Tanzania. He was a serious amateur photographer interested in framing his experience of the world through images. As a member of the African National Congress in exile, he left South Africa to

avoid imprisonment, which you explore in your film *Twelve Disciples of Nelson Mandela* [2005]. Both he and our mother were very much involved in the South African liberation struggle and the Pan-Africanist community. There would be as many as forty people visiting our house regularly almost every weekend. I can recognize an extension of this sensibility in the *Ektachrome Archive*, with its photographs of our immediate family members—you, our mother, our cousins Alex and Peggy—along with close friends, colleagues, and many others. It's actually a very queer reading that transgressively expands the notion of family, visually documenting a diversity of relationship modalities in dialogue with more traditional African American understandings of extended family and community.

Thomas: *There's also a degree to which a queer reading of family isn't so much about who you're partnered with or sleeping with as it is about the creation of a counter-narrative to the patriarchal model of the nuclear family. In terms of the* Ektachrome Archive, *many communities that would not necessarily mix are represented there, intersecting through you, through your body—lovers/intimates, hang-out buddies, professional colleagues. The* Archive *documents an assemblage of different groupings spanning a particular period of time.*

Lyle: It actually starts from a highly personal entry point, a very private place. The earliest image in the *Archive* is probably a 1987 photograph of a boyfriend I met at the New York nightclub Area, while I was a junior at Wesleyan. I had just returned from visiting you in Amsterdam, where I first read about the artist Andres Serrano in a Dutch magazine and discovered Allan Sekula's seminal publication *Photography Against the Grain* [1984]. Around that same time I also met and befriended Renée Cox, who had been shooting a commercial photography job for *Essence* magazine, where I was interning.

My own photographic practice took off when I attended grad school at CalArts in 1989. Initially I had difficulty with the art theoretical discourse, which I found alienating in terms of my own experiences. I had never been exposed to a theoretical vocabulary used to engage issues around the body, identity, and sexuality. In the first semester I attended a one-week workshop with bell hooks based on her book *Talking Back* [1989], which changed my life. Working with bell irrevocably changed my way of thinking and really helped me become more comfortable speaking in my own voice, empowering me to be able to talk back. I began to engage in more extensive diaristic photo-documentation and explore discursive strategies in image production, with

the encouragement of Catherine Lord, who was then dean of the art school, as well as professors such as filmmaker John Greyson, photographer Allan Sekula, and photographer John Divola, who advised me not to become just another MFA grad with lots of theory.

Thomas: *Throughout your artistic career you've worked collaboratively in various ways, but you've developed a unique partnership over the years with Tommy Gear, which has continued since your time at CalArts.*

Lyle: The period reflected in the *Ektachrome Archive* covers the beginnings of our close friendship and longtime partnership; it follows our romantic relationship, our travels in Europe, and our subsequent "break-up" period. He has clearly been a muse, but also a lover, a friend, a confidant, a teacher—someone who knows me intimately on a cellular level. There are few people who really know me that way. After we initially became lovers in the traditional sense, I began to realize how limiting the term *lover* is; we eventually became soul mates in the truest sense, each able to bear witness for the other. My home in LA with Tommy Gear was a welcoming space where new friends like Marlon Riggs, bell hooks, and Essex Hemphill would visit and commune. I photographed them here and got to know them intimately. The *Archive* and this book include photos from the earliest period of our relationship. Today our relationship is very different. Our close work together in developing the recent installations of the *Ektachrome Archive*, first at the 32nd São Paulo Bienal and then at the Whitney Biennial in 2017, speaks to our deep, ongoing connection.

On my eventual return to New York in 1992 to attend the Whitney ISP [Independent Study Program], I befriended many up-and-coming artists of my generation, like Dread Scott and the late Michael Richards, who we lost on 9/11, both of whom are represented here [p. 69 and p. 231, respectively]. There are also several candid shots documenting milestone cultural events that took place in the 1990s, including the *Black Popular Culture* conference [1991], the *Black Male* exhibition at the Whitney Museum [1994], and the *Black Nations/Queer Nations?* conference [1995]. These images, whose composition often suggests mirroring, speak to my subjective experience at that time, as a young, out, queer, African American guy, coming into direct contact with contemporary cultural theory among the Black, transatlantic academic community. All of my work privileges subjectivity, as opposed to thinking that one's personal experience, one's subjectivity, can be left in the margins. In actuality, personal subjectivity is central, and it's

informed by, and in turn informs, intellectual discourse in the public sphere—each represents interdependent tracks that sometimes collide, sometimes coincide.

I continued shooting Ektachrome film extensively until 2000, when I resumed shooting 35 mm black-and-white film to document the culture of Italian soccer as a Fellow at the American Academy in Rome.

Thomas: *Seeing the images in the* Ektachrome Archive *through your particular lens, even people who were not actually connected become connected, even though these photos were shot at a time before social media as we know it today. Your* Archive *brings together different people across diverse spaces— formal public spaces as well as very personal spaces—art world spaces, academic spaces, spiritual spaces, and erotic spaces.*

In many images I see a figure—you as a young artist, who is exploring different spaces and roles. Your presence in these spaces feels very organic. Looking back now, who is this person we see depicted?

Lyle: I guess it portrays me at different phases in my life, but I don't really see myself, per se. It's more as if the images themselves serve as witnesses to a particular time. Rather than being about self-portraits or "selfies," it's about the idea of documenting a particular figure at a particular time, which was important for me because I didn't often find myself portrayed in conventional representations. It was a way to frame myself in relation to historical and cultural narratives. I remember being a voracious reader, yet I did not see myself represented; there was a serious dearth of Black queer subjects at that time. There was a desire to find that subject position, which was absent from most liberal, left-leaning cultural discourse, as well as the desire to lay claim to a space of greater visibility and agency. Searching for that mirror became a perpetual longing for my reflection.

Thomas: *In some ways, these images are your self-reflection.*

Lyle: In a certain sense. It's one thing to exist in the flesh; it's another thing to exist in representation, to use photography to claim a space within the field of visuality. I somehow understood the importance—maybe inherited from our grandfather—of laying a claim to representation by making images and putting them into circulation. There's also a sense that my image may have been too much for some people at that time—too queer, too Black. Many of the photographs in the *Archive* portray people mirroring one another

in various ways, discovering multiple points of resonance to empower one another. And those people were able to mirror me in the same way: "I see you, I recognize you for who you are. Go for it!"

Thomas: *This book documents a very fluid time and space in the early 1990s, which at that moment felt like a renaissance; historic shifts were occurring cultur-ally that impacted individual psyches. It was a time of major cultural interventions, both theoretically and practically, from journalism to critical theory to art. There was an air of excitement as well as a sense of urgency and activism, especially due to the impact of the HIV/AIDS pandemic, a plague time with many people dying.*

Lyle: Yes. The *Archive* also contains images of Marlon Riggs with his mother and grandmother [pp. 232–33], photographed near the end of his life, which offer a counter-narrative to the stereotypical portrayal of Black gay men dying of AIDS all alone. In actuality, those photographs from the early 1990s bear witness to a space of caring and community that cuts across several generations.

Thomas: *I can recall certain moments, after having had casual sex with a hook-up, when you can hug, see one another and be seen—that's the moment I was actually looking for, as opposed to merely connecting for a sexual transaction. Seen as a kind of queer family album, your* Archive *also captures a time of community and sensuality.*

Lyle: Despite the specter of AIDS, there was also the need to find and sustain pleasure and joy in life. Many of the images capture the pleasure of just looking at someone. I often felt energized by the prospect of seduction, which motivated me to engage with people. The images capture the sensual-ity of those engagements.

Thomas: *Photographing people also sometimes got you into trouble, espe-cially when making private images public. While many of the images in your* Archive *capture people in vulnerable moments, it also conveys an overall sense of respect for the subjects you've photographed.*

Lyle: I've come to understand that I, too, was looking for tenderness, as well as a way to capture those often brief, ephemeral moments of intimacy. Photography offered me a way to document those moments of tenderness. I agree that sex can often be transactional, especially given the way it gets

marketed or the way Black bodies have been consumed historically. But whether it's in the realm of the erotic or the personal, I wanted to make sure that Black desire was being articulated and visualized. An example is *Sleeping boy* [pp. 144–45], a young, cute guy that I met outside a club who needed a place to sleep for the night. I thought we were going to have sex, but he was exhausted. The photographs of him record that particular fleeting moment.

The early 1990s was also a time when New York City could be very dangerous. Several of the photographs speak to that complicated ambivalence in moments when you realize that the situation you're in could potentially lead to death, which my personal journals from that period certainly reflect. In contrast to the photographs, the journals offer a discursive series of reflections, recording my thoughts and impressions of those moments. They also include things like tear sheets of hustler sex ads from gay rags, or news clippings about Jeffrey Dahmer, or exhibition announcements from museum visits, or Polaroids chronicling my personal altars over time. The various elements scattered throughout the pages of my journals produce a frottage, a tension that's been essential in the *Archive*'s formation.

Thomas: *The frottage you mention is exemplified by the image of M. Lamar; it's a candid photograph of various men negotiating the space of a public restroom at the Yerba Buena Center in San Francisco [pp. 90–91]. It's not the kind of social situation that is typically portrayed in a documentary context or in Black cultural production, a notable exception being Alvin Baltrop's photo-documentation of the New York piers in the 1970s.*

Lyle: This type of subject matter was often considered inappropriate for public consumption. Even today, there's a way in which African American culture can be quite conservative in this regard. Recent generations have come to embrace inclusion of this type of work as part of the public archive. I'm all about coming out of the shadows and shedding light as a subversive strategy.

Thomas: *Let's get back to some of the key public events that you mentioned earlier, in particular the* Black Popular Culture *conference, which represented a real thrust to embrace the personal as political. Images of Anita Hill and Justice Clarence Thomas were actually featured on the printed poster for the conference, which was taking place in New York at the same time Anita Hill's testimony was broadcast on national television from the Senate floor in Washington, DC,*

describing in detail the ways that Clarence Thomas had sexually harassed her. Dialogues were raging throughout the Black community concerning what should and shouldn't be discussed publicly, which images should be visualized and which ones shouldn't be made public.

Lyle: But it was also about who is empowered to talk back. Arriving at the *Black Popular Culture* conference on the heels of finishing my MFA at CalArts, I immediately sensed that there was something historically significant going on, and I felt compelled to get involved. I think the reason I photographed that event goes back again to our grandfather, who showed us the power of the visual image in relation to the construction of one's self, family, and lineage—how to create community visually, which also serves as documentation for the historical record. Photography also offered me a form of mediation, a way to negotiate that public space through the camera lens, resulting in a visual analog of my voice.

Thomas: *Hosted by the Dia Center for the Arts and the Studio Museum in Harlem, that three-day conference attracted a diverse audience with hundreds of people in attendance—artists, academics, activists—and served as a point of intervention for progressive Black intellectuals and cultural producers to harvest seeds planted during the civil rights movement. There was the brilliance of Michele Wallace, author of* Black Macho and the Myth of the Superwoman *[1978], who organized the conference as a real political statement, bringing people together in a way that served as a cultural call to action around Black diasporic identity, exemplified in the work of John Akomfrah, Coco Fusco, Stuart Hall, and Isaac Julien, among other event presenters. There were filmmakers like [Marlon] Riggs, whose* Tongues Untied *[1989]—and Julien, whose* Looking for Langston *[1989]—represented major interventions in putting Black, gay, male subjectivity front and center. And given the continuing HIV/AIDS pandemic, many Black filmmakers found ourselves having to negotiate between the mainstream culture and the African American church, on the one hand, and the white LGBT community and predominantly white filmmaking community on the other hand.*

Lyle: In a way, it was the first time that left-wing liberals were being challenged by the intersectionality of race, sexual difference, and postcolonial theory—the decentering of whiteness. Earlier this year I was invited to take part in the Smithsonian's HIV/AIDS oral history archive project, which allowed me to delve into private moments lived twenty years ago, sharing

remembrances of my friendships with Marlon Riggs and Essex Hemphill, especially their impact on my development of a public voice about being Black, queer, and HIV-positive, as well as coming to terms with self-acceptance around recovery.

Thomas: *The photographs you shot at the* Black Popular Culture *conference remind me of the amazing range of people who participated, including Douglas Crimp, Angela Davis, Henry Louis Gates Jr., Paul Gilroy, and Faith Ringgold [pp. 110–19]. I recall that many conversations among audience members at the conference spilled out into the streets and into nearby cafés. New connections were forming, people were engaging issues in a different way. It was a landmark sociohistorical event that still reverberates today.*

Lyle: At the same time you had been working as a producer at WNET/ Thirteen in New York, developing public affairs television programming that featured contemporary cultural figures.

Thomas: *I was creating shows that highlighted the work of artists, activists, and intellectuals such as Gordon Parks, Karen Finley, and David Wojnarowicz, among others. I was also just starting work on my first feature documentary,* Vintage—Families of Value *[1995], that we collaborated on, which explores queerness and community in the context of three families, including three queer women, sharing the same mother with different fathers, who as mothers themselves were creating an expanded notion of family. In contrast to much of contemporary queer theory, that film was very much grounded in African American traditions of extended family, although a queer sensibility is clearly reflected in the film and remains a definite influence.*

Lyle: It was a time of major shifts taking place in thinking around Black culture—that it was *culture*—that would engender a field of research beyond anyone's particular identity. I think it may have been the first time that Black culture received serious consideration by critical theorists working in the mainstream US academy and in the discourse of contemporary art. The voices of Black, public intellectuals were getting heard and being covered internationally.

Thomas: *It's also clear to me the extent to which your* Archive *project resonates with contemporary documentary films, such as Ava DuVernay's* 13th *[2016] and Raoul Peck's* I Am Not Your Negro *[2016].*

Lyle: Definitely. Perhaps one of the major reasons the *Ektachrome Archive* is attracting so much interest at the present time is that it helps bring to light the systemic cultural and political amnesia that has taken place over the past few decades. Recently over lunch, the cultural critic and historian Tavia Nyong'o acknowledged the level of cultural amnesia that's also prevalent among queer communities, which makes the *Ektachrome Archive* particularly significant now. For example, he reported that at a recent conference attended by about a hundred queer people, only four knew who Marlon Riggs was. Given the seemingly full embrace of trans culture today, there exists a "colonialism of the present" that excludes certain Black diasporic communities as well as more radical thinkers such as Riggs. This is a significant concern that the *Ektachrome Archive* engages, along with other recent projects such as your film *Through a Lens Darkly: Black Photographers and the Emergence of a People* [2014]; Carrie Mae Weems's *LIVE: Talks and Conversations* [2014], held at the Guggenheim; John Akomfrah's *The Unfinished Conversation* [2013]; and Arthur Jafa's *Love Is the Message, the Message Is Death* [2016]. These endeavors speak to a contemporary activist movement that is—to quote my NYU students—"demanding cultural authority, not just cultural sensitivity."

This interview has been condensed and edited for clarity. The conversations from which it has been drawn took place on December 9, 2016, and April 10, 2017.

Introduction to a Select Bibliography
Parissah Rhayee Lin

There is a delicate balance in the act of looking: the infinite gap between seeing (to feel, to empathize, to remember) and spectacle. The oversaturation of images of Black death, within the cadre of so many forms of oppression and injustice, has more often than not reproduced the spectacle of trauma, yielding a swaddling societal numbness rather than an ignition point for action and change. Obscurity, opacity, and invisibility, however, produce much of the same effect. Only in the 2010s, after the nationwide uprising following the murders of Trayvon Martin, Michael Brown, and Eric Garner, did "the nation" begin to build a contemporary public vocabulary for the systematic murder and oppression of Black folks, picking up on seeds sewn decades ago. Only in the wake of the massive 2016 protests against the Dakota Access Pipeline did the majority of young Americans hear of the centuries-long effort to eliminate Native land and culture. Only in August 2016, after the massacre of predominantly Black and Latinx queers at the Pulse nightclub in Orlando, Florida, did mainstream media begin to admit that the legality of gay marriage did not ensure queer safety.

As the *Ektachrome Archive* shows, none of this is new. Within the lifetime of one artist such as Lyle Ashton Harris, we see waves of history crashing down, one after the other: ACT UP and the most powerful movement of HIV activism; Black organizing and urban resistance in response to the murder of Rodney King; the expansion of LGBTQ activism around the nightlife scene in New York; the emergence of the Black Atlantic arts movement birthed in the wake of the Black Arts Movement of the 1960s and 1970s; Black and third-world cultural criticism at the intersection of the artistic, political, and academic spheres. We see these waves not as facts in Western history textbooks, but as fragments in literature, film, music, art—and in the faces of the *Ektachrome Archive*.

Over the course of two and a half years I spent endless hours with the *Ektachrome Archive*. I combed through thousands of 35 mm slides animated by a light box: Lyle and his friends lounging in a hotel room in Guadalajara; his mother, Rudean, cocooned in a burgundy glow, squinting through sleep-hazed lids; Stuart Hall sitting soft and alert with a salt-and-pepper beard; Marlon Riggs snuggled next to his mother and grandmother in the muggy backseat of a town car—I felt them within arms' reach. If I squint I can imagine us breathing the same air, feeling the same sticky vinyl seat of a rented convertible, smelling the same sweat-soaked cigarette smoke. It is this wattling—of intimacy and performance, pleasure and trauma, desire and rejection, private with public and counterpublic—that breathes life into the archive. I feel

a swell of excitement watching Michele Wallace and Henry Louis "Skip" Gates Jr. captured in a moment of fervent interaction, and as deep an aching and exhaustion reading in Lyle's handwritten journals, "In a way I am tired of all the analysis. It is okay just to be still." The capacity of the archive to fuel emotional and mental stimulation comes not only from the images but from their relationship to history, theory, memory, and the texts that encompass them.

It is often said that history is written by the victors. However, it would be more apt to say that history is maintained and produced by power, which in turn reproduces itself. The "canon" is not universal, nor by any means an impartial collection of objectively more worthy works. In the words of Paul Gilroy in *Postcolonial Melancholia*, one of the many volumes included in the following bibliography, "deluded patterns of historical reflection and self-understanding are not natural, automatic, or necessarily beneficial to either rulers or ruled." When so many of us find ourselves in one margin or another, our stories rewritten or simply omitted from history, and our memories and traumas diminished or dismissed as untruths, it becomes clear: the world is in need of new methods of storytelling and seeing: as Michele Wallace says in *Black Macho and the Myth of the Superwoman*, "either we will make history or remain the victims of it." The following selection of books, essays, films, poems, and performances by those pictured in the archive and others seeks to work in conjunction with the images to counter this erasure.

We need to be able to see our past with all its inconsistencies and contradictions, so we can situate ourselves in the present and imagine our future. We need images that keep our eyes thirsty, rather than images that allow us to look away. We need to be pulled deeper so that we ache for context and scavenge for history around each fragment. The *Ektachrome Archive* is our entry point, our kindling, our pinhole into the future: rather than offering up images that paralyze us, the archive provides undeniable proof of a complex and fraught humanity. The images along with the bibliography that follows beg us to situate, research, and produce meaning, fulfilling Stuart Hall's promise, in *Representation: Cultural Representation and Signifying Practices*, that "It is the participants in a culture who give meaning to people, objects, and events." We must give meaning to the *Ektachrome Archive*, submerge ourselves in it, and begin the chaotic process of unlearning and re-remembering how to see.

Books and Articles

Baldwin, James. *Collected Essays: Notes of a Native Son; Nobody Knows My Name; The Fire Next Time; No Name in the Street; The Devil Finds Work; Other Essays.* New York: Library of America, 1998.

Bancroft, Dick, and Laura Waterman Wittstock. *We Are Still Here: A Photographic History of the American Indian Movement.* St. Paul: Minnesota Historical Society Press, 2013.

Beam, Joseph, ed. *In the Life: A Black Gay Anthology.* Boston: Alyson Books, 1986.

Blessing, Jennifer. *Rrose is a Rrose is a Rrose: Gender Performance in Photography.* New York: Solomon R. Guggenheim Museum, 1997.

Bordowitz, Gregg, and Douglas Crimp. *The AIDS Crisis Is Ridiculous and Other Writings, 1986–2003.* Edited by James Meyer. Cambridge, MA: MIT Press, 2004.

Clarke, Cheryl, ed. *Sister Outsider: Essays and Speeches by Audre Lorde.* Berkeley, CA: Crossing Press, 2007.

Crenshaw, Kimberlé. "Mapping the Margins: Intersectionality, Identity Politics, and Violence Against Women of Color." *Stanford Law Review* 43, no. 6 (July 1991): pp. 1,241–99.

Crimp, Douglas. *Melancholia and Moralism: Essays on AIDS and Queer Politics.* Cambridge, MA: MIT Press, 2004.

Debord, Guy. *The Society of the Spectacle.* Detroit: Black and Red, 1970.

Delany, Samuel R. *Times Square Red, Times Square Blue.* New York: New York University Press, 2001.

Derrida, Jacques. *Archive Fever: A Freudian Impression.* Translated by Eric Prenowitz. Chicago: University of Chicago Press, 1996.

Enwezor, Okwui. *Archive Fever: Uses of the Document in Contemporary Art.* New York: International Center of Photography/Steidl, 2008.

Fanon, Frantz. *Black Skin, White Masks.* Translated by Charles Lam Markmann. New York: Grove Press, 1967.

Foster, Hal. "An Archival Impulse." *October* 110 (Fall 2004), pp. 3–22.

Foucault, Michel. *The History of Sexuality, Volume 1.* London: Allen Lane, 1978.

Fusco, Coco, ed. *Corpus Delicti: Performance Art of the Americas.* London: Routledge, 1999.

Gilroy, Paul. *The Black Atlantic: Modernity and Double-Consciousness.* Cambridge, MA: Harvard University Press, 1993.

———. *Postcolonial Melancholia.* New York: Columbia University Press, 2006.

Golden, Thelma. *Black Male: Representations of Masculinity in Contemporary American Art.* New York: Whitney Museum of American Art, 1994.

Hall, Stuart. *Cultural Studies 1983: A Theoretical History.* Edited by Jennifer Daryl Slack and Lawrence Grossberg. Durham, NC: Duke University Press, 2016.

———, ed. *Representation: Cultural Representations and Signifying Practices.* London: Sage, 1997.

Harris, Lyle Ashton. *Blow Up.* New York: Gregory R. Miller & Co., 2008.

———. *Excessive Exposure: The Complete Chocolate Portraits.* New York: Gregory R. Miller & Co., 2010.

———. *Lyle Ashton Harris.* With an essay by Anna Deveare Smith. New York: Gregory R. Miller & Co., 2004.

Harris, Verne, and Terry Cook. *Archives and Justice: A South African Perspective.* Chicago: Society of American Archivists, 2007.

Hartman, Saidiya V. *Scenes of Subjection: Terror, Slavery, and Self-Making in Nineteenth-Century America.* New York: Oxford University Press, 1997.

Hemphill, Essex. *Brother to Brother: New Writings by Black Gay Men.* Washington: Redbone, 2007.

———. *Ceremonies: Prose and Poetry.* New York: Plume, 1992.

hooks, bell. *Ain't I a Woman: Black Women and Feminism.* Boston: South End, 1981.

———. *Feminist Theory: From Margin to Center*. Boston: South End, 1984.

———. *Talking Back: Thinking Feminist, Thinking Black*. Boston: South End, 1989.

Kincaid, Jamaica. *The Autobiography of My Mother*. New York: Farrar, Straus & Giroux, 1996.

Locke, Alain LeRoy. *The New Negro*. New York: Albert and Charles Boni, 1925.

Marable, Manning. *Malcolm X: A Life of Reinvention*. London: Penguin, 2011.

Moten, Fred. *In the Break: The Aesthetics of the Black Radical Tradition*. Minneapolis: University of Minnesota Press, 2003.

Mumford, Kevin J. *Not Straight, Not White: Black Gay Men from the March on Washington to the AIDS Crisis*. Chapel Hill: University of North Carolina Press, 2016.

Muñoz, José Esteban. *Disidentifications: Queers of Color and the Performance of Politics*. Minneapolis: University of Minnesota Press, 1999.

Osthoff, Simone. *Performing the Archive: The Transformation of the Archive in Contemporary Art from Repository of Documents to Art Medium*. New York: Atropos, 2009.

Reid-Pharr, Robert. *Once You Go Black: Choice, Desire, and the Black American Intellectual*. New York: New York University Press, 2007.

Sharpe, Christina Elizabeth. *In the Wake: On Blackness and Being*. Durham, NC: Duke University Press, 2016.

Smith, Barbara. *Toward a Black Feminist Criticism*. Brooklyn: Out and Out Books, 1980.

Taylor, Diana. *The Archive and the Repertoire: Performing Cultural Memory in the Americas*. Durham, NC: Duke University Press, 2003.

Taylor, Keeanga-Yamahtta. *From #BlackLivesMatter to Black Liberation*. Chicago: Haymarket Books, 2016.

Van Alphen, Ernst. *Staging the Archive: Art and Photography in the Age of New Media*. London: Reaktion, 2014.

Wallace, Michele. *Black Macho and the Myth of the Super-woman*. New York: Dial Press, 1978.

———. *Black Popular Culture*. Edited by Gina Dent. Seattle: Bay Press, 1992.

Warner, Michael. *Publics and Counterpublics*. New York: Zone Books, 2002.

Films and Performances

Black Is . . . Black Ain't, 1995. Directed by Marlon Riggs for California Newsreel, Lancaster, PA.

Ethnic Notions, 1987. Directed by Marlon Riggs for California Newsreel, Lancaster, PA.

The History of Sexuality Volume One by Michel Foucault: An Opera, 2010. Performed October 2010. Directed by Gregg Bordowitz for Museum of Modern Art Foundation, Ludwig, Vienna.

Looking for Langston, 1989. Directed by Isaac Julien for Sankofa Film & Video Productions, London.

Through a Lens Darkly: Black Photographers and the Emergence of a People, 2015. Directed by Thomas Allen Harris for Independent Lens, PBS.

Tongues Untied, 1989. Directed by Marlon Riggs for Frameline, San Francisco.

Urinal (*Pissoir*), 1988. Directed by John Greyson, Toronto.

Vintage—Families of Value, 1995. Directed by Thomas Allen Harris for Chimpanzee Productions, New York.

Vince Aletti is an author and curator. His exhibition reviews have been featured in the *Village Voice*, where he was the art editor from 1994 to 2005, and the *New Yorker*'s Goings On About Town section. He contributes a regular column about photobooks for *Photograph* as well as reviews and features for *Aperture* and *Artforum*. He is the winner of the 2005 Infinity Award in writing from the International Center of Photography, where he was an adjunct curator in 2009. *Male*, a book of photographs and other artwork from Aletti's collection, was published by Andrew Roth's PPP Editions in 2008; PPP Editions published another view of that collection, *Untitled Anonymous*, in 2015.

Martina Attille is a founding member of the London-based Sankofa Film and Video Collective. From 1983 until 1988, she worked closely with fellow founding members Nadine Marsh-Edwards, Isaac Julien, Maureen Blackwood, and Robert Crusz. Attille's debut as writer and director for Sankofa, *Dreaming Rivers* (1988), was awarded one of five Filmdukaten der Stadt Mannheim at the XXXVII Internationale Filmwoche Mannheim in 1988.

Ulrich Baer is a writer, editor, and translator. Among his books are *Spectral Evidence: The Photography of Trauma* (MIT Press, 2002); *110 Stories: New York Writes After September 11* (New York University Press, 2004); *The Claims of Literature: A Shoshana Felman Reader* (with Eyal Peretz and Emily Sun, Fordham University Press, 2007); *The Rilke Alphabet* (Fordham University Press, 2014); and *We Are but a Moment* (self-published, 2017). He regularly writes on photography for museums and various publications. He is professor and vice provost at New York University, where he teaches literature, photography, and globalization, and directs the Center for the Humanities. He is the recipient of DAAD, Getty Foundation, Alexander von Humboldt, and John S. Guggenheim awards.

Gregg Bordowitz is an artist, writer, and filmmaker. His publications include *The AIDS Crisis Is Ridiculous and Other Writings, 1986–2003* (with Douglas Crimp, MIT Press, 2004); *Volition* (Printed Matter, 2009); *General Idea: Imagevirus* (Afterall, 2010); *Taking Voice Lessons* (If I Can't Dance I Don't Want to Be Part of Your Revolution, 2014). His films and performances have appeared in three historical survey exhibitions: *This Will Have Been: Art, Love, and Politics in the 1980s* (Museum of Contemporary Art, Chicago, 2012), *Blues for Smoke* (Los Angles Museum of Contemporary Art, 2012–13), and *NYC 1993: Experimental Jet Set, Trash and No Star* (New Museum, New York, 2013). Most recently, his work was included in *Greater New York* at MoMA PS1 (2015–16). His films, including

Fast Trip, Long Drop (1993), *The Suicide* (1996), and *Habit* (2001), have been screened internationally. He is currently the director of the low-residency MFA program at the School of the Art Institute of Chicago.

Johanna Burton is Keith Haring Director and Curator of Education and Public Engagement at the New Museum in New York and the editor for the museum's Critical Anthologies in Art and Culture series. She has contributed articles and reviews to numerous journals—including *Artforum*, *Art Journal*, *October*, and *Texte zur Kunst*—as well as to exhibition catalogues for institutions throughout the world. Burton has curated or cocurated exhibitions, including *Sherrie Levine: Mayhem* at the Whitney Museum of American Art, New York, in 2011–12 (with Elisabeth Sussman); *Anti-Establishment* at the Center for Curatorial Studies at Bard College, Annandale-on-Hudson, New York, in 2012; *Take It or Leave It: Institution, Image, Ideology* at the Hammer Museum, Los Angeles, in 2014 (with Anne Ellegood); and at the New Museum: *Simone Leigh: The Waiting Room* (with Shaun Leonardo and Emily Mello) in 2016; and *A.K. Burns: Shabby But Thriving* in 2017 (with Sara O'Keeffe), among other projects. She is the editor of *Cindy Sherman* (October Files, MIT Press, 2006) and coeditor (with Shannon Jackson and Dominic Willsdon) of *Public Servants: Art and the Crisis of the Common Good* (New Museum and MIT Press, 2016). Prior to her work at the New Museum, Burton was director of the graduate program at the Center for Curatorial Studies at Bard College (2010–13) and associate director and senior faculty member at the Whitney Independent Study Program (2008–10).

Adrienne Edwards is curator at Performa, curator at large at the Walker Art Center, and a PhD candidate in performance studies at New York University. Her scholarly and curatorial work focuses on artists of the African diaspora and the Global South, and includes the *Blackness in Abstraction* exhibition and catalogue for Pace Gallery, New York, and the 1:54 PERFORMS section for the 1:54 Contemporary African Art Fair. For Performa, Edwards has curated programs, projects, and productions with a wide range of artists. These include the Performa Commissions by Edgar Arceneaux, Lorraine O'Grady, Wangechi Mutu, Carrie Mae Weems, and others. She is a contributor to numerous exhibition catalogues and art publications, including *Aperture*, *Art in America*, *Artforum.com*, *Parkett*, and *Spike Art Quarterly*.

Malik Gaines is an artist and writer based in New York. His book *Black Performance on the Outskirts of the Left* (New York University Press, 2017) traces the circulation of political ideas in performances of the 1960s and beyond. His essays have appeared in *Art Journal*, *Women & Performance*, and exhibition

catalogues. Since 2000, Gaines has performed and exhibited with collaborators Jade Gordon and Alexandro Segade as the group My Barbarian, whose work has been shown at the Museum of Modern Art, the Studio Museum in Harlem, and The Kitchen, New York; the Los Angeles County Museum of Art; Amsterdam's De Appel; Cairo's Townhouse Gallery; and many others. It has also been included in the Whitney Biennial, two Performa biennials, and the Baltic Triennial, and has been the subject of solo exhibitions at the New Museum; the Hammer Museum; Museo Experimental El Eco, Mexico City; and Yaffo 23, Jerusalem, among others. Gaines also makes performance and video work on his own, and as part of other collaborations. He is assistant professor of performance studies in New York University's Tisch School of the Arts.

Lucy Gallun is assistant curator in the Department of Photography at the Museum of Modern Art. She has curated or cocurated several recent exhibitions at MoMA, including *Ocean of Images: New Photography 2015* (2015); *Soldier, Spectre, Shaman: The Figure and the Second World War* (2015); and *Art on Camera: Photographs by Shunk-Kender, 1960–1971* (2015). Gallun is also coeditor of a three-volume history of photography at the museum, including the recent publications *Photography at MoMA: 1920 to 1960* and *Photography at MoMA: 1960 to Now*, and the upcoming *Photography at MoMA: 1840 to 1920*. Prior to joining the Department of Photography at MoMA, Gallun was the Whitney-Lauder Curatorial Fellow at the Institute of Contemporary Art in Philadelphia, and a Helena Rubinstein Curatorial Fellow at the Whitney Museum Independent Study Program. Gallun has also served as associate publisher at Gregory R. Miller & Co., New York.

For more than two decades, **Lyle Ashton Harris** (born 1965, New York) has cultivated a diverse artistic practice ranging from photographic media to collage, installation, and performance. His work explores the intersections between the personal and the political, examining the impact of ethnicity, gender, and desire on contemporary social and cultural dynamics. Harris's work has been exhibited widely, including at the Guggenheim Museum and the Whitney Museum of American Art, New York, among others, as well as at international biennials, such as Bienal de São Paulo, 2016; Busan Biennale, 2008; 52nd International Art Exhibition at the Venice Biennale, 2007; International Biennial of Contemporary Art of Seville, 2006; and Gwangju Biennale, 2000. His work is represented in the permanent collections of major museums, most recently the Whitney Museum of American Art and Museum of Modern Art, New York. In 2014, Harris joined the board of trustees of the American Academy in Rome and was recipient of the David C. Driskell Prize by the High Museum of Art, Atlanta. In 2016, he was awarded the

John Simon Guggenheim Memorial Foundation Fellowship and was appointed a trustee of the Tiffany Foundation. Harris studied at Wesleyan University, the California Institute of the Arts, and the Whitney Museum of American Art Independent Study Program, and is currently an associate professor of art and art education at New York University. He is represented by Salon 94, New York.

Raised in the Bronx, New York, and Dar es Salaam, Tanzania, **Thomas Allen Harris** is the founder and president of Chimpanzee Productions, a company dedicated to producing unique audio-visual experiences that illuminate the search for identity, family, and spirituality. Chimpanzee's award-winning films, videos, and transmedia projects have received critical acclaim at international film festivals such as Sundance, Berlin, Toronto, FESPACO, Outfest, Flaherty, and Cape Town, and have been broadcast on PBS, SundanceTV, ARTE, CBC, Swedish Television, and Television New Zealand. They have been exhibited at the Museum of Modern Art's Documentary Fortnight, New York; Whitney Museum of American Art Biennial, New York; Corcoran Gallery, Washington, DC; Gwangju Biennale, South Korea; and Melbourne Arts Festival. A graduate of Harvard College and the Whitney Museum Independent Study Program, Harris has received numerous awards, including an NAACP Image Award and African Oscar, as well as Guggenheim, Rockefeller, and United States Artists Fellowships. He is a member of the Academy of Motion Picture Arts and Sciences. In 2009, Harris and his team launched the socially engaged art project Digital Diaspora Family Reunion, and as of summer 2017, he is also in production on a new television series entitled *Family Pictures USA*.

Rashid Johnson is a sculptor and photographer who works in a wide range of everyday materials. Recent solo exhibitions include *Rashid Johnson: Hail We Now Sing Joy* (Kemper Museum of Contemporary Art, Kansas City, Missouri, 2017); *Fly Away* (Hauser & Wirth, New York, 2016); *Within Our Gates* (Garage Museum of Contemporary Art, Moscow, 2016); *Anxious Men* (The Drawing Center, New York, 2015); *Three Rooms* (Kunsthalle Winterthur, Switzerland, 2014); *Shelter* (South London Gallery, London, 2012); and the major touring exhibition *Message to Our Folks*, which opened at the Museum of Contemporary Art, Chicago, and traveled to the Miami Art Museum and the High Museum of Art, Atlanta, in 2012–13.

Thomas J. Lax was appointed associate curator of Media and Performance Art at the Museum of Modern Art in 2014; previously he worked at the Studio Museum in Harlem. His organized projects include *Steffani Jemison: Promise Machine* (with Stuart Comer, 2015), *Greater New York* (with Douglas

Crimp, Peter Eleey, and Mia Locks, 2015), *Maria Hassabi: PLASTIC* (2016), and *Projects 102: Neïl Beloufa* (2016), and a publication on the work of Ralph Lemon (Museum of Modern Art, 2016). He is affiliated with the Institute for Curatorial Practice in Performance at Wesleyan University's Center for the Arts; the Vera List Center for Art and Politics; the Laundromat Project; Recess Activities; and Contemporary And. In 2015, Lax was awarded the Walter Hopps Award for Curatorial Achievement.

Sarah Elizabeth Lewis is an assistant professor of History of Art and Architecture and African and African American Studies at Harvard University. Lewis received her bachelor's degree from Harvard, an MPhil from Oxford University, and her PhD from Yale University. Lewis served as guest editor for "Vision & Justice," an issue of *Aperture* magazine, which received the 2017 Infinity Award for Critical Writing and Research from the International Center of Photography. Her research interests focus on representations of race in contemporary art and nineteenth- and early twentieth-century American culture and across the Black Atlantic world; and her scholarship has been published in many academic journals, including the *New Yorker*, the *New York Times*, *Artforum*, *Art in America*, and in publications by the Smithsonian and the Museum of Modern Art. She is also the author of the *Los Angeles Times* bestseller *The Rise: Creativity, the Gift of Failure, and the Search for Mastery* (Simon & Schuster, 2015). Before joining the faculty at Harvard, she held curatorial positions at the Museum of Modern Art, New York, and the Tate Modern, London, and taught at Yale University School of Art. She lives in Cambridge, Massachusetts, and in New York City.

Parissah Rhayee Lin is an educator, researcher, and media maker. Her artistic praxis uses video art, archival and collected footage, public mourning, and performance. She received her bachelor's degree from New York University's Gallatin School of Individualized Study. She is a director and educator at the New York City nonprofit We Make Noise and has been the studio manager for Lyle Ashton Harris since 2015. She is a founding member of the Yellow Jackets Collective, a queer intersectional and interdisciplinary collective of East Asians collaborating toward radical futures that centralize marginalized bodies.

Catherine Lord is professor emerita of studio art at the University of California, Irvine. She is a writer, artist, and curator whose work addresses issues of feminism, cultural politics, and colonialism. She is the author of two text/image experimental narratives: *The Summer of Her Baldness: A Cancer Improvisation* (University of Texas Press, 2004) and, with Richard Meyer, the survey *Art and Queer Culture* (Phaidon Press, 2013). Her critical essays and fiction have been published in *Afterimage*, *Art & Text*, *New Art Examiner*, *Art Journal*, *GLQ*, *X-tra*, and *Art Paper*, as well as in the collections *Reframings: New American Feminist Photographies* (Temple University Press, 1995); *Illuminations: Women Writing on Photography from the 1850s to the Present* (Duke University Press, 1996); and *WACK! Art and the Feminist Revolution* (MIT Press, 2007), among others. Her work as a visual artist has been shown at Site Santa Fe, New Mexico; La Mama Gallery, New York; Post Gallery and Thomas Jancar Gallery, Los Angeles; and the Carpenter Center at Harvard University, Cambridge, Massachusetts.

Roxana Marcoci is senior curator, Department of Photography, at the Museum of Modern Art and the recipient of the Center for Curatorial Leadership Fellowship in 2011. She has curated major exhibitions of the work of Louise Lawler (2017), Zoe Leonard (2015), Christopher Williams (2014), Taryn Simon (2012), Sanja Iveković (2011), Olafur Eliasson (with Klaus Biesenbach, 2008), and Thomas Demand (2005), as well as thematic surveys, including *Transmissions: Art in Eastern Europe and Latin America, 1960–1980* (with Stuart Comer and Christian Rattemeyer, 2015); *From Bauhaus to Buenos Aires: Grete Stern and Horacio Coppola* (with Sarah Meister, 2015); *Staging Action: Performance in Photography since 1960* (with Eva Respini, 2011); and *The Original Copy: Photography of Sculpture, 1839 to Today* (2010). Marcoci has written extensively on postwar and contemporary art, and is a contributor to *Aperture*, *Art in America*, *Art Journal*, and *Mousse*, among other journals. She is coeditor of *Photography at MoMA: 1960 to Now* (2015), *Photography at MoMA: 1920 to 1960* (2016), and *Photography at MoMA: 1840–1920* (2017), and is a visiting critic in the graduate program at Yale University.

Pamela Newkirk is a journalist and media scholar. Her most recent book, *Spectacle: The Astonishing Life of Ota Benga* (Harper Collins, 2015), won the NAACP Image Award for Outstanding Non-Fiction Literature and the Zora Neale Hurston/Richard Wright Foundation Legacy Award. Dr. Newkirk is the editor of *Letters from Black America* (Farrar, Straus & Giroux, 2009) and *A Love No Less: More than Two Centuries of African American Love Letters* (Doubleday, 2003), and author of *Within the Veil: Black Journalists, White Media* (New York University Press, 2000). Dr. Newkirk is professor of journalism and director of undergraduate studies in New York University's Arthur L. Carter Journalism Institute and previously worked at four news organizations, including *Newsday*, where she was part of a Pulitzer Prize–winning team. Her articles on media, race, and African American art, history, and culture have appeared in numerous publications, including the *New York Times*, the *Washington Post*, the *Guardian*, the *Nation*, and *Artnews*.

For ten years, **Clarence Otis Jr.** was chief executive officer of Darden Restaurants, a *Fortune 500* company that owns Olive Garden, Capital Grille, and several other national restaurant chains. Prior to joining Darden, Clarence was an investment banker in New York City, finishing his financial services career leading a securities unit of a predecessor firm of JP Morgan Chase. Otis serves on the board of directors of Verizon, VF Corporation, MFS Funds, Jazz at Lincoln Center, and the Boys & Girls Clubs of America. He is also a member of the board of trustees of Williams College, his alma mater, and the board of visitors of Stanford Law School, where he received his law degree.

Robert Reid-Pharr is Distinguished and Presidential Professor of English and American Studies at the Graduate Center of City University of New York, where he also directs the Institute for Research on the African Diaspora in the Americas and the Caribbean. Reid-Pharr works to disrupt narrow conceptual and disciplinary boundaries as he examines the interconnections between discourses of race, gender, class, and sexuality. His major works include *Conjugal Union: The Body, the House, and the Black American* (Oxford University Press, 1999); *Black, Gay, Man: Essays* (New York University Press, 2001); *Once You Go Black: Choice, Desire, and the Black American Intellectual* (New York University Press, 2007); and *Archives of Flesh: African America, Spain, and Post-Humanist Critique* (New York University Press, 2016). His writing has appeared in *American Literary History*, *American Literature*, *Small Axe*, *The Chronicle of Higher Education*, *Women & Performance*, *Social Text*, *Transition*, *Studies in the Novel*, *Callaloo*, *African American Review*, *Art in America*, and *Feminist Formations*, among many other publications. Reid-Pharr is a recipient of research awards from the National Endowment for the Humanities, the Alexander von Humboldt Stiftung, and the John Simon Guggenheim Memorial Foundation. He is a member of the Johns Hopkins Society of Scholars.

Robert Storr is an artist, critic, and curator. From 1990 to 2002, he was curator and then senior curator in the Department of Painting and Sculpture at the Museum of Modern Art, New York, where he organized thematic exhibitions such as *Dislocations* and *Modern Art Despite Modernism* (2002), and solo shows for such artists as Elizabeth Murray, Gerhard Richter, Max Beckmann, Tony Smith, and Robert Ryman. Storr has taught at the Institute of Fine Arts at New York University, the Graduate Center of the City University of New York, Bard Center for Curatorial Studies, Rhode Island School of Design, Tyler School of Art at Temple University, New York Studio School, and Harvard University. From 2006 to 2016, he served as professor of painting and printmaking and dean of the Yale University School of Art. Since 1981, Storr has been a contributing editor at *Art in America*. He writes frequently for *Artforum*, *Parkett*, *Art Press*, *Frieze*, and *Corriere della Sera*, in addition to authoring catalogues and books. Storr has been the recipient of numerous awards and grants, including a Penny McCall Foundation grant for painting and a Norton Family Foundation Curator Grant.

Mickalene Thomas is a 2015 United States Artists Francie Bishop Good & David Horvitz Fellow and a visual artist, filmmaker, and curator. Her recent solo exhibitions include *Waiting on a Prime-Time Star* at Newcomb Art Museum of Tulane University (2017); *Mickalene Thomas: Do I Look Like a Lady?* at MOCA Grand, Los Angeles (2016–17); *Mickalene Thomas: Mentors, Muses, and Celebrities* at Aspen Art Museum, Colorado (2016); and *Muse: Mickalene Thomas Photographs*, originated by Aperture Foundation, New York (2016), and traveling through 2019 to several venues across the United States and featuring an accompanying exhibition, *tête-à-tête*, curated by the artist. Thomas's work is in the permanent collections of the San Francisco Museum of Modern Art, Brooklyn Museum, Guggenheim Museum, and Smithsonian National Portrait Gallery, among many others. Thomas is represented by Lehmann Maupin, New York and Hong Kong; Kavi Gupta Gallery, Chicago; and Galerie Nathalie Obadia, Paris and Brussels. She serves on the boards of the Brooklyn Museum, Children's Museum of the Arts, Museum of Contemporary African Diasporan Arts, MoMA PS1, *BOMB Magazine*, and the Rush Philanthropic Arts Foundation.

Iké Udé is an aesthete, dandy, writer, and founder of the seminal art/fashion print magazine *aRUDE* (1995–2009). *Vanity Fair* included him in the magazine's International Best Dressed List in 2009, 2012, and 2015. His artworks have been exhibited in solo and group exhibitions and featured in a number of publications, including *Art in America*, the *New Yorker*, *Art Daily*, *L'Uomo Vogue*, *Flash Art*, and the *New York Times*. His articles on fashion and art have been published in magazines and newspapers worldwide and his books include *Style File: The World's Most Elegantly Dressed* (Harper Collins, 2008) and *Nollywood Portraits: A Radical Beauty* (Museum of Contemporary Photography/Skira, 2017).

293

Acknowledgments

For friends, family, lovers, and strangers, as well as the numerous "image makers," whose generous participation enabled me to photographically capture many otherwise fleeting moments, I am incredibly grateful.

My heartfelt thanks goes to all who contributed essays to this monograph, each offering their distinctive recollections and personal insights into the pivotal time and coincident lives that these photographs serve to memorialize. I am deeply moved by their reflective engagements with the works that comprise this archive.

For her wonderful introduction and dedicated editorial vision in assembling a unique collection of essays, I am particularly grateful to Johanna Burton, the Keith Haring Director and Curator of Education and Public Engagement at the New Museum, New York.

I am thrilled to have closely collaborated with Lesley A. Martin, whose keen eye and fierce passion proved invaluable, and I am greatly indebted to everyone on the Aperture team for their diligent efforts in facilitating the publication of this singular monograph, especially Chris Boot, Emily Grillo, Blanche Norman, Samantha Marlow, Nelson Chan, and Marisa Sottos.

Special thanks goes to Sandra van der Doelen and Teun van der Heijden for their rigorous and elegant design.

I also give thanks to my studio team for their commitment to this project over the last years: Parissah Lin, Studio Manager and Lead Researcher on the *Ektachrome Archive*; Joseph Imhauser, Production Manager; Erin Sweeny, Photography Archivist; Bonnie Lane, Image Consultant; Mayid Guerrero, Studio Assistant; and Christopher Minafo, Studio Intern.

For their unstinting support, my utmost appreciation goes to Agnes Gund, Miyoung Lee and Neil Simpkins, Jacqueline Bradley and Clarence Otis Jr., Gregory R. Miller, and Michael Wiener, as well as those who contributed inestimably toward realizing this endeavor: Carmine D. Boccuzzi and Bernard Lumpkin, Katie and Jim Brennan, David Castillo, Andrew Craven, Gregory Crewdson, Dawn L. Davis, Beth Rudin DeWoody and Firooz Zahedi, Tasos Draillos, Carlo Ferraris, Alex Fialho, Alissa Friedman, Tommy Gear, Jeanne Greenberg Rohatyn, Charles Griffin, Alvin D. Hall, Jim Hodges, Michael Hoeh, Robert E. Holmes, Noel Kirnon, Rudean Leinaeng, Christopher Y. Lew, Benji Liebmann, Mia Locks, Serge Maruani, Laurent Mercier, Gabi Ngcobo, Junko Sakuno, Richard Shebairo, Ann G. Tenenbaum and Thomas H. Lee, Jochen Volz, Carrie Mae Weems, and Deborah Willis. I am truly blessed!

295

Lyle Ashton Harris: Today I Shall Judge Nothing That Occurs
Selections from the *Ektachrome Archive*

Front cover: Self-portrait, Rome, 1992

Photographs and journals by Lyle Ashton Harris
Introduction by Johanna Burton
Contributions by Vince Aletti, Martina Attille, Gregg
Bordowitz, Adrienne Edwards, Malik Gaines, Lucy Gallun,
Rashid Johnson, Thomas J. Lax, Sarah Elizabeth Lewis,
Catherine Lord, Roxana Marcoci, Pamela Newkirk, Clarence
Otis Jr., Robert Storr, Mickalene Thomas, and Iké Udé
Additional essays by Ulrich Baer and Robert Reid-Pharr
Conversation with Thomas Allen Harris
Bibliography by Parissah Rhayee Lin

Editor: Lesley A. Martin
Contributors' Text Editor: Johanna Burton
Design: Teun van der Heijden, Heijdens Karwei
Production Director: Nicole Moulaison
Production Manager: Nelson Chan
Associate Editor: Samantha Marlow
Senior Text Editor: Susan Ciccotti
Copy Editors: Paula Kupfer, Sally Knapp
Index: Paula Kupfer
Work Scholars: Marisa Sottos, Lucas Vasilko, Simon Hunegs

Additional staff of the Aperture book program includes:
Chris Boot, Executive Director; Amelia Lang, Executive
Managing Editor; Taia Kwinter, Associate Managing Editor;
Kellie McLaughlin, Director of Sales and Marketing; Richard
Gregg, Sales Director, Books

Special thanks:
Lyle Ashton Harris: Today I Shall Judge Nothing That Occurs
was made possible with generous support from Agnes Gund,
Ann Tenenbaum and Thomas H. Lee, Bernard I. Lumpkin and
Carmine D. Boccuzzi, Beth Rudin DeWoody and Firooz
Zahedi, Jim Hodges, and Miyoung Lee and Neil Simpkins.

Additional support was provided by Alvin D. Hall, Andrew
Craven, Dawn L. Davis, Gregory R. Miller and Michael Wiener,
Katie and Jim Brennan, Michael Hoeh, Noel Kirnon, Richard
Shebairo and Kathleen Monaghan, and Robert E. Holmes.

First edition, 2017
Printed by Ofset Yapimevi in Turkey
10 9 8 7 6 5 4 3 2 1

Library of Congress Cataloging-in-Publication Data
Names: Harris, Lyle Ashton, 1965- Photographs. Selections.
Title: Lyle Ashton Harris : today I shall judge nothing that
occurs : selections from the Ektachrome Archive /
contributions by Vince Aletti, Martina Attille, Ulrich Baer,
Gregg Bordowitz, Johanna Burton, Adrienne Edwards, Malik
Gaines, Lucy Gallun, Thomas Allen Harris, Rashid Johnson,
Thomas J. Lax, Parissah Lin, Sarah Lewis, Catherine Lord,
Roxana Marcoci, Pamela Newkirk, Clarence Otis Jr., Robert
Reid-Pharr, Robert Storr, Mickalene Thomas, and Iké Udé.
Other titles: Today I shall judge nothing that occurs
Description: First edition. | New York, N.Y. : Aperture
Foundation, 2017. Includes bibliographical references and
index.
Identifiers: LCCN 2017023381 | ISBN 9781597114127
(clothbound : alk. paper)
Subjects: LCSH: Photography, Artistic. | Vernacular
photography. | Photography--Social aspects. | Harris, Lyle
Ashton, 1965---Friends and associates. | African American
photographers. | Cross-cultural studies.
Classification: LCC TR655 .H36737 2017 | DDC 779.2--dc23
LC record available at https://lccn.loc.gov/2017023381

To order Aperture books, contact:
+1 212.946.7154
orders@aperture.org

For information about Aperture trade distribution worldwide,
visit aperture.org/distribution

aperture

Aperture Foundation
547 West 27th Street, 4th Floor
New York, N.Y. 10001
aperture.org

Aperture, a not-for-profit foundation, connects the photo
community and its audiences with the most inspiring work,
the sharpest ideas, and with each other—in print, in person,
and online.